SEEING
SALVATION

SEEING SALVATION

IMAGES OF CHRIST IN ART

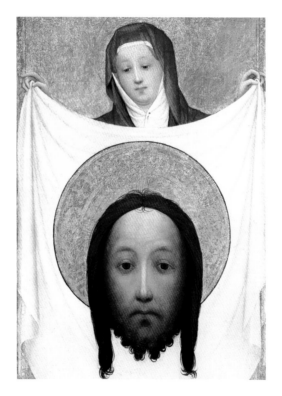

NEIL MACGREGOR

with ERIKA LANGMUIR

Yale University Press
New Haven & London

Title page: MASTER OF ST VERONICA, *St Veronica with the Sudarium, c. 1420*

This book is published to accompany the television series
Seeing Salvation, first broadcast on BBC2 in 2000.

Published by BBC Worldwide Limited,
Woodlands, 80 Wood Lane, London W12 0TT
Published in the United States by Yale University Press

Executive producer: Keith Alexander · Series producer: Patricia Wheatley
Producers: Tim Robinson and Patricia Wheatley

ISBN 0-300-08478-1

Commissioning editor: Sheila Ableman
Project editor: Martha Caute · Copy editor: Ruth Thackeray
Designer: Linda Blakemore · Picture researcher: Deirdre O'Day

Set in Sabon by BBC Worldwide
Printed and bound in Great Britain by Butler & Tanner Limited, Frome
Color separations by Radstock Reproductions Limited, Midsomer Norton
Jacket printed by Lawrence Allen Limited, Weston-super-Mare

The paper in this book meets the guidelines for permanence and durability
of the Committee on Production Guidelines for Book Longevity
of the Council on Library Resources.

10 9 8 7 6 5 4 3 2 1

CONTENTS

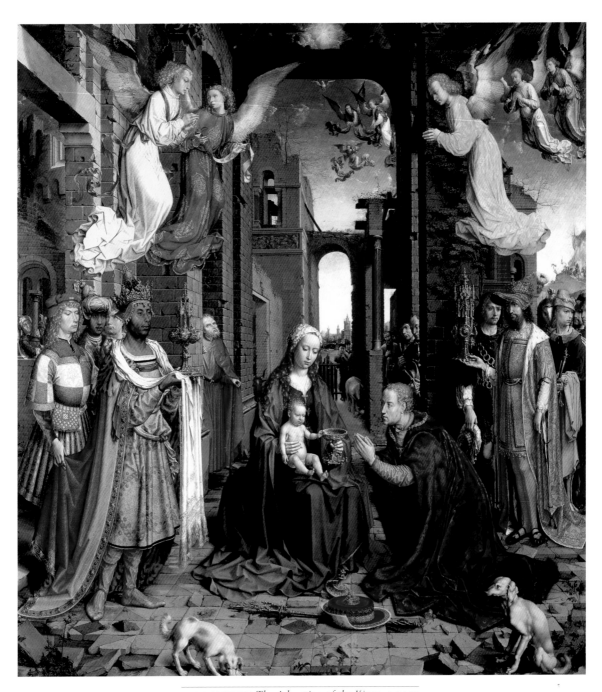

1 JAN GOSSAERT *The Adoration of the Kings, c.* 1510

INTRODUCTION

Lord, now lettest thou thy servant depart in peace, according to thy word: For mine eyes have seen thy salvation.
LUKE 2:29–30

With these words this book begins and ends. They were spoken by the old priest Simeon as he took the infant Jesus in his arms and saw in him the Saviour. In this child, Christians believe, the boundaries of the human and the divine were permanently redrawn for us all. The implications of Simeon's vision for European art are the subject of this book.

When you walk through any of the world's great collections of European painting, you cannot fail to notice how many of the pictures – and how many of the greatest – deal with the life and death of Jesus Christ. It is a subject which was for centuries the staple of Western European artists, who tried to express through painting and sculpture what Jesus's life on earth meant to them, and to everybody, for, with the exception of a small Jewish community, everybody in Europe would have agreed that the fact and the meaning of Christ's life and death were the most important notions that could be addressed.

Presumably these pictures and sculptures are still likely to be of interest to believing Christians whose faith they were made to strengthen. But most of the National Gallery's visitors today, like most of the population of Europe and America, are not believing Christians, and these pictures may well appear remote or daunting. I believe, however, that they can still speak powerfully to believers and non-believers, that they are as important to us now as a way of understanding our lives as they were when they were made. And that is because the greatest artists, in representing the life of Christ, did something even more difficult: they explored the fundamental experiences of every human life. Pictures about Jesus's childhood, teachings, sufferings and death are – regardless of our beliefs – in a very real sense pictures about us.

Because every life was held to be in some measure divine, the language of Christian art still allows Leonardo and Rembrandt, Michelangelo and Rubens, to speak to us of love and suffering, loss and hope.

Neil MacGregor

PART ONE

THE BIRTH OF A GOD

*And when they were come into the house,
they saw the young child with Mary his mother,
and fell down, and worshipped him.*

MATTHEW 2:11

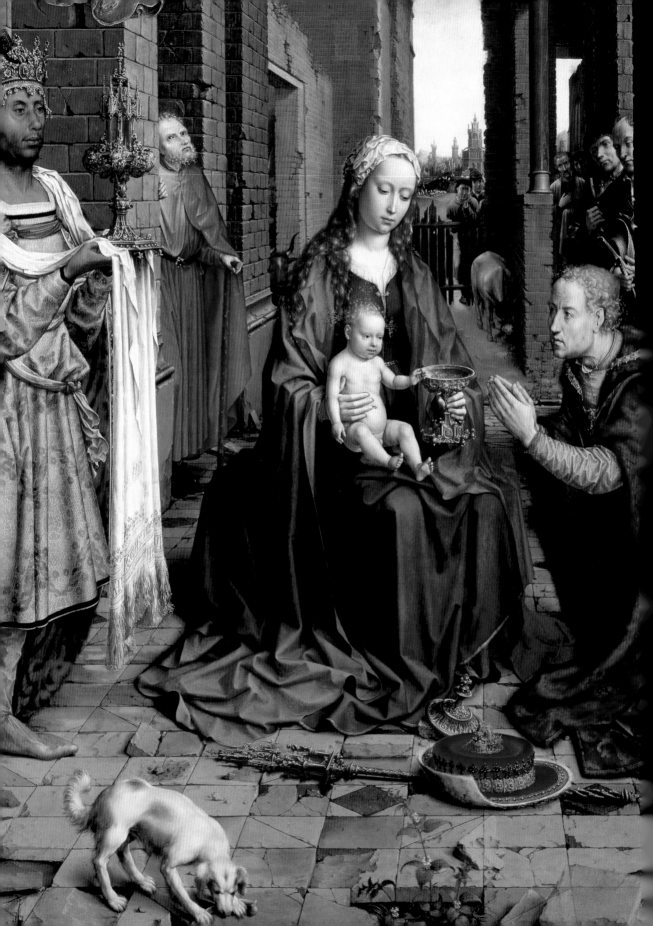

CHAPTER ONE

JAN GOSSAERT
The Adoration of the Kings

Towards the end of December in Palestine, a Jewish carpenter and his pregnant wife travelled from Nazareth to Bethlehem to be taxed by the bureaucrats of imperial Rome. There was no room for them at the inn, so they lodged in a stable, where the young woman, weary after the long journey, gave birth to a son. Ox and ass stood beside the manger in which the new-born baby lay, warming him with their breath. Alerted by angels, shepherds hurried down from the hills to see the baby. Three kings, guided by a star, came from the East to offer him gifts.

This, in broad outline, is the Christmas story as every schoolchild has been told it. And in this sense we are all schoolchildren. Christians and non-Christians alike brought up in the European tradition are familiar with these events, more or less heavily embroidered with picturesque detail, from Christmas cards and paintings, Christmas carols and Nativity plays, even shop window displays. In many European countries, they are re-enacted in cribs and collections of carved figures assembled at home, in churches and, especially in Italy and Germany, city streets.

We have been here so often that when we first look at Jan Gossaert's *Adoration of the Kings* [PLATES 1 and 2], which now hangs in the National Gallery in London, we instantly feel at ease. We know what we are going to find, and we know this is how it was.

Yet a second look is enough to convince us that Gossaert, who lived in the Low Countries fifteen hundred years after the birth of Christ, is not recording the story as every schoolchild knows it and even less the event as it might really have happened, even if interpreted in 'modern dress'. Wherever we turn within the painting, we find improbabilities and impossibilities, none of which, on closer examination, appears to be accidental.

The imposing ruins are a very strange stable and offer no shelter. The ox and ass peering out from among them are unlikely ever to have been installed there. No carpenter's wife was ever so lavishly turned out, in a blue dress and mantle painted with ground lapis lazuli, a pigment costlier than gold and brought to Europe with great difficulty and at great expense from Afghanistan. No mother is

likely to hold her twelve-day-old baby naked on her lap outdoors in the dead
of winter. Baby and mother appear singularly poised in the centre of the compo-
sition, graciously receiving the homage of a fantastical crowd who have obviously
changed – somewhere in the wings, as it were – out of their travelling clothes into
elaborate court and pageantry costumes.

The mother's elderly husband – his age and decrepitude emphasized by the
cane on which he leans – looks on from behind a pillar.

The Three Kings have names cleverly inscribed about their clothing like the
most elegant designer labels, or marked on the gifts they bring. Kneeling, hands
folded in prayer before the child, is Gaspar. Balthazar, the black king, stands
to the left, and Melchior to the right. Their gifts, or rather the gifts' golden
containers, could not possibly have been made at the time of Christ's birth either
in Palestine or in the East from which the wise men came. Instead, they resemble
objects used in the church worship of the artist's day. Gaspar's goblet, which he
has handed to the baby's mother and whose lid is on the floor beside his hat and
sceptre, is more properly a ciborium, in which the Host, the consecrated wafer
used in the Eucharist, is kept. Here it holds gold coins, one of which the preco-
cious infant seems to be handing back to the king with a smile. It is not clear
which of the other two kings brings frankincense, and which myrrh.

The angels come as no surprise, for they are part of the story, but descending
on golden rays from the miraculous guiding star is a dove, planing on outstretched
wings above the mother and child.

And as we look further into the picture, we see that it shows events that
happened at different times. The shepherds, who came the night the child was
born, are still here, on Twelfth Night, when the wise men came, watching them
from behind the picket fence. And, if you look really closely, you can spot the
angel announcing the happy event in the fields in the far background, before they
even set off for Bethlehem and the stable.

We could go on pointing out details invisible in reproduction. The capital of
a column to the right of the mother and child is sculpted with the Old Testament
scene of Abraham about to sacrifice his son Isaac to God, until stopped by an
angel. On the top of Gaspar's highly worked sceptre the goldsmith has sculpted a
figure of Moses with the stone tablets of the Law, given him, as Exodus tells us,
by God on Mount Sinai.

What is going on? How did a painting as seemingly obvious in subject as
Gossaert's turn out to be so packed with obscure complexities?

Christianity is, like Judaism and Islam, a religion of the book. Along with
them it proposes a set of teachings and practices deriving ultimately from texts

(in some cases, the same texts), which have been meticulously expounded by the learned, and enlarged and enriched by centuries of tradition. In all three faiths mankind strives for God through the Word. But unlike Muslims and Jews, Christians (or at least the early Christians) have *seen* their God; for Christianity is the religion of the Word made flesh, and, largely as a consequence, it is also a religion of the image.

Making an image of God who has become man is, as we shall see, a tricky business. Artists attempting it have to negotiate a series of specifically visual problems, unknown to authors. Paradox is easy to write, but hard to paint. The Gospel tells us quite straightforwardly that the helpless, swaddled infant is in reality God incarnate, but how do you *show* that it is God in nappies, that the purpose of this child is to redeem the world by his death? How can a painter make clear that the man brutally being put to death on a cross, to every human eye a man completely ordinary and like any other, is also totally divine; that limitless power has chosen absolute submission?

Like all great religious images, Gossaert's *Adoration* neither simply illustrates a religious story nor interprets it according to the painter's own caprice. It translates into a visual language a pictorial theology, a distillation of the Western Church's teachings on the dual nature of Christ, as at once God and man, taking into account centuries of pious poring over sacred texts to find hidden meanings and correspondences, and to wring from them every drop of possible meaning. Gossaert's picture does not show us the birth of Christ: it paints a meditation on the meaning of the birth of Christ and why it matters to us now.

Like all works of art, it reflects the interests of those who paid for it, and those who viewed and used it, as much as the concerns of the artist who made it. We can perhaps quickly resume the latter. Gossaert clearly wished to demonstrate his dazzling mastery of the exacting techniques of oil painting developed in the Low Countries through the fifteenth century, his familiarity with the last word in the crafts of others: fashionable goldsmiths, weavers, embroiderers, cobblers and all, and to be recognized as a learned artist who consorted with scholars, princes and prelates. As a token of his own Christian belief, his personal witness to the birth of his Saviour, he may have introduced his self-portrait in a small, barely visible figure standing in the doorway behind the ox.

Gossaert's *Adoration*, made around 1510, was an altarpiece, probably painted for the Lady Chapel in the church of a Benedictine abbey in Geraardsbergen in East Flanders. Its main function was to serve as the focus of worship at the altar, the celebration of the eucharistic service, in this case the Roman Catholic Mass, which re-enacts the Lord's Supper – when Christ gave

bread to his disciples, saying, 'Take ye, and eat. This is my body' – and his sacrifice on the Cross, through which his body becomes the bread of life.

This function, as part of the eucharistic worship, may well explain why one of the gold pieces brought by Gaspar in the ciborium is given back to him by the Christ Child. The gesture is that of a priest administering Holy Communion as he takes from the ciborium a wafer to give to the communicant. Gold was, *par excellence*, the tribute paid by kings to a king, after the example of Solomon. The carpenter's wife's son is, in fact, a King among Kings – but this royal tribute will be redeemed with his own body, here shining in its nakedness. Christ the King, in his infinite charity, is also Christ the Saviour, the Child born to die in atonement for our sins.

According to St Paul and biblical commentators through the centuries, the redemptive sacrifice of Christ, the son of God, recorded in the Gospels, was fore-shadowed by Abraham's willingness to sacrifice his son Isaac in the Old Testament – the scene sculpted on the capital of one of the columns. The birth of Christ was recorded as the culmination of the Old Testament, the moment at which the old Jewish law was fulfilled and replaced by the new dispensation. And so we see in the ruins the fading away of Judaism, the replacing of the Synagogue and the Temple with the Church. The Law of the Hebrew Bible has been super-seded by Christ's Grace of the New Testament, whose Church, for Roman Catholics embodied in his mother Mary, rises out of these ancient bricks and stones. For those who can come close enough to the picture to see it, and who know the Gospels by heart, Gaspar's sceptre laid before the Child reinforces the message. On it the tiny figure of Moses holds the Ten Commandments, God's instructions to the Jews which are now to be completed: 'For the law was given by Moses, but grace and truth came by Jesus Christ' (John 1:17).

Jesus Christ is the son of the carpenter's wife, but he is not her humble husband's child. He is, for Christians, one of the persons of the Holy Trinity of God the Father, the Son and the Holy Spirit. The dove here, and in innumerable other Christian images, is the visible embodiment of the Holy Spirit. John the Baptist, having baptized Jesus Christ, says (in the words of St John's Gospel): 'I saw the Spirit descending from heaven like a dove, and it abode upon him' (John 1:32). In this picture then, while Isaac and Moses point backwards, the dove looks forwards to the Baptism of Christ and the public declaration that he is God's son.

The dove seldom appears in images of the Adoration, but 6 January, the day on which the Western Church now celebrates the Epiphany, the coming of the Kings on the twelfth night after the birth of Christ, has since the early centuries of the Church been the feast day of his Baptism. The word Epiphany, or

'apparition of God', now used to mean Christ's revelation to the Gentiles in the persons of the Kings, who are held to represent all non-Jewish peoples, was a word first applied to the Baptism. Also celebrated on 6 January, if a little less fervently, was Christ's first miracle, when his divine nature became apparent to many of his followers, as he turned water into wine at the wedding in Cana. Gossaert is showing us different ways and moments in which Jesus was revealed as God.

The precise day of Christ's birth, which remained in doubt for centuries, was also for long dated by many to 6 January (which might account logically for the presence here of the shepherds). It was the Christians in Rome who first, some time in the fourth century, assigned it to 25 December, the winter solstice and the birthday of a pagan sun god, Mithras – on the grounds that Christ was the true unconquered Sun. But even when the date was generally agreed in the West, Christmas, Christ's 'birth in the flesh', seemed, as we shall see, of no great importance until very much later. For as St John Chrysostom, a fourth-century Christian cleric, wrote: 'It was not when he was born that he became manifest to all, but when he was baptized.' Significantly, and we will also return to this, the same author believed that 6 January would also be the date of Christ's Second Coming at the end of the world.

Precisely how much of this obscure early church history Gossaert knew may be debatable, but that he knew a considerable amount about the later theology is clear from his inclusion of the dove. And since the dove is the visible sign of the Holy Spirit making manifest the divine nature of this Child, we may reasonably conclude that the excessively bright and haloed star from which it descends, and which parts the clouds so that it seems to reside in a heaven beyond the physical sky, represents something more than the star which the kings followed. It has been convincingly argued that it symbolizes God the Father. Gossaert's Christ Child is not only visibly divine, we are to view him as one of the persons of the Trinity.

Even now we are far from having exhausted the doctrinal subtleties of this picture – and although in this book I shall focus almost exclusively on the image of Christ, it is instructive to see how other, related themes are depicted. We can pass over rapidly the fact that there are here nine angels, representing the nine heavenly hierarchies derived from St Paul, which organized angels into categories long established and lovingly elaborated in the Middle Ages – seraphim, cherubim, thrones, dominations, virtues, powers, principalities, archangels and angels. Gossaert, perhaps luckily for his viewers, does not distinguish them by colour or number of wings. One of them simply holds a suitable scroll, inscribed *Gloria: in: excelsis: deo:*, Glory to God in the Highest.

More significant is Gossaert's treatment of the Virgin Mary. If the altarpiece's original location was, as the earliest documents suggest, a chapel dedicated to her, part of its function would have been to honour her in her own right. And that is precisely what the painting does. Mary's precious blue clothing is traditional; the great medieval Italian poet Dante calls her 'the beautiful sapphire by which the brightest sky is ensapphired'. But she is not always as much the centre of attention as she is here. Near the hem of the white cloth held by Balthazar are embroidered the opening words of a hymn composed in her honour, the *Salve Regina*: 'Hail Queen, Mother of mercy, our life, our sweetness and our hope … most gracious advocate.' We, the spectators, are invited to pray to her to intercede with her son on our behalf when the hour of judgment comes.

The cult of Mary was assisted by a Christian reading of the Old Testament, above all by an allegorical interpretation of the *Song of Songs*, now believed to be a collection of love poems to be recited and sung at weddings. Christians identified Christ with the Lover and Bridegroom mentioned in these texts; and they understood the Beloved and Bride as a metaphor of the Virgin Mary, and of the Christian Church itself. It is mainly as an embodiment of the Church of Christ that Mary reigns over this picture. It is she who holds the ciborium offered by Gaspar. Christ sits in her lap as upon a throne – a throne which is simultaneously the altar on which his redeeming sacrifice is perpetually re-enacted in the celebration of the Mass. Mary, the Queen of Heaven, Christ's Virgin Mother and Bride, indeed the Church itself, has also become God's Throne of Mercy.

We have probably looked closely enough at Gossaert's altarpiece to see how a major European artist of the fifteenth century resolved the problems of painting both the event and the theology of the Adoration of the Christ Child as it was understood in his day. We can, I think, admire his success in depicting the ungraspably complex nature of the Christ Child: King of Kings and humbly born, fully divine and fully human, priest and sacrifice. But if we turn from tradition to textual sources, and read again the two Gospels which give an account of these events, there are surprises in store. For the angels, shepherds and stable appear only in the Gospel of Luke, who seems to be describing a quite different event from Matthew, with his wise men from the East. And the New Testament nowhere mentions an ox and an ass, nor does it describe the visitors as Kings. Only by returning to the earliest art of Christianity can we really begin to trace the long and tortuous route by which Gossaert and his contemporaries came to produce the kind of image with which we are now so familiar, and thus discover how that image was constructed from those words, and how it changed as religious ideas and beliefs changed over time and in different places.

A KING AMONG KINGS

Rather bewilderingly for the casual reader, the first verses of the New Testament are merely a long list of names. They are particularly disconcerting if the casual reader has to read them out loud, for they include names like Ezekias, Salathiel and Zorobabel, which few of us can pronounce with total confidence. But Matthew's list is there for a crucial purpose. The names are those of Joseph's ancestors, and they include not just Abraham and Isaac, but David and Solomon, the great Kings of the Jews, proof that on his foster-father's side the child Jesus was nonetheless of the house and lineage of David and belonged to a line of kings. And this royal nature is recognized in the next chapter of Matthew's Gospel, when the wise men come to worship the King of the Jews. But that kingship was, as all the Gospels made clear, not of this world – it would be realized fully on earth only at the end of time. And so from the beginning the Church linked the first humble coming of Christ as the King the Jews did not recognize with his second coming as ruler and judge of all. The Anglican collect for the first Sunday in the church year, the beginning of Advent, when spiritual preparations for Christmas get under way, makes it clear:

> *Almighty God, give us grace that we may cast away the works of darkness and put upon us the armour of light, now in the time of this mortal life, in which thy son Jesus Christ came to visit us in great humility, that in the last day when he shall come again in his glorious Majesty to judge both the quick and the dead, we may rise to the life immortal.*

This, then, was the task painters had to address: how to show in an image that this child, born in poverty, was not just King of the Jews, but the universal King who would judge us all at the last day. We have seen how Gossaert tackled it. But his solution was arrived at only slowly, over centuries of theological debate and artistic invention.

The Gospel of Mark, generally accepted as the earliest of the four Gospels and dated to between AD 65 and 75, tells us nothing at all about Christ's birth or infancy, but begins directly with an account of John the Baptist preaching in the wilderness, and the baptism of Christ with the descent of the Spirit like a dove. No help for Christmas painters here.

Matthew's Gospel, usually dated to about AD 85 or 90, is believed to have been written for a community in Antioch, Syria, made up of Christians largely of Jewish origin.

Matthew, as we have seen, begins with the genealogy of Jesus Christ, traced back – through Mary's husband, Joseph – to demonstrate that Jesus is Israel's long-awaited Messiah, come to bring about the Kingdom of God. Later in the chapter, Jesus's conception through the Holy Spirit is confirmed by an angel sent to Joseph in a dream. The events surrounding the birth of Jesus are recounted in the second chapter:

> *Now when Jesus was born in Bethlehem of Judaea in the days of Herod the king, behold, there came wise men from the east to Jerusalem,*
>
> *Saying, Where is he that is born King of the Jews? for we have seen his star in the east, and are come to worship him.*
>
> *When Herod the king had heard these things, he was troubled, and all Jerusalem with him.*
>
> *And when he had gathered all the chief priests and scribes of the people together, he demanded of them where Christ should be born.*
>
> *And they said unto him, In Bethlehem of Judaea: for thus it is written by the prophet.*
>
> *And thou Bethlehem, in the land of Juda, art not the least among the princes of Juda: for out of thee shall come a Governor, that shall rule my people Israel.*
>
> *Then Herod, when he had privily called the wise men, enquired of them diligently what time the star appeared.*
>
> *And he sent them to Bethlehem, and said, Go and search diligently for the young child: and when ye have found him, bring me word again that I may come and worship him also.*
>
> *When they had heard the king, they departed: and, lo, the star, which they saw in the east, went before them, till it came and stood over where the young child was.*
>
> *When they saw the star, they rejoiced with exceeding great joy.*
>
> *And when they were come into the house, they saw the young child*

with Mary his mother, and fell down, and worshipped him: and when they had opened their treasures, they presented unto him gifts: gold, and frankincense, and myrrh.

And being warned of God in a dream that they should not return to Herod, they departed into their own country another way.

And when they were departed, behold, the angel of the Lord appeareth to Joseph in a dream, saying, Arise, and take the young child and his mother and flee into Egypt, and be thou there until I bring thee word: for Herod will seek the young child to destroy him.
MATTHEW 2:1–13

So Matthew gives us some, but only some, of our familiar picture; for he tells us nothing of the circumstances of the birth itself.

The Gospel traditionally attributed to 'the beloved physician' Luke, a companion of St Paul's, is thought to have been written late in the first century for a predominantly Gentile, Greek-speaking Christian community.

After a short prologue, Luke devotes his first two chapters to an account of the birth and childhood of both John the Baptist and of Jesus, whose mothers, Elizabeth and Mary, are said to have been cousins. The Christmas story proper begins in Chapter 2. Luke, alone among the Gospel writers, gives us details of the birth, but there is no trace here of the wise men: the only Adoration he mentions is that of the shepherds.

And it came to pass in those days, that there went out a decree from Caesar Augustus, that all the world should be taxed.

(And this taxing was first made when Cyrenius was governor of Syria.)

And all went to be taxed, every one into his own city.

And Joseph also went up from Galilee, but of the city of Nazareth, into Judaea, unto the city of David, which is called Bethlehem: (because he was of the house and lineage of David:)

To be taxed with Mary his espoused wife, being great with child.

And so it was, that, while they were there, the days were accomplished that she should be delivered.

And she brought forth her firstborn son, and wrapped him in swaddling clothes, and laid him in a manger: because there was no room for them in the inn.

And there were in the same country shepherds abiding in the field, keeping watch over their flock by night.

And, lo, the angel of the Lord came upon them, and the glory of the Lord shone round about them: and they were sore afraid.

And the angel said unto them, Fear not: for, behold, I bring you good tidings of great joy, which shall be to all people.

For unto you is born this day in the city of David a Saviour, which is Christ the Lord.

And this shall be a sign unto you: Ye shall find the babe wrapped in swaddling clothes, lying in a manger.

And suddenly there was with the angel a multitude of the heavenly host praising God, and saying,

Glory to God in the highest, and on earth peace, good will toward men.

And it came to pass, as the angels were gone away from them into heaven, the shepherds said one to another, Let us now go even unto Bethlehem, and see this thing which is come to pass, which the Lord has made known unto us.

And they came with haste, and found Mary, and Joseph, and the babe lying in a manger.

And when they had seen it, they made known abroad the saying which was told them concerning this child.

And all they that heard it wondered at those things which were told them by the shepherds.

But Mary kept all these things, and pondered them in her heart.

And the shepherds returned, glorifying and praising God for all the things they had heard and seen, as it was told unto them.

And when eight days were accomplished for the circumcising of the child, his name was called JESUS, which was so named of the angel before he was conceived in the womb.

And when the days of her purification according to the law of Moses were accomplished, they brought him to Jerusalem, to present him to the Lord.

LUKE 2:1–22

Finally, St John's Gospel. Written late in the first century, perhaps after the other three, it is both the most literary in its carefully crafted form, and the most abstract and conceptual of the four. John avoids any description of Jesus's birth or infancy, writing instead of the astonishing mystery of the Word made flesh, casting the incarnation as the cosmic struggle between the light of the world and

the darkness that surrounded it. John, like Mark, begins his account of Jesus's life with the Baptism and the descent of the Holy Spirit like a dove. He then goes on immediately to the calling of the disciples and the first showing of Christ's divine power in the miracle at the marriage in Cana.

The story of the distinguished visitors who bring gifts of gold, frankincense and myrrh to the new-born Christ Child thus appears only in Matthew, and that of the shepherds only in Luke. Nowhere does Matthew mention the visitors' names, nor that they were three in number, nor that they were kings. And neither Luke nor Matthew specifies the ox and the ass now so indispensable in any representation of the Nativity or the two Adorations.

Let us first dispatch, as it were, these sympathetic animals. Their presence at the manger is not as obvious, nor as benign, as art has made us believe. It originates in a verse from the Book of Isaiah (1:3): 'The ox knoweth his owner, and the ass his master's crib: but Israel does not know, my people does not consider.' Now biblical scholars and commentators argued that every verse of the Bible can illuminate every other verse, if read aright. And so the passage came to be associated with Luke's account of the new-born Jesus being laid in a manger and Isaiah's lament was interpreted by Christians as a prophecy of the Jews' failure to recognize Jesus Christ as the Messiah. The ox and ass are in the stable because that would not be surprising. And they are there to contrast the Jews, who do not see their saviour, with the non-Jewish wise men who have travelled to pay him homage. It is not a pleasant message.

Isaiah was the Old Testament prophet who played perhaps the greatest part in Christian theology. The Book of Isaiah has even been called the 'Fifth Gospel', because it recounts the life of the Messiah in such a way, wrote the great translator of the Bible into Latin, St Jerome, as to make one think he is 'telling the story of what has already happened rather than what is still to come'. It is more often quoted in the New Testament than any other book of the Hebrew Bible except the Psalms. Some commentators believe that Matthew's own version of the events surrounding Christ's birth may be indebted to Isaiah:

> *Arise, shine: for thy light is come, and the glory of the Lord is risen upon thee ... And the Gentiles shall come to thy light, and kings to the brightness of thy rising. The multitude of camels shall cover thee, the dromedaries of Midian and Ephah; all they from Sheba shall come: they shall bring gold and incense; and they shall shew forth praises of the Lord.*
> ISAIAH 60:1, 3, 6

More probably, however, these particular verses influenced the story and interpretation of the Adoration only much later, for Matthew, as we have seen, identifies the gift-bearing visitors not as kings but only as wise men. It was subsequent biblical scholars, who, reading Isaiah and Matthew together, as with the ox and the ass, brought the kings into the stable. Nor does Matthew mention camels and dromedaries, inconspicuously present in the right-hand background of Gossaert's *Adoration*, although – as that ever-obliging every-schoolchild knows – more prominent in many other paintings of the subject.

When Christians began to picture Matthew's visitors to the manger, they pictured them in his words as wise men from the East – Magi. (A Magus was a priest of the Medes and Persians.) These early Christian artists were, of course, living and worshipping in a context quite different from Gossaert's. And so the significance of the Magi, and their appearance, were very different from what we have come to expect.

But none even of these images is contemporary with St Matthew's Gospel. A specifically Christian art did not apparently emerge until over a hundred years after the Gospel texts were written, over two hundred years after the birth of Jesus Christ, and in centres – notably Rome – far away from the places in Palestine where he was born, lived, gathered together his disciples, preached to his followers and was killed.

The reason for the long absence of imagery is obvious: Jesus and those who first believed in him were Jews; he proclaimed in himself the fulfilment of ancient Jewish prophecy, enshrined in the sacred texts of Judaism. These same texts prohibit the making of images. In the second commandment to Moses God instructs Israel:

> *Thou shalt not make unto thee any graven image, or any likeness of any*
> *thing that is in heaven above, or that is in the earth beneath, or that is*
> *in the water under the earth: Thou shalt not bow down thyself to them,*
> *nor serve them, for I the Lord thy God am a jealous God.*
> EXODUS 20:4–5

From earliest times Jews had lived surrounded by peoples who believed in multiple gods and worshipped their images – which, we must imagine, is why the commandment was issued in the first place. Since making images seems to be such a universal human drive, it is remarkable that Jews observed the second commandment to the letter as long as they did, and perhaps not surprising that the Old Testament tells of periodic backsliding into the worship of idols.

But in Rome, where religious images of all sorts were venerated, and in other cities throughout the Roman empire, hostility towards imagery was diluted, even among the Jews. By the third century, Christians as well as some Jewish groups had come to interpret the second commandment as an interdiction of idolatry rather than a ban on all representational art. They understood by this that God – who in the Bible is heard but whose face is never seen – must not be pictured. In the early centuries, Christians did not generally extend the prohibition of images of God to the depiction of Jesus Christ, God made man. Later, when Islam, founded in the seventh century, again invoked the letter of the second commandment (thus going on to develop an artistic tradition based almost entirely on calligraphy and geometric forms), the question of representing Christ would be reopened – with, as we shall see, profound consequences for Christian art. At the Reformation in Western Europe, the question again became one of burning importance and, as most Protestants will know, it has never quite gone away since.

For the early Christians, cult images – idols – meant monumental statues. During many centuries in the West, and still today in the Eastern Church, only two-dimensional images, or small-scale objects in gold or ivory, or low-relief carvings on stone, were acceptable in places of worship.

But the problem of how to decorate churches did not really affect the beginnings of Christian art. The early Christians celebrated the Eucharist very simply by breaking bread together, praying and preaching, in each others' houses. Christian art, now so intimately associated with Christian worship, did not originate in churches, because the early Christians had none. What they did have was places where they buried their dead.

Unlike most of the pagans, Jews and Christians did not cremate their dead. Since Roman law forbade any burials within the city, the dead were inhumed in specially designated areas outside the city walls. As pressure of numbers grew, these were extended underground, producing the catacombs: series of long passages lined with tombs stacked one above the other along the walls, once enclosed with marble slabs, now usually open and lying empty. The pagans called such a place a necropolis, a city of the dead. To the Christians, it was a cemetery, from the Greek word for dormitory, a place to sleep in. The faithful assembled there had not been obliterated but lay in the sleep of death, awaiting the resurrection in the flesh, when they would wake to join Christ, body and soul, in Paradise.

The galleries are interrupted, here and there, by small chambers in which whole families, or groups of associates, were entombed so as to remain near each other. And here, in these chambers the living could also gather: not in the first place to hide from persecution, but for prayer, for commemorative meals in the

company of the sleeping dead, all awaiting together the fulfilment of the promise of life everlasting.

The catacombs were, therefore, places of hope and looking forward. Hopeful inscriptions and symbols were carved on the marble slabs, and the chambers were painted with images of resurrection and God's triumphant intervention to save us from perpetual destruction. Any visitor today can see that this decoration was never a high-quality job. It is cheap and cheerful, made by jobbing painters more used to working in modest homes than princely palaces – suitable for the modest, if prosperous, community of believers who met here.

In one such chamber, the Capella Greca (or Greek Chapel) in the Catacomb of Priscilla on the Via Salaria in Rome, we find the common, everyday vocabulary of Roman domestic art, deftly adapted to the Christian message, cheek by jowl with an astonishing medley of scenes of salvation drawn from both New and Old Testaments and the Apocrypha, as well as classical myth. There are garlands and festoons of flowers and fruit. Moses strikes water from the rock. Shadrach, Meshach and Abednego are saved from the burning fiery furnace as the prophet Daniel describes; Susanna, in the apocryphal book that bears her name, is ogled by the wicked elders, falsely accused, and her reputation vindicated. Jesus heals the paralytic, and raises Lazarus from the dead. The mythical phoenix rises from her ashes. And nature is reborn in the cycle of the seasons.

And it is here, among this company, in what is probably the oldest surviving image of the Adoration, that we find the Magi [PLATE 3]. They are clearly nothing to do with Christmas and its celebrations as we now understand them; the figures are surrounded by no stable, no manger, no animals. Like those saved from the flames and like Lazarus raised, the Magi point forward to a future salvation: they move to greet Christ at his first coming, as all believers will move to greet him at his Second Coming. No wonder St John Chrysostom dated both events to 6 January.

Like everything else here, the Magi direct our thoughts towards our resurrection at the end of time. Since all those gathered in the catacombs were certain by virtue of their faith that they would join Christ in Paradise, the idea of a Last Judgment as something to fear would probably not have presented itself urgently. But it would do so presently – and the Church still teaches us to use Advent to prepare ourselves for judgment. It is an aspect of the Adoration we may today largely have lost sight of, but it was to be of profound importance to the Church, and, necessarily, therefore to artists.

There are here three Magi. But Matthew's text gives no number, and in the early centuries sometimes two, sometimes four were pictured. It was, however, quickly – and not unreasonably – decided that as there were three gifts, there must

have been three visitors. Not many people bring two presents; no wise man, surely, would have been foolish or rude enough to come with none.

We know the figures in the Capella Greca are Magi, because they wear the Phrygian cap, a soft cloth bonnet associated in the ancient world with the countries around and beyond modern Turkey. They are dressed in green, red and white. They continue to be painted in these colours for many centuries, and although colour symbolism is a tricky subject we can perhaps hazard a guess as to what the colours might signify. Green has always been associated with springtime vegetation, the return of life after death. Red is the colour of blood and sacrifice. References to white as the colour of purity and innocence are found throughout the Bible. All these have obvious relevance to the Child of a Virgin born to restore humanity through his suffering. Other meanings, as we will see, will be added later, but they all reinforce the same message: we shall be reborn through the sacrifice of the innocent Child that the Magi – and we with them – have come to adore.

There is nothing in any way royal about this image of the Magi, or about the catacombs. But two centuries after the catacomb paintings were made, Christianity was no longer a minority religion, one sect among many. As it was transformed, so were its buildings and the images they contained.

After 313, when the Emperor Constantine had granted Christians freedom of worship, they erected purpose-built churches as meeting places and for the public celebration of the Eucharist. As a consequence, Christian art inevitably moved from a domestic to a monumental scale, a development that quickened after 324, when Christianity became a state religion and grandiose churches began to be commissioned by the emperor himself. Although remodelled and rebuilt by later generations, Constantine's magnificent Roman basilicas, among them the Lateran and the Vatican, continue to impress by their sheer scale.

But however rich in churches, Rome was losing in central political importance. Subjected to relentless waves of barbarians from Northern Europe, the city of pagan emperors and Christian martyrs fell into decline. In 330 Constantine founded a new city in Byzantium, a small town on the Straits of Bosphorus which divide Europe from Asia Minor. The new city was named Constantinople, after the emperor, and dedicated to the new Christian religion. Captured by the Turks in 1453, it is now known as Istanbul.

Constantinople became the Roman emperors' residence in the Eastern parts of their domain. The capital of the Western, or Latin, half was moved from Rome first to Milan and then, shortly after 400, to Ravenna, an important port on the Adriatic coast, with easy access by sea to Constantinople.

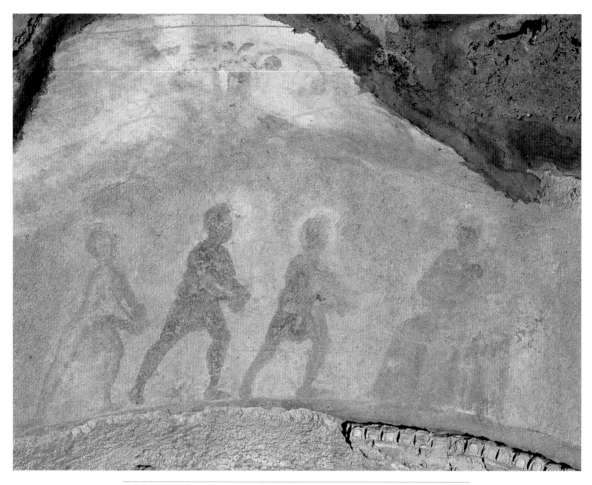

3 *Adoration of the Magi*, Capella Greca, Catacomb of Priscilla, Rome, *c.* 200

4 (OPPOSITE) Apse mosaics, view of the whole, San Vitale, Ravenna, completed *c.* 547

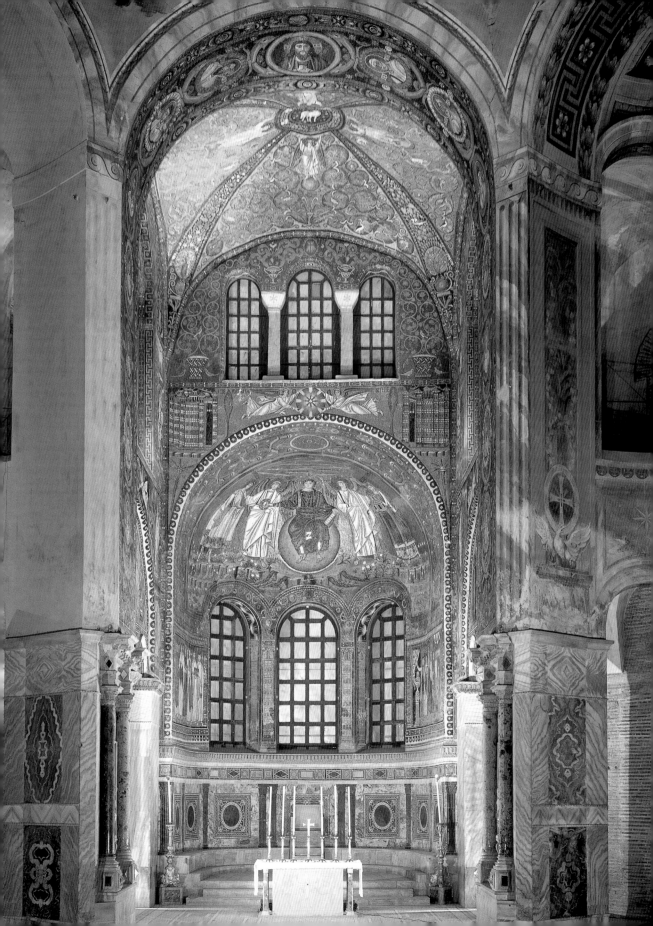

But Ravenna also fell to the barbarians – the Ostrogoths – and was governed benevolently for over thirty years by the Ostrogoth King Theodoric (to whose people's peculiar form of Christian belief we will return later) before being conquered for the Byzantine Emperor Justinian, in May 540. Throughout this period and after its reconquest it was adorned with some of the most splendid palaces and churches ever built – and because it later lived on in gentle, undramatic provincial torpor, some of the churches have survived almost intact. It is here, as a result, that we can best see how Christian art was transformed in keeping with its new public and official role.

One of the most beautiful is San Vitale, begun by Theodoric and completed around 547 under Justinian. It is decorated with spectacular mosaics [PLATE 4]. This is indeed art fit for a king, an emperor, because mosaic is an extremely expensive technique which involves inserting particles of coloured stones, or gold and silver fused in glass, into fresh plaster to create wall and ceiling images of virtually indestructible brilliance. The result is a very grand state church, an official setting in which the monarchs and their representatives could play a central part. And they wanted to be seen playing it in the company of their fellow king, Jesus Christ. For when Christianity became an imperial state religion, the question of the kingship of Christ inevitably took on a new, political dimension.

In a medium of this splendour deployed on this vast scale, artists can achieve effects unthinkable in the catacombs. Framed by luxuriant decoration rich in symbolic meaning, the complex narrative of sacrifice and salvation now unfolds in ample landscapes. In this sumptuous whole, all elements combine to dazzle and overwhelm, so that even fifteen hundred years after their creation, the mosaics still offer us what their creators intended: a vision of the majesty of God, made manifest to us by the munificence of an earthly monarch.

The approach to the altar is flanked by scenes from the Old Testament. On the left Abraham prepares to sacrifice his son Isaac, foreshadowing the sacrifice of Christ. On the right are pictured the sacrifices of Abel and Melchidesech, images designed to evoke the great sacrificial prayer said during the service of Holy Communion, as the priest offers up to God the bread and the wine in memory of the death and resurrection of Christ:

Be pleased to look upon these offerings with a favourable and gracious countenance; accept them as You were pleased to accept the offerings of Your servant Abel the righteous, the sacrifice of our father Abraham, and that of Melchidesech, Your high priest, a holy sacrifice, a spotless victim.

Behind the altar, in the starry vault of heaven, is the Worthy Lamb of the Book of Revelation that was slain, and thus redeemed us. Lambs were eaten at the Paschal meal celebrated by Christ and the disciples at the Last Supper. The Bible holds them up as examples of meekness and obedience, but they also came to symbolize the weak, to whom God promised victory over the strong; it may be in that sense that John the Baptist addressed Jesus as the Lamb of God. In Revelation, the mystical book of the New Testament which foretells the end of time, the Lamb is both victim and victor, just as it is shown in these mosaics.

In the apse below sits a youthful, beardless Christ enthroned on the globe of the world as both ruler and judge, robed in imperial purple, between two winged courtier-angels and two other figures, including the bishop founder of this church who presents Christ with a model of the building. The globe of the world itself rests on a rocky knoll in a flowering meadow, from which four streams issue, the streams named in the second chapter of Genesis as the rivers Pison, Gihon, Tigris (Hiddekel) and Euphrates that watered the Garden of Eden. For Christians, they symbolize the living waters of the four Gospels.

With one hand, Christ holds a scroll sealed with the seven seals of Revelation, which only the Lamb is worthy to open. With the other, he bestows a victor's crown on San Vitale. We are witnessing the Second Coming of Christ. But, in contrast with the catacombs where all, because of their belief, are assured of salvation, in this building dedicated to a state religion, he has emphatically come to judge the quick and the dead.

On either side, approaching the altar, and moving towards Christ, are the sovereigns. The Emperor Justinian with his military escort, courtiers and church dignitaries, and the Empress Theodora with her ladies-in-waiting bring their offerings. Justinian's is a huge gold paten – the plate on which the bread of the Eucharist is placed – Theodora's a hardly less conspicuous gold chalice [PLATE 5].

But where are the Magi? Justinian and Theodora are, after all, doing no more than emulating them in coming from the East to adore Christ with gifts. We would expect the Magi to be here – and so they are, but in no danger of stealing the limelight. Tucked away in the folds of Theodora's hem, the three figures familiar to us from the catacombs press forwards, but we cannot see to what [PLATE 6]. It would have been unthinkable to put an image of the Virgin and Child at ankle height, where it might be kicked or soiled. Theodora had clear ideas about what respect was due to an empress, and so the wise men take their chance on the hem of her garment while Mary and her royal son are decorously and safely hidden from view.

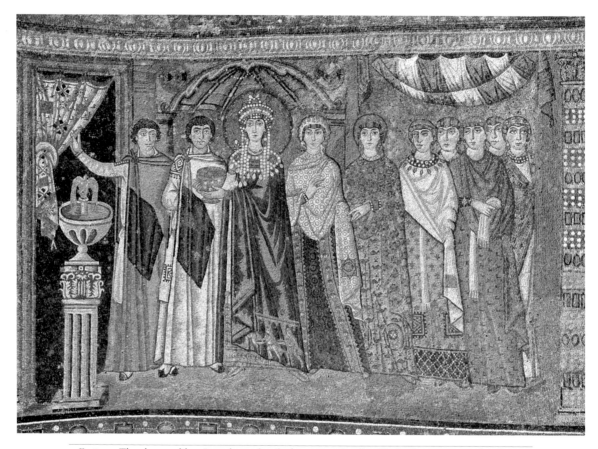

5 *Empress Theodora and her Attendants*, detail of apse mosaics, San Vitale, Ravenna, completed *c.* 547

6 (OPPOSITE) Detail of above showing the *Adoration of the Magi* on the hem of Theodora's dress

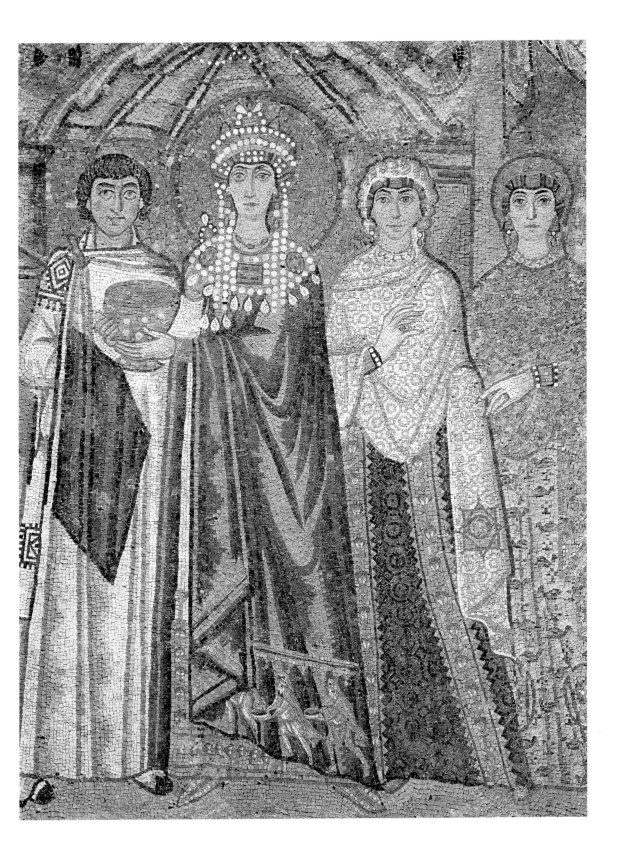

The mosaics of San Vitale show that once Christianity became the established church of the empire, and a central part of the apparatus of government, salvation was turned into a high affair of state. Justinian and Theodora, who never actually visited Ravenna, are through their portraits perpetually here at the court of Christ, who is now the supreme sovereign among sovereigns.

Bringing the gifts, the emperor and empress demonstrate their willingness to serve Christ. But as all three wear the same imperial purple, they are also demonstrating their common royalty. Christ has been incorporated into the club of the powerful.

In the mosaics of another imperial church in Ravenna, a different strategy is used to achieve the same end, and the notion of a royal Christ is developed even further [PLATES 7 and 8]. In San Vitale the adult Christ, returning in glory, was a king among kings; here, in Sant'Apollinare Nuovo, the infant Christ is shown not so much as a baby, but as a miniature sovereign. True, he sits on his mother's lap, but she is now every inch a queen on a jewelled throne, and he, although an infant, wears the adult toga of the highest ranks of Roman aristocracy. The Holy Family has become a hereditary monarchy.

And in this triumphant assertion of Christ's kingship, the wise men and their gifts now have a new and an important role to play. As we know, gold had been the proper tribute to a king since the days of Solomon, and here it is, as in Gossaert's *Adoration* some thousand years later, the first gift, offered to Christ in an open dish for all to see – and as the glass mosaic fragments are backed with real gold leaf, the gift as represented is in fact real gold. We know from St Matthew's Gospel that the two closed vessels carried by the other wise men must contain frankincense and myrrh. If gold was evidently the attribute of a king, it took little ingenuity for fifth-century theologians to conclude that frankincense, burnt in temples throughout the ancient world, must be an allusion to divinity, and that myrrh, used in anointing the dead for burial, prophesied that this child has been born in order to die. The extraordinary quality of these gifts is that they define the nature of the child to whom they are given. But what of those who bring them?

In the catacombs the Magi represented the community of the faithful, coming before the throne of God. At San Vitale, tucked into their hem, they were a luxurious footnote to the imperial couple's presentation of their own offerings at the altar. Here, in Sant'Apollinare Nuovo, stylishly dressed, larger in scale, demonstrably rich, the wise men have assumed prominence in their own right. They are clearly people of standing, at home in a court. But who are they? To the scholars who scoured the scriptures in an effort to find out, the gifts provided the

key, and the clue was found in the prophetic words of Isaiah cited on p. 21, in the story of the Queen of Sheba who visited Solomon bringing not only gold but also spices (1 Kings 10:1–2) and, above all, in Psalm 72:10, where, to the righteous and all-powerful king's son, 'The Kings of Tarshish and of the Isles shall bring presents: the Kings of Arabia and Saba shall bring gifts.'

Once again, reading Matthew and this Psalm together, it required only a very little imagination and very modest prophetic skills to recognize in the wise men of the gospel the gift-bearing kings of the Old Testament. Before long, the three wise men had not only come to worship a king, but had themselves become kings, and royal they have remained to this day. From now on, the adoration of the wise men will increasingly be seen as a kind of state visit from three monarchs to their new (admittedly superior) colleague.

As the centuries passed, the Three Kings became liturgical stars throughout the Western Church. As their royal status became more established, their story was elaborated, legend, as always, filling out the dry biblical commentaries with a host of personal details. They acquired names. As they had to represent the whole world, so their origins were located in the three continents known to the ancients, Asia, Africa and Europe. Their legend was resumed in the 'obituary notice' of a medieval calendar of saints:

> *Having undergone many trials and fatigues for the Gospel, the three*
> *Wise Men met at Sewa* [in Armenia] *in AD 54 to celebrate the feast*
> *of Christmas. Thereupon, after the celebration of Mass, they died:*
> *St Melchior on January 1, aged 116; St Balthazar on January 6, aged*
> *112; and St Gaspar, on January 11, aged 109.*

Having lived and died, they were even able to leave behind them relics – their bones, which since 1164 have been preserved in a shrine in Cologne Cathedral [PLATE 9], where once again faith, politics and art mingle with startling results.

How the relics come to be in Cologne is part of that same complex history of empire and invasion as Ravenna. We first hear of the Magi's bones in Constantinople, where they were carried in imperial processions to legitimize and sanctify the emperors' rule. When that city was threatened by Muslim invaders, they were brought West to Milan for safekeeping in the church of Sant'Eustorgio, whose bell tower, the tallest in Milan, even today bears a star, instead of a cross, in their honour. Scarcely a century later, in 1162, the German King and Holy Roman Emperor Frederick I – Barbarossa, 'Redbeard', to Italians – captured a rebellious Milan and seized the precious relics, consigning them for safekeeping to

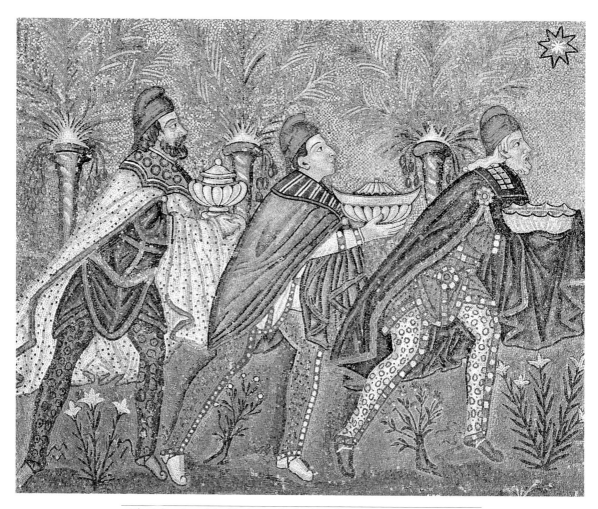

7 *The Adoration of the Magi*, mosaic, Sant'Apollinare Nuovo, Ravenna, 556–69

8 (OPPOSITE) *Madonna and Child*, mosaic, Sant'Apollinare Nuovo, Ravenna, 556–69

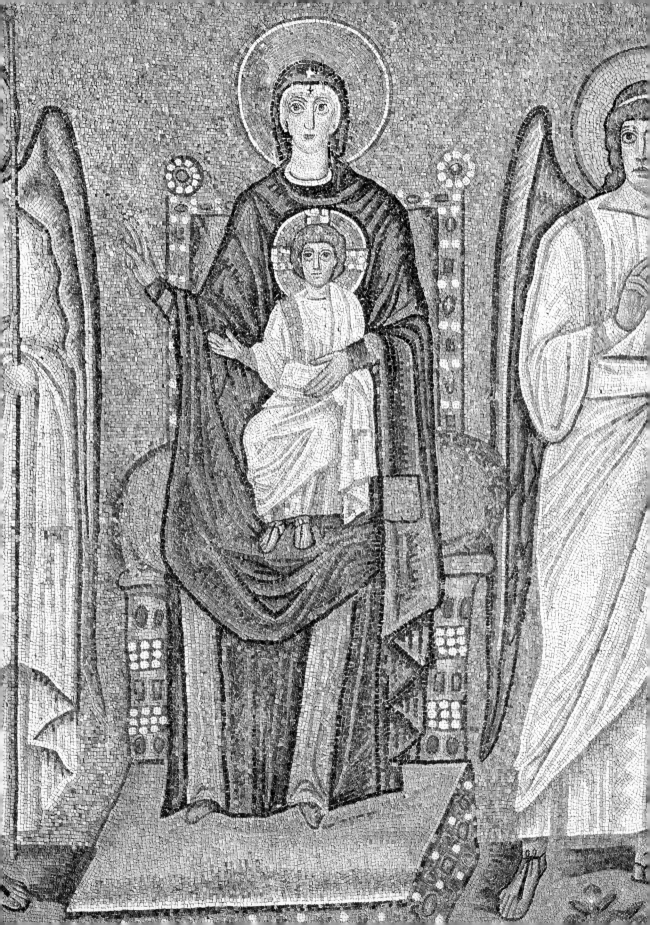

his chancellor, the Archbishop of Cologne. They soon became the major attrac-
tion of the largest and most important city in medieval Germany, and the Three
Kings became known throughout Europe as the 'Three Kings of Cologne'.

Milan bitterly resented the loss, and a few bones were eventually returned –
but only in 1906, after seven hundred years of complaint. The bulk of the Kings'
relics, however, are still housed today in a shrine in Cologne Cathedral in a superb
metalwork reliquary, begun in 1181 and completed a little after 1200. The reli-
quary is an elaborate miniature Gothic church, and the sculptural decoration – of
prophets and saints – proclaims the significance of the contents. The façade is
divided into two Epiphanies showing on one half the *Baptism of Christ*, and on
the other the *Adoration of the Kings* [PLATE 9]. The Virgin and Child sit on the
right of the Three Kings who approach with their gifts – and who, to our surprise,
are closely followed by what seems to be a fourth king. He is, in fact, the medieval
German king Otto IV, who, having won a disputed election and been crowned by
the Archbishop of Cologne in 1200, hastened in gratitude on the Feast of
Epiphany, 6 January, to donate three gold crowns to the shrine of the Three Kings,
and to have himself represented beside them, enjoying, like them, privileged access
to Christ.

German kings were crowned at Aachen, the burial site of Charlemagne, King
of the Franks, who had been crowned as the first Holy Roman Emperor on
Christmas Day 800. After 1215, newly crowned kings travelled immediately after
the coronation ceremony to Cologne, to touch the relics of the Three Kings – as
if these were their source of legitimacy, their protectors and their guarantors. In
an ironic twist of history, now that the Magi had been turned into real kings, real
kings were anxious to join the Magi. As their cult spread throughout Europe, they
became by extension the patrons of kings everywhere.

The Cologne shrine and its glamour may seem to us now a distant, if elo-
quent echo of high medieval monarchy. But there is one medieval monarchy which
in many of its religious aspects has survived almost intact. In the Chapel Royal at
St James's Palace in London, only a few hundred yards from the bedlam of the
New Year's sales in the shops on Oxford Street, on 6 January every year since at
least the fifteenth century the English monarch joins the Magi and offers to the
Christ Child, in the best medieval tradition, the royal gifts of gold, frankincense
and myrrh. Until the eighteenth century, monarchs usually attended the ceremony
in person and presented the gifts; today the offerings are made on the sovereign's
behalf by two Gentlemen Ushers to the Queen, in the presence of a detachment of
the Yeomen of the Guard. The frankincense and myrrh are provided by the
Apothecary to the Queen, and are later consigned to churches for use, while the

gold consists of twenty-five gold sovereigns loaned by the Bank of England, and an appropriate equivalent in money is later donated to charity. The announcement in the Court Circular treats the event as an affair of State. The spirit of Justinian's Ravenna is still alive in one of the few countries where the head of state is, even today, the anointed of the Lord.

It was not just kings who wanted to assert a special relationship with the Magi. The three travellers who had endured trials and fatigues carrying gold and precious goods over long distances not surprisingly also became patrons of Europe's travelling merchants and bankers. The rich, like the royals, were eager to join the retinue of the Kings. We can see the process best in Florence, a city of merchants *par excellence*. There the Confraternity, or Compagnia, of the Magi, a group of wealthy laymen who especially venerated them, put on magnificent pageants in which the journey of the royal wise men was retraced through the streets of the city from the Piazza della Signoria, the seat of the republican city government, to the church of San Marco where the confraternity had its head-quarters and where every year the manger at Bethlehem was represented. These were civic festivities, organized, in the words of a document of 1417, 'first for the honour and glory of God and his most holy Trinity, and then for the fame of the city and the consolation and joy of all citizens'.

This broadly civic character of the celebrations changed after 1434, when the powerful banker Cosimo de'Medici was recalled from exile back to Florence. Cosimo rapidly rose to power in Florence, virtually becoming the city's ruler, although apparently preserving its republican institutions. Before long, the Medici came to dominate the affairs of the Confraternity of the Magi and, in a way that by now seems almost predictable, to try to link themselves with its patron saints.

In the new priory which he financed at San Marco, Cosimo reserved a cell for his own use when on spiritual retreat. Beside it was a private chapel, which he had decorated with a fresco of the *Adoration of the Magi* by a young assistant of Fra Angelico, Benozzo Gozzoli. But in this sober Dominican conventual setting, and on such a modest scale, neither patron nor artist could really let rip. Ostentation had to wait until Cosimo's son, Piero de'Medici, always nicknamed 'the Gouty', entrusted Benozzo with the decoration of a private chapel specially created, thanks to an exceptional papal dispensation, within the walls of the Medici family palace.

The chapel itself was conceived as a small room with no natural light, a precious casket designed to be seen in the flickering light of torches and candles. Around its walls Benozzo painted the cavalcade of royal Magi leading us to join the Virgin in adoring the Christ Child [PLATE 10].

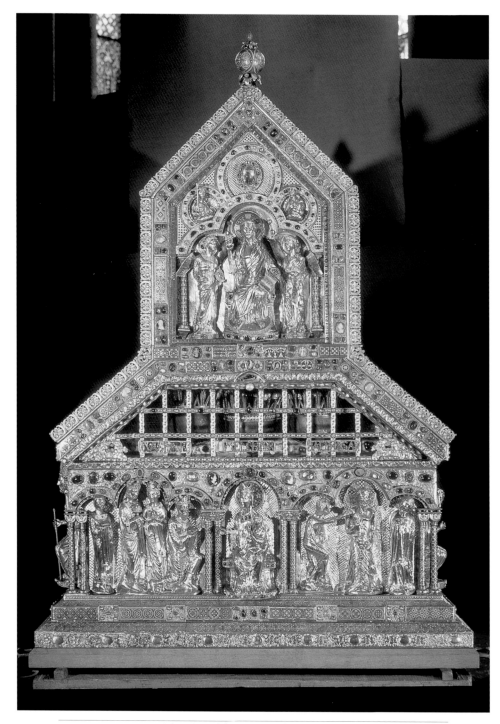

9 NICOLAS OF VERDUN *Adoration of the Kings, with Otto IV and the Baptism of Christ,*
Reliquary of the Three Kings, Cathedral, Cologne, begun 1181

10 (OPPOSITE) Interior of the Chapel of the Magi, Palazzo Medici-Riccardi, Florence, 1459–61

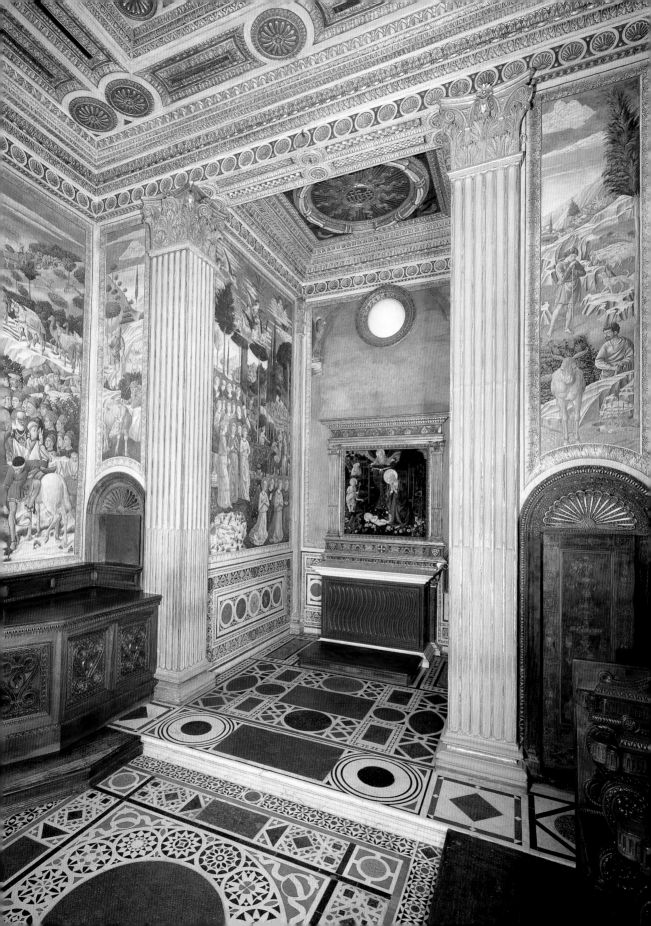

From the elaborately carved and gilded ceiling, through the choir stalls of walnut wood, to the floor inlaid with precious marbles and porphyry in imitation of imperial Christian churches – but incorporating Medici family emblems – everything is luxurious and expensive. The murals, with their abundance of detail, meticulous execution and costly pigments, give the effect of hugely expanded pages from illuminated manuscripts. The chapel was conceived as a single, highly wrought work of art. It is no less coherent a statement of the theology of the Magi as we have seen it developing over the centuries, but presented now with a very particular spin – needless to say, in honour of the Medici.

The chapel has been considerably altered. Most obviously, the west wall has been brought forward in part – brutally cutting in half the white mule of the oldest of the Three Kings – to accommodate a new staircase, to which the chapel's entrance has been moved.

Until these changes were made, you entered the chapel through a different door (now in the private apartments of the Prefect of Florence), passing beneath a painting of the sacrificial Lamb, on an altar, surrounded by the seven candelabra and seven seals of Revelation. Immediately in front is the altar of the chapel itself, with its altarpiece of a mystic Nativity by Filippo Lippi. The original is now in Berlin, but the copy still shows clearly the link the artist intended between the Lamb on the sacrificial altar over the door, and the Christ Child worshipped on the altar within. The short side walls on either side of the altar recess are painted with singing angels, while above there were once the symbols of the four Evangelists. Only Matthew's angel and John's eagle now remain. Mark's lion and Luke's ox were destroyed when a window was cut into the wall. This window was removed when electricity was installed, but by then the animals had gone.

Like the Lamb, these four symbols are linked to the Book of Revelation and thus point to the end of time. They are often used to refer to the four Gospels, but they are no less importantly the 'beasts of the Apocalypse' who sit round about the throne of God in Revelation 4:7. As in the catacombs, therefore, the Magi of the Medici travel not only to adore the Child of the Nativity, but also to greet the Christ of the Second Coming – who will come in glory to judge.

The intended message of the painted decoration was spelled out by the priest Gentile Becchi, tutor to Piero de'Medici's sons: 'In Cosimo's chapel there were painted, in the first part the Magi, in the second angels singing, in the third Mary adoring her new-born, so that visitors might offer tribute with their hearts, with words and with works. The gifts of the Kings, the prayers of celestial beings, the intellect of the Virgin are the sacred things at this altar.'

The Magi still symbolize all humanity, but their scope has expanded in the

centuries since they were pictured in the catacombs; drawing on yet richer traditions of interpretations, Benozzo associates them with the three ages of man, the seasons, the times of day and the virtues. On the east wall behind which dawn breaks rides the youthful King Gaspar, dressed in white, colour of innocence, of spring flowers and of the theological virtue of Faith [PLATE 11]. On the south wall of noon rides the mature Balthazar, in the green of summertime foliage and of Hope. And on the now-incomplete west wall, where the sun sets, rides old Melchior, wearing the red of sacrifice, of autumn fruits and of Charity.

But if they are totally universal, these Kings are also very specifically part of the Medici world. Gaspar rides a horse whose trappings bear Medici emblems – entirely appropriately, since the family was bankrolling a great many fifteenth-century European rulers. The Magi in Cologne are joined by only one German monarch. But here Benozzo shows them with a whole company of rulers – a selection of princely Medici allies and no fewer than three generations of Medici themselves. We can recognize, from their portraits in other contexts, Sigismondo Malatesta, Lord of Rimini; Galleazzo Maria Sforza, Duke of Pavia; the elderly Cosimo de'Medici, his son Piero the Gouty and his youthful grandsons Lorenzo (later known as 'the Magnificent') and Giuliano. Riding behind them is the author of this magnificent pageant: Benozzo Gozzoli, who has proudly signed his work in golden letters on his red hat.

Despite the coherent theological framework of the chapel listed by Becchi, Benozzo has endowed the Magi's cortège with all the trappings of an aristocratic outing – an idealized version of excursions actually enjoyed by the Florentine rich. In a landscape somewhere between Tuscany and fairy land, the shepherds have now left the manger and are safely back with their flocks, surprisingly having taken the ox and the ass away with them. The countryside is shown, not as the site of a harrowing and dangerous journey, but as a place for noble exercise and pleasure. Never can the Magi's retinue have had such fun. The Kings seem to have set off as much for the delights of the hunt as for the journey to Bethlehem. Their pages carry the royal gifts, but their other companions have with them spears, crossbows and bows and arrows – dogs, falcons and hunting animals of all sorts. And some even break off from the procession to hunt their prey. The purpose of the journey may be of ultimate seriousness, but much pleasure may be had on the way.

It is hard, in front of all this material magnificence, to interpret the gold presented by the Kings to the Christ Child as 'the treasures of our mind' or 'the purest gold of a clean conscience', as contemporary preachers did in their sermons on Epiphany. But nor, I think, is it merely a celebration of wealth and power. It is

surely a joyful sanctification of the fruits of trade, at a time when Italian, Spanish and Portuguese trade was expanding the mental frontiers of Europe to encompass more and more of the world. And while nobody doubted the spiritual significance of the Magi's journey, it was the commercial value of their material gifts that drove traders and explorers to travel ever further afield – in search of incense, spices and above all, and always, gold. And they took the Kings with them.

Where the thirteenth-century Venetian traveller Marco Polo had reached the Far East by following, like Benozzo's kings, overland trade routes, the later explorers could travel on new ocean-going ships, which carried more men, arms and provisions than could any caravan of mules or camels. By 1500 Portuguese navigators had rounded the Cape of Good Hope to find the eastward sea route to India. Some twenty-five years earlier, however, the Genoese Christopher Columbus, advised by a Florentine astronomer, had conceived of reaching India more directly by sailing west. In 1492, after first applying to the kings of Portugal and of England, he finally persuaded the Spanish sovereigns, Ferdinand and Isabella, to finance his first Atlantic voyage.

All his life, Columbus believed that the islands he discovered on this and a subsequent journey lay off the east coast of India – he called them the West Indies. Only on his third voyage, in 1498, did he reach the mainland of a continent until then unknown to Europeans, later named after Amerigo Vespucci, the Florentine who followed in his wake: America.

In South America the explorers eventually found the gold and silver they had come to seek. But they also found, high in the Peruvian Andes, one of the most advanced empires in the world – and destroyed it.

In 1533 Francisco Pizarro entered the Inca capital, Cuzco, and seized it in the name of the Spanish crown and the Christian faith. The city was swiftly looted of its gold and brutally transformed, as the Spanish conquistadors and the priests and friars who had accompanied them set about building on the foundations of this unimaginably alien culture, a citadel of European Christianity. Cuzco became the centre of an enormous new diocese.

The new churches were, like European churches, filled with paintings to strengthen the faith of the newly converted Indians. The Spanish missionaries in Peru arranged for copies of the most up-to-date religious art of Spain, Flanders and Rome to be sent to America, and commissioned, from the few European artists who had emigrated, works designed to speak directly to the native population. The most startling example I know of this new exotic flowering of European religious paintings is in Juli – 12,000 feet above sea level, on the shores of Lake Titicaca, at the foot of mountains long held to be sacred.

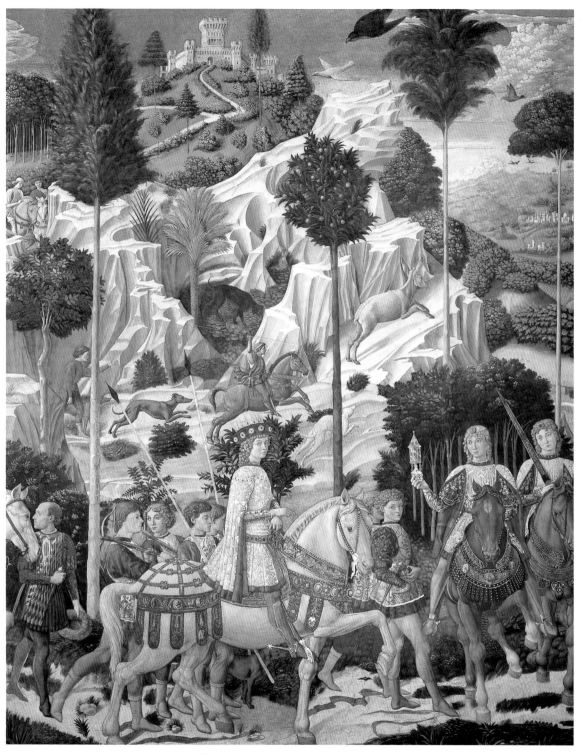

11 BENOZZO GOZZOLI *The Journey of the Magi*, detail of the east wall of the Chapel of the Magi, Palazzo Medici-Riccardi, Florence, 1459–61

For the Spanish colonial administrators, this was the edge of the world – an edge that had somehow to be incorporated into an imperial system run from Madrid. But for the Jesuit priests who evangelized here, it was also new territory theologically. How could the New World and its peoples be fitted into a tradition of biblical interpretation developed and refined long before the modern European voyages of 'discovery'? The answer was yet another twist in the story of the Three Kings.

The early missionaries brought with them imagery that would long have been familiar to any European: paintings of the Adoration in which the Kings represent the three continents of Asia, Africa and Europe – with the African king (who since the late fourteenth century was often pictured as a black African) alone standing for all distant and exotic people. But what about America? Had they been excluded from the stable?

Around 1650 Diego de la Puente, a Flemish-born Jesuit priest and painter working in Peru, created an altarpiece of the *Adoration of the Kings* specifically designed to allow the local congregation in the Jesuit church in Juli to find their place in the story. It illustrates the native population's belief (a belief naturally fostered by the Church) that their ruler had indeed been present in Bethlehem. The story had been recounted some decades earlier by the native chronicler Guamán Poma: 'In the time of Sinchi Roca Inca [an early, perhaps legendary emperor of the Incas] the Infant Jesus was born in Bethlehem … and was adored by the three kings of the three nations which God had put in the world: Melchior the Indian, Balthazar the Spaniard, and Gaspar the Negro.'

Balthazar the Spaniard presents a case of Spanish gold coins. The black Gaspar offers myrrh. But it is the native Indian king Melchior who brings frankincense, the offering due to a god. And there can be no doubt that this king comes from Titicaca – he and his retinue are shown in front of one of the sacred mountains of Juli. They have the characteristic facial features of the Aymara people that can still be seen in the streets of the town. The king himself wears the headdress, fringe and costume of a local chieftain – who thus leads his people freely, long before their conquest by Europeans, from idolatry to the worship of the one true God.

Matthew's Magi have come a long way. From the catacombs to Lake Titicaca, artists have shown them with Byzantine emperors, German kings, Medici bankers and South American chieftains. Yet throughout all the evident political manipulations, the meaning of these representations of the Magi remains constant: they behold and proclaim the utter universality of Christ.

CHAPTER THREE

SOVEREIGN
HELPLESSNESS

About the same time that Diego de la Puente included a Peruvian Indian chieftain in his *Adoration of the Kings*, Georges de La Tour, working in Lorraine, now eastern France, painted an image of a new-born child held by his mother, while a second woman, perhaps a midwife, looks on in wonder [PLATE 12]. It is one of the supreme religious paintings of seventeenth-century Europe, and as a vision of the Incarnation, could hardly be more different from the pictures we have just been looking at.

We know little about La Tour. He seems to have received commissions from the ducal court of Lorraine and from Paris, and presumably worked also for local townspeople and clerics. He was clearly affected by the religious revival in that part of France led by the Franciscans. At first glance, there is nothing to show that this is a holy picture at all. We might not read this intimate scene as representing the Christ Child in the arms of the Virgin Mary. Yet that is undoubtedly what it is, despite the absence of haloes or any other obvious symbols.

The candle held by the second woman is shaded by her hand; its concealed light is reflected from the head and shoulders of the swaddled baby, as if the child itself were the source of light within the picture. In silence and stillness, the two women look down at the equally silent and still infant: so still, so pale, that its tight swaddling bands might equally be a shroud. While the standing woman quietly marvels, the mother seems to hold the baby with a mixture of muted emotions easier to recognize than to spell out: humble pride, reverence and joy, tenderness and sad apprehension.

Simplified in form and detail, the image is at once contemporary with the painting and timeless. The costumes may be local, but the picture is universal. This is the cosmic miracle of the Incarnation, of God made man, the Light of the World made flesh. But it is also the miracle of every single new-born child, and by insisting on this simple and very visible fact, La Tour makes clear that the incarnate Christ is universal, in and of each one of us, not because he rules the world, but because he chose to be born just like every one of us. As the swaddling/shroud

suggests, this baby is born to die in shame and horrible agony to redeem our sins; he, in whom there is no sin, will atone for ours. Like any infant he is completely helpless, dependent on human love – that means our love. The point of the picture is to elicit that love, and it is not in the least surprising that the artist who painted it had been exposed to the teachings of the Franciscans.

For if we had to name the person who was more than any other responsible for shifting our attention from the Adoration of the Christ Child to his actual birth, from the Feast of the Epiphany to the Feast of Christmas, it would be the founder of the Franciscan order, St Francis of Assisi. His influence on the teaching of the Western Church was enormous, and the impact of that teaching on the art of Europe can hardly be exaggerated.

His real name was Giovanni Bernardone; he was born in Assisi in Central Italy in 1181 or 1182, while his father, a rich merchant, was travelling in France, and was nicknamed Francesco, 'little Frenchman'. He learnt the language of the troubadours, the Provençal poets of courtly love; he became known for his own love of games and jokes, and of knightly exercises. When about to set out on a military expedition, splendidly equipped and hoping to be knighted by the count who was leading it, a dream of Christ commanding him to do battle only on his behalf sent him back to Assisi. There, abandoning the delights of love, society and war, he began to devote himself to the poor and the sick.

In 1206, as he prayed in front of a crucifix in the ruined chapel of San Damiano outside Assisi, he heard Christ speak to him from the Cross, demanding that Francis repair his Church – which he took in the first instance to mean the little building he was in. His conversion dates from then. Weeping with pity and love for the crucified Christ, he gave all his money to the restoration of the little church. Against his father's wishes, he renounced his inheritance, stripping himself even of his clothes, and vowed himself to a life in the service of God. Putting himself under the protection of the Bishop of Assisi, he returned to San Damiano as a hermit, rebuilding the chapel and other ruined churches with his own hands and feeding himself by begging for scraps.

Francis's vow of absolute poverty was inspired in 1209 by a sermon he heard on Christ's charge to the disciples as he sent them out to preach: 'Provide neither gold, nor silver, nor brass in your purses, Nor scrip [pilgrim's wallet] for your journey, neither two coats, neither shoes, nor yet staves' (Matthew 10:9–10).

Discarding his shoes and his staff, his hermit's robe for an even rougher tunic he made himself, his leather belt for a rope, Francis set out to preach repentance and the imitation of Christ. By 1210 his infectious zeal had drawn to him eleven like-minded followers: laymen devoted to apostolic poverty. He drew up for them

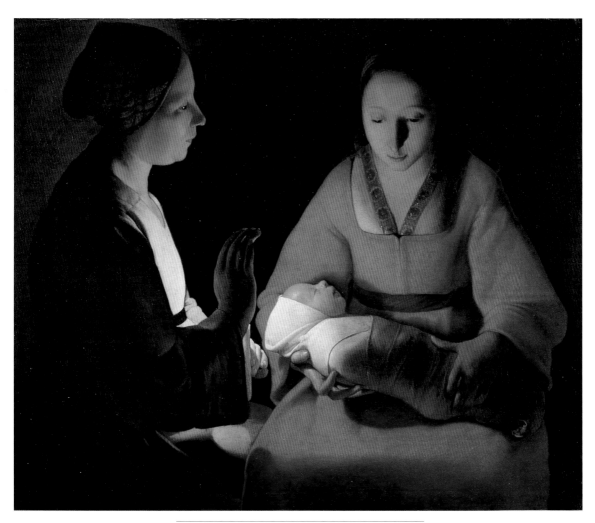

12 GEORGES DE LA TOUR *The New-born Child, c.* 1648

a rule founded, like that of the older monastic orders, on chastity, poverty and obedience, with a particular emphasis on poverty. With the support of the Bishop of Assisi he and his disciples set out for Rome and received papal approval for an order of 'brothers minor': the Franciscans.

The movement grew with phenomenal speed. At the first general assembly in 1219, five thousand members were present, and five hundred more clamoured for admission. The Franciscans soon spread over the whole of Europe and beyond. When Francis went to Egypt in 1223, the Order obtained from the sultan the privilege of becoming guardians of Christ's sepulchre in Palestine.

Francis died in 1226 aged forty-five, and was declared a saint only two years later – an astonishingly rapid canonization. But by the time of his death, he had already been ousted from the generalship of the Order he had founded, largely because of his uncompromising ideal of absolute poverty. This proved even more problematic as the community grew: the Order's preachers, scholars and theologians wanted books, houses of study in which to study them, and seminaries in which to teach from them. With the aid of the papacy, Francis's successors did not delay in erecting a vast, lavishly decorated church in his honour in Assisi, which is to this day made prosperous by crowds of pilgrims buying souvenirs of the 'Poverello', the Little Poor Man. And many other churches and houses followed.

The Franciscans – and their rivals, the more scholarly Dominicans, to whom we shall return later – differed from the older monastic orders that had been established in the West since the sixth century. Monks withdrew from the cities to wild and remote places in the countryside, to spend their lives in prayer, meditation and study, secluded from the evils of the world. They supported themselves by working the land and growing their own food. By the thirteenth century many monasteries had accumulated vast estates and great wealth. The friars (from *fratres*, brothers) revived the apostolic ideal of spreading the Gospel in cities; in theory, they had no property but relied on alms. These 'mendicant' or begging orders ministered to men and women eager for salvation, but unwilling or unable to give up their entire lives in pursuit of it, in short, people who lived ordinary working lives, who married and had children, people not necessarily rich or poor, but who could afford alms and could be recalled by the Franciscans to their prime duty of charity. A central part of that strategy was to use the love that we all naturally have for children to lead us to the love of God.

Of course, any process of changing attitudes is a gradual one, but if we had to fix the time and place when Francis redirected our attention from the Adoration to the Nativity, it would be in Greccio, sixty miles north of Rome, on Christmas Eve in the year 1223. There he set up the first Christmas crib in a

natural grotto which has since been turned into a small chapel. For centuries the great winter feast of the Church had been the Epiphany. The events of Greccio are in a way nothing less than the invention of Christmas. They were recorded in 1229 by Francis's first official biographer, Tommaso of Celano, and they were depicted in a crude and half-ruined fourteenth-century fresco decorating the chapel/grotto [PLATE 13].

Celano describes how Francis sent for his friend and patron, Giovanni Vellita, Lord of Greccio, a fortnight before Christmas, and said to him:

'If you desire us to celebrate the Holy Nativity at Greccio, then hurry and prepare for it as I tell you. I would like to represent the birth of the Child just as it took place at Bethlehem, so that men should see with their own eyes the hardships He suffered as an infant, how He was laid on hay in a manger with the ox and the ass standing by.'

When the good man heard these words, he immediately set to work with great zeal and prepared everything in the said place as the Saint had told him to do. Thus the blessed day of rejoicing approached. The friars were summoned from many places, and men and women of the town happily prepared candles and torches, to illuminate as well as they could the night on which the Star had risen which pierces all time with the rays of its light.

When Francis came to the place, he found everything prepared and was well pleased. The manger was ready, the hay was brought, an ox and an ass were led in. Thus was holy simplicity honoured, holy poverty exalted, and gentle humility touched all hearts. Verily, in that hour Greccio became a new Bethlehem ...

The Saint stood before the manger, heaving deep sighs, his heart full of heavenly bliss. Mass was said over the manger, and the priest who celebrated it enjoyed a new consolation. The Saint, who was a deacon, donned a surplice and intoned the gospel, singing in a loud voice, strong, clear and melodious, inviting all those present to take part in the ever-lasting song of praise. Then he preached to the assembled people, and told them in mellifluous words of the birth of the poor King in the little town of Bethlehem ...

A man was vouchsafed a wondrous vision that night: he saw a child lying in the manger as though it were dead, but when St Francis came near it seemed to awaken to life. This vision was not meaningless, for had not the Child Jesus died the spiritual death of oblivion in many

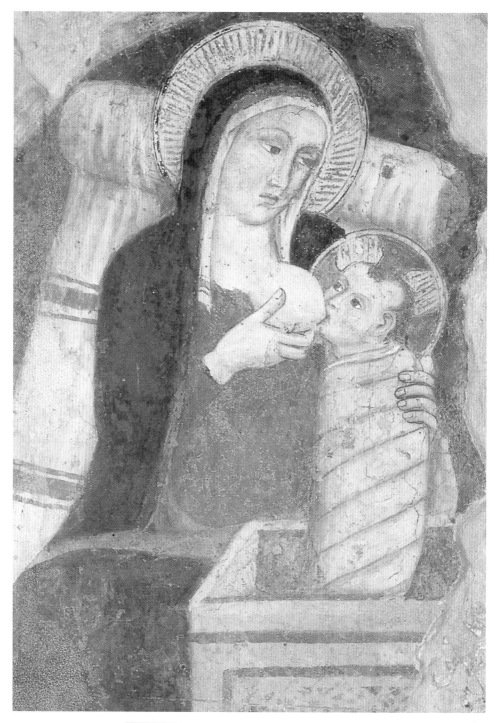

13 *Franciscan crib with the Madonna del Latte*, detail,
Franciscan sanctuary, Greccio, fourteenth century

14 ROBERT CAMPIN (?) *The Virgin and Child in an Interior, c.* 1432

hearts, to be awakened to new life, and to reign forever in those hearts by God's grace and the ministrations of St Francis?

This was, of course, good street theatre, but it was also a brilliant teaching device. By re-enacting the Nativity, and by linking the crib with the sacrifice of the Eucharist, Francis brought into reach of all men and women the most advanced religious thinking of the universities and the monasteries. He made instantly intelligible the theology developed in the mid-twelfth century by the Cistercian monk St Bernard of Clairvaux: God is love, in his infinite love he has created us, and in his love by dying, he has redeemed us. To return to him, we, too, must learn to love; but blinded as we are by sin, most of us can rise to spiritual love of God only through a simpler human love for a God like ourselves, who has become incarnate in the helpless infant, Jesus. Both the contemplation of the Christ Child and the taking of communion can bring about the rebirth of the love of God in our hearts; for we shall be moved by a God who now depends on us to survive, and a God who for us allowed himself to be put to death.

The abstractions of theology become with Francis wonderfully concrete. Isaiah's metaphors of the ox and the ass become living beasts. The swaddling bands double as a shroud, and, in the Greccio fresco, the Child is laid in a manger which is actually a stone coffin. By it sits St Joseph, meditating on the mystery of our redemption and salvation, of which Christmas is the first step. We can approach it, with Francis, very directly: as long as children are born, God will have mercy on us.

The high mystery of the Incarnation becomes, in Francis's Christmas crib, the easily comprehensible but utterly astonishing moment when, quite simply, God becomes a baby.

This God is entirely man, needing to be loved and looked after. The fourteenth-century artist at Greccio makes plain what La Tour only hints at: this is a child who requires a mother's milk, and Mary, like a humble woman of the people, is quite willing to nurse him herself. Francis called the day when God first sucked on a human breast the 'celebration of celebrations'.

For artists, this shift in conception of Christ, triggered by Bernard and Francis, had enormous repercussions. It was clear that the centuries-old theme of the Virgin and Child could never be thought about or painted in the same way again. One quick comparison shows the huge distance covered. In the mosaic in Sant'Apollinare Nuovo in Ravenna [PLATE 8] the infant Christ sits like a tiny adult ruler, rigidly upright on the throne of his mother's lap and dressed in the toga of a Roman aristocrat. In the 1420s an artist working in the Low Countries

[PLATE 14] shows us the same Christ Child: but now he is a naked baby boy at the moment of bath time, wriggling on his mother's knee as he touches her chin with one hand and plays with his penis with the other. They are not a completely ordinary mother and child. The Virgin is dressed in expensive lapis lazuli blue and the house she sits in is luxuriously furnished; but this is a very human little God indeed.

It is obvious that Francis's refocusing of devotion from the mighty King of Kings to the vulnerable and helpless baby, dependent on his mother, might appeal forcefully to women. La Tour shows the Christ Child's first witness as a woman, just as another woman, Mary Magdalene, would be the first person to see Christ after the Resurrection. But it was not only childbearing women, uneducated or humble women who responded with fervour to the Franciscan innovations.

By the fifteenth century noblewomen entering Netherlandish convents were commonly presented with a cradle, sometimes an almost life-size one that could hold a figure of the Christ Child, but more often an elaborately carved and gilded miniature, like the one now in the Burrell Collection in Glasgow [PLATE 15]. We read of nuns sewing clothes for Baby Jesus dolls, and, at Christmas, taking turns to rock them in cradles moved from their own cells to communal places, singing lullabies. These luxurious cribs were meant to be everything the manger at Bethlehem should have been: fit for the son of God. But this love is tough, not sentimental. On one end of the Glasgow crib is carved one of the most famous legendary acts of practical charity – St Martin dividing his cloak with the beggar. On the other is the Virgin holding the dead Christ on her lap. The new-born Jesus will change the way we live, but above all because he died.

The Franciscan emphasis on the Incarnation re-humanized Christ. It also restored the Christ Child to the poor. The main point of this child was not that he was worshipped by rulers representing the whole of creation. It was his acceptance of the mean grubby business of life on earth. And so the very first visitors to the manger are rehabilitated: after centuries spent in the shadow of the Kings, the shepherds could now star in their own Adoration. Rembrandt shows us just how powerful a theme this could be in his *Adoration of the Shepherds* of 1646 [PLATE 16].

Unlike the *Adoration of the Kings* painted by Gossaert a century and a half earlier [PLATE 1], Rembrandt's *Adoration of the Shepherds* is not an altarpiece; far from being an accessory of public worship, it was meant for viewing at home. For, with Rembrandt, we find ourselves in a predominantly Protestant state, which had through bloody rebellion freed itself from the domination of Catholic Spain. Although Catholic worship was tolerated, state churches had been stripped of their

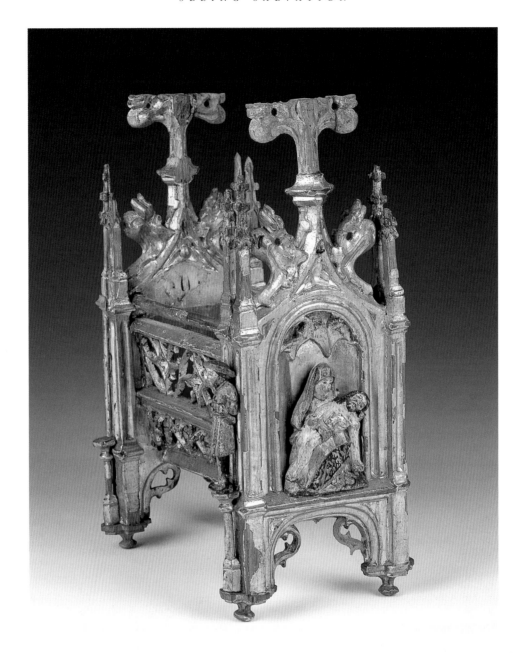

15 Unknown Netherlandish artist *Christ's cradle, c.* 1480–1500

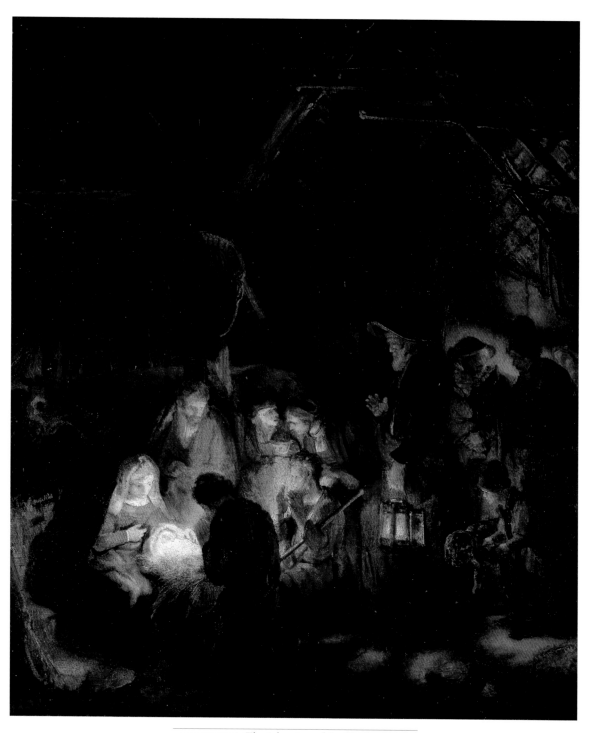

16 REMBRANDT *The Adoration of the Shepherds*, 1646

images. Religious imagery was not, as has sometimes been suggested, prohibited, but it was now, above all, intended as a means of instruction and a source of visual pleasure.

Like the Jews, the Protestant Dutch were essentially people of the Word. Their church services centred on sermons and readings from Scripture. They also read the Bible at home, translated into their own language, and pondered not only the New Testament but also the moral lessons to be derived from the Old – frequently identifying themselves with the people of Israel guided and rescued from slavery and oblivion by God. The earliest religious and moral teaching was expected to be given to children at home by their mothers, and in this task pictures on the walls could play an important part.

We do not know, of course, whether Rembrandt's *Adoration* was ever expounded to children, but it is not hard to imagine. This is the night of the birth of Christ; the first Christmas. In the dark recesses of a real working Dutch barn, the ox and the ass gently ruminate. Mary and Joseph are receiving the visitors who have come to revere the new-born child; the shepherds have brought their wives and children with them, perhaps an old granny or two. They look in some ways more like Dutch fisher folk than shepherds. But they are clearly country people, and all are well wrapped against the bitter winter cold.

The baby lies swaddled and snug in the warm hay, glowing like the brightest of lamps. His light eclipses that of the visitors' lanterns.

Above the Holy Family, the struts and beams and ladder of the barn form a sturdy vertical star shape, with a winnowing basket in its centre. And here, if we wish, we can discern symbolic meanings that Rembrandt may have intended to enrich our viewing. The arrangement of straight lines recalls the early Christian monogram, in which the first two Greek letters of Christ's name, the X-shaped Chi and the P-shaped Rho, are superimposed [PLATE 19]. It was, as we shall see, an emblem used in the first centuries of the Church, and later by the Emperor Constantine and his successors. The basket itself suggests various appropriate associations: a winnowing basket is used to separate the wheat, which will be stored, from the chaff, which will be burnt, as Christ on his return will judge us (Matthew 3:12; Luke 3:17); the Jews were commanded to offer the first fruits of the harvest to God in a basket (Deuteronomy 26:2) and Christ will become the first fruits of them that sleep; and the infant Moses, who later brought Israel the law, as Christ will bring grace, was saved from the waters in a basket of bullrushes (Exodus 2:3).

But nothing compelled even seventeenth-century Dutch readers of the Bible to analyse the picture in this way, and nothing compels us now. The small, friendly

canvas, with its warm earth tones, its rough texture, its freely brushed paint, goes straight to the heart. The shepherds – among whom it is hard to find any sheep – are people like Rembrandt's family and their neighbours, and by extension like us: good-hearted northern people gathered on a dark, cold and damp December night to welcome the new-born baby for whom there was no room at the inn. And when the shepherds had seen him, says the author of a medieval book of meditations, 'they went on their way rejoicing'.

The Franciscan crib tradition expanded to encompass all, and all sorts, of life, enabling us to visualize and participate in the mystery of salvation. Its extraordinary achievement has been to involve everybody, not just shepherds and kings, but people from every part of society to play their role in the story of the birth of Christ.

Yearly on Christmas Eve, the people of Greccio relive the moment when St Francis set up the Christmas crib among them. A costumed procession makes its way by torchlight from the town square to the Franciscan sanctuary with its hallowed grotto. On the mountainside – for the grotto is now too small, too enclosed by buildings, to accommodate everyone – a pageant with actors and a living ox and ass re-enacts Tommaso of Celano's account, closely following the thirteenth-century text. The sets are made at Cinecittà, Italy's film production centre in Rome, and many hundreds of people come to watch.

Across the world, even if Francis's role in the Christmas tradition has been more or less forgotten, Christmas processions and Nativity plays are staged everywhere. Churches and families at home set up miniature panoramas of the crib, some with entire landscapes through which figures of shepherds and kings pass: deserts, mountains and grottoes, cities and countrysides teeming with life, with every trade and condition of mankind represented in minutely realistic contemporary detail. The most elaborate and the most famous of these cribs were made in eighteenth-century Naples for the instruction and entertainment of the court, and we now find them proudly exhibited in museums as far away as New York.

But there can be few places where the crib tradition remains more alive than in the old Catholic towns of southern Germany. In Bamberg, for example, you frequently have the impression that the figures from the Christmas story have taken over the entire town. People throng Christmas markets, where religious figures, ornaments, mulled wine and gingerbread are sold cheek by jowl, marking a festival that is at once civic, religious and straightforwardly commercial. Outdoor cribs show, one after another, the episodes surrounding the birth of Christ, beginning with the very moment of the Incarnation, when the Angel Gabriel appears to Mary to tell her that she will bear the son of God.

17 *Christmas crib*, detail, Obere Pfarre Church, Bamberg, figures eighteenth and ninetenth century

The finest of Bamberg's cribs is, without question, the one in the church of the Obere Pfarre, where eighteenth- and nineteenth-century figures tell the story as it might have happened in Bamberg itself [PLATE 17]. The angel appears to Mary, who lives not in an ordinary, half-timbered house, but in a smart stone pavilion, very much like one that can still be seen a few hundred yards away on the Michelsberg. Adoring the new-born child are identifiable local characters, among them a celebrated Bamberg horseradish seller.

Yet if everything is happening in the same place, it is certainly not happening at the same time. In front of the stable where the Three Kings have left their horses, summer corn is being threshed, and fruit and flowers, for which Bamberg's market gardens are still famous, are being sold – because the events of Christmas touch daily life at every season of the year.

The cribs of Bamberg have been called 'a meditation for the eyes'. What they teach is that there is no need for us to struggle to Bethlehem like the Peruvian chieftain, because Bethlehem is where we live. The stable is in our town, Christ is being born now, here, and we should pay attention.

What Francis achieved was the most astonishing act of public education. Different texts of the Bible drawn together, their meaning elaborated over the centuries of theological discussion, have become something visible and understandable, livable as an act and a fact by everybody of whatever level of belief, education and age. But what we have lost in our sentimentalizing, commercializing and trivializing of the Franciscan tradition is something which Francis himself, with his tears of pity and love for the crucified Christ, his mixing of the crib and the tomb, never forgot: the sheer horror of the Incarnation, of God born in order to be put to death by men.

PIETER BRUEGEL THE ELDER
The Adoration of the Kings

To paint the infant Christ at any date is to take a view of the nature and purpose of his birth, for this most simple and familiar of subjects is infinitely rich in meaning. In the hands of a great artist it can move us and teach us, carry the most cynical political ambitions, or the subtlest meditations on the love of God. I should like to close this section by looking closely at another *Adoration of the Kings*, painted by Pieter Bruegel the Elder [PLATE 18]. It hangs in the National Gallery, London, opposite the Gossaert *Adoration*, with which we began. And it is indeed an opposite in many more senses than that.

This painter of the robust labours and pleasures of peasant life, of proverbs and country landscapes, was after his death believed to have been a peasant himself: 'Peasant Bruegel', 'Droll Bruegel'. This was fantasy. He was, in fact, an educated and well-travelled man, in touch with the artistic and intellectual innovations of his time. His work was collected by some of the richest and most highly educated people of the day. But in his works, he wore this culture with an off-hand ease, and could exploit a sometimes savage humour to present universal truths with a contemporary twist. Bruegel's topical references to popular theatre and religious processions, local Flemish folklore and proverbs, and satirical prints, some of which he himself designed, can make much of his work seem enigmatic to us, and rarely more so than in this picture. We do not know for whom, or why, it was made.

Bruegel's *Adoration of the Kings* is signed and dated 1564, a year after the artist had moved from bustling, cosmopolitan, commercial Antwerp to aristocratic Brussels, seat of government, and a centre of tapestry weaving. Raphael's famous tapestry designs for the Sistine Chapel in the Vatican (now in the Victoria and Albert Museum, London) had been sent there to be woven, and all but one were still there when Bruegel arrived. The *Adoration* may well have been influenced by Raphael. The figures crowd the composition, which echoes the central Epiphany scenes of older Netherlandish art, as do the costumes of the Three Kings – compare, for example, the soft riding-boots of the black King Balthazar with

those of his counterpart in Gossaert's altarpiece [PLATE 1]. But the rich exotic ret-
inue of Gossaert's Kings, with their courtly pages and train-bearers, their horses
and camels, is totally absent. And strangely for Bruegel the landscape painter,
there is no hint of surrounding countryside: just an oppressive throng by the
wooden shed where the Kings present their gifts. There is no weather, no time of
year: Joseph's straw hat, that provides a sort of halo for the Virgin, seems more
appropriate for summer travel than in December.

Equally unsettling is the totally contemporary air of the curiously prominent
soldiery – an archer with an arrow stuck in his hat and a band of rough-and-ready
halberdiers – and the civilian onlookers. One of these whispers in Joseph's ear;
another ogles Balthazar's gorgeous censer – part nautilus shell, part crystal globe,
part golden ship – through round-rimmed glasses.

Most equivocal of all is the ugliness of all the participants except for the
Virgin and the Christ Child. We seem to be looking at caricatures of fallen human-
ity. The soldiers, like the townsmen, have eyes only for the Kings' treasures; even
Joseph may be assessing their material worth. And the Three Kings appear not to
have humbled themselves before the King of Kings: humiliated by the painter's
brush, they have been made grotesque examples of earthly pomp that requires
armed battalions to keep it in power.

We sense that our unease is shared by the Child himself. The open dish
proffered to Christ by the oldest king seems to hold, not gold, but granules of
myrrh resin used for anointing the dead. While Gossaert shows us the Child King,
Bruegel shows us the Child born to die. The gift tells the future, and he recoils,
shrinking back in to the protective arms of his mother.

At the time Bruegel was painting this *Adoration*, terrible trouble was brew-
ing in the Low Countries. The Emperor Charles V, King of Spain and lord of the
Netherlandish provinces, had in 1555 abdicated in favour of his son, Philip II.
Unlike Charles, who had been born and brought up there, Philip had no natural
links with Flanders; he was Spanish through and through. In Brussels, Spaniards
were elbowing Netherlandish nobles out of the high councils of state. More and
more taxes were forcibly exacted by central government from towns and villages,
with property and crops confiscated in default of payment. Many had broken
away from the Roman Church to embrace various forms of Protestant belief;
these 'heretics' were pursued with torture and death, in disregard of civil and civic
rights long held sacred. Although most Netherlanders remained Catholic, there
was a general sense of revulsion against the harsh edicts, the persecutions and
bloody executions of Protestants carried out by bureaucrats and soldiers in the
service of the king. In 1559 Philip departed for Spain, leaving behind him his able

18 PIETER BRUEGEL THE ELDER *The Adoration of the Kings*, 1564

half-sister, Margaret of Parma, as regent, but with intransigent Spanish officials to keep her in place – and a disaffected clergy, nobility and populace.

On the last day of 1564 (the year in which the picture was made), William, Prince of Orange, at that time still a loyal subject and a Catholic, addressed his fellow Netherlandish noblemen: 'The king goes astray if he thinks that the Netherlands, in the midst of lands where freedom of religion exists, can continue to endure the blood-stained edicts ... No matter how strongly I am attached to the Catholic faith, I cannot approve of princes who wish to govern the souls of their subjects and to deprive them of their liberty in matters of conscience and religion.'

Two years later, in 1566, groups of zealous Protestants broke into churches and convents throughout Flanders, destroying religious paintings and sculptures. Philip responded by sending an army under the Duke of Alva, who was given unlimited power to subdue the country and reinstate the Catholic religion by force of arms. The 'Spanish Fury' that sacked Antwerp, and massacred eight thousand of its inhabitants, was soon to be unleashed. By the end, many other cities had been destroyed; Alva would boast that he had killed some eighteen thousand people; many more fled into exile. The rebellion would eventually lead to the break-up of the Spanish possessions in Northern Europe, and the formation of an officially Protestant state, the Dutch Republic.

I am not claiming prophetic powers for Bruegel as he painted this picture. Yet it is clear that much of what was to come was already in the air, and that the *Adoration of the Kings* refers to it. In the Franciscan spirit, he located Christ's birth in the Low Countries and in his own time, using the idiom of the Bible to paraphrase the travails of his own land. The ass in the stall – there is no ox – knows his master; like Balaam's ass, he has eyes to see the Angel of the Lord (Numbers 22:21–34), while those who are blinded by cupidity and illusory earthly power, and need glasses, remind us of the 'rebellious house' lamented by Ezekiel: 'Son of man, thou dwellest in the midst of a rebellious house, which have eyes to see, and see not' [Ezekiel 12:2].

Far from Christ welcoming the kings and acknowledging their royal fellowship, we feel that the opposition between him and them is complete. Their escort is made up not of courtiers, but of brutal soldiers. And, a few verses later in St Matthew's Gospel (2:12–16), soldiers like these, acting on the orders of another king, Herod, will kill all the boys in Bethlehem under two years of age, to eliminate the threat that the new-born Jesus poses to the established order. Their first gift is not the 'purest gold of a clean conscience', but the myrrh of death. No wonder the Christ Child recoils.

It is a profoundly subversive picture.

PART TWO

THE
QUESTION
OF
APPEARANCE

I am the good shepherd,
and know my sheep,
and am known of mine.

JOHN 10:14

SIGNS AND DEEDS

We have mainly been looking so far at images of Christ as a baby. Now it is a sad fact that for most of us, one baby looks very much like another and indeed their specific appearance is generally of absorbing interest only to their near relations, who scan the features looking for resemblances to one or the other side of the family. And that, in essence, is the perennial problem for artists portraying Jesus Christ at any stage of his life: how to show him at one and the same time as his mother's son – fully human; and his Father's – fully divine.

The problem is not acute when he is represented as a baby in Christmas or Epiphany scenes: context is all. He may appear naked or swaddled, or dressed in a Roman toga. He may lie in a manger, or upon the ground, or sit enthroned on his mother's lap. He may be adored by rich and poor, black and white, by wise men or by kings, by shepherds, by women and children and by angels. He may reach out for an offering, or recoil from a portent of death. He may, as in early Christian art, have the proportions of a miniature adult [PLATE 8], but the point is that he is *miniature*; what his face looks like does not matter. He is in fact shown as *any* baby, and artists have devised other means to let us recognize his true nature – the animals of Scripture, the gifts of the Kings, the manipulation of light tell us that this is not just a child but the Messiah. And when it came to representing Jesus the grown man, the teacher and worker of miracles, the Saviour, they initially went about it in the same sort of way.

The earliest Christian art evolved, as we have seen, in a milieu suspicious of imagery; and at the beginning, Christ was represented not through images but in signs, which we first find scratched on funerary slabs, and which soon spread from catacombs and marble sarcophagi to everything: seals, jewellery, lamps and other household objects. As we might expect in a society of mostly Jewish-born converts, these signs depend on words and word games. A monogram was formed from the first two Greek letters for the word Christ, the Chi Rho already mentioned [PLATE 19]. It had long existed among the pagans as an abbreviation of the similar Greek word *chrestos*, meaning 'auspicious', and had been used as a

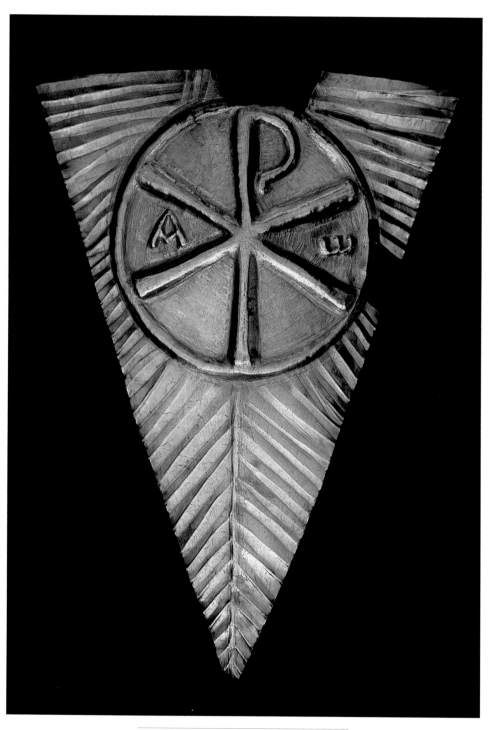

19 Votive plaque with Chi Rho, fourth century

symbol of good omen; it was probably for this reason that it was first adopted by the Emperor Constantine on the Roman imperial standard. The Chi Rho could be shown wreathed with a victor's crown, like the one Christ confers on San Vitale in Ravenna; Christians also often appended to it the Greek letters alpha and omega, the first and last letters of the Greek alphabet: 'I am Alpha and Omega, the beginning and the ending, saith the Lord, which is and which was, and which is to come, the Almighty' (Revelation 1:8).

As with Yahweh in the Old Testament, so for his son in the New: God is not named or shown, but alluded to by letters. An even older sign is that of the fish [PLATE 20]. This is more of a visual pun, based on an acrostic, than a simple monogram. The initial letters of the words Jesus Christ God's Son Saviour – I-ch-th-y-s – form the Greek word for fish. This intrigued and delighted the first Christian scholars, who took a donnish pleasure in elaborating the joke.

Tertullian, a second-century theologian, would mix the Greek and Latin words for fish, to write: 'We little fishes [*pisciculi*], after the image of our Ichthys Jesus Christ, are born in the water, nor otherwise than swimming in the water are we safe.' He is, of course, referring to the saving water of baptism, and the baptismal font came to be called a piscina, literally a fish-pond.

But the sign of a fish easily shades into an image of a fish, and as the catacombs begin to be decorated with frescoes we find the fish pictured as an item of food, referring to Christ in the Eucharistic meal, 'giving himself as food to the disciples by the seashore, and offering Himself to the whole world as Ichthys'.

The author quoted is Prosper of Aquitaine, a fifth-century theologian. By mentioning the seashore, he associates the edible fish not simply with the Eucharist, but also with a particular scriptural event. Chapter 21 of the Gospel of St John recounts a miraculous appearance of Christ after the Resurrection, when he showed himself to seven of his disciples fishing on the sea of Tiberias. They had caught nothing. An unknown man advised them from the shore to cast their net on the right side of the boat. The catch was so huge they could barely bring it to land. But when they did so they found Christ, whom they now recognized – having already lit a fire on which fish were grilling; there was also bread. He said to them: 'Come and dine.'

Pictures of a single fish were soon expanded to a fish with a basket of bread. We also find paintings in the catacombs of two fishes, with seven bread baskets to symbolize the seven disciples. The two fishes now refer to the miracle of the two fishes and five loaves, which Christ multiplied to feed a multitude of five thousand (Mark 6:34–44), a miracle often compared with Christ's continuing feeding of the faithful through the Eucharist.

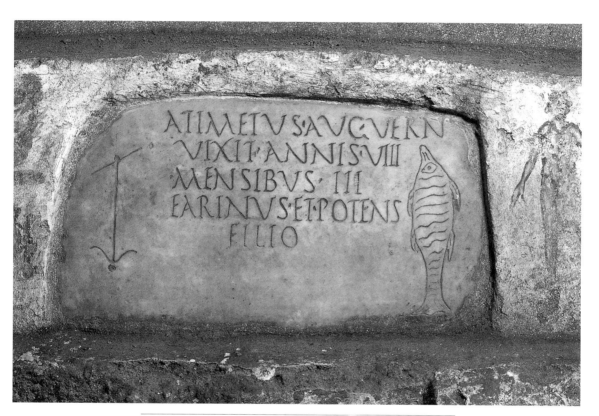

20 Funerary tablet with Fish, Catacomb of St Sebastian, Rome, *c.* 200

Fish had another obvious Gospel association, recalling the first disciples' occupation as fishermen, and Christ's summons: 'Come after me, and I will make you to become fishers of men' (Mark 1:17). By happy coincidence fishing scenes, which offered pleasing opportunities to paint expansive landscapes, were already extremely common in the decorative art of pagan Rome; now they were readily transposed to the Christian catacombs, where they signified the apostolic fishermen, catching *pisciculi* to be baptized and saved.

We can see from this single example of the fish-sign that, in a Roman culture rich in imagery and artists, it would have been difficult for any purists hostile to images to hold the line. The initials of a simple declaration of faith – Jesus Christ, Son of God and Saviour – became a word, the word a sign, the sign an image – and the image was then woven into entire stories. Once signs were admitted, a whole pictorial repertoire would follow. But it was a repertoire not of Christ's likeness, but of aspects of his nature, and it was also word-based, drawing on the vivid verbal imagery of scripture which could easily be translated into pictures. Most of it remains perfectly familiar and perfectly understandable today.

Vines heavy with bunches of grapes twine through early Christian decoration in every medium [PLATE 21; see also PLATE 4]. They are an image of the Saviour who said of himself, 'I am the true vine' (John 15:1). And as he is the vine, the faithful are the branches, so this is also an image of the Church. Encyclopedias could be compiled on the Christian imagery of vintage and wine-making, referring above all to the wine of the Eucharist (which in turn harks back to the wine of Old Testament rituals). Here again, there was a rich tradition of pagan decoration to draw on, for not only did the pagans use wine in their religious ceremonies and sacrifices, but the Greek and Roman god of wine, Dionysus or Bacchus, was also a deity believed to have died, been buried and risen again. Vines, grapes and all that went with them adorned both pagan and Christian tombs as a hopeful sign of life after death. The Christian tombs can usually be distinguished by wreathed Chi Rho monograms combined with the scrolling vines, sometimes shown growing out of an amphora, the two-handled wine jar of the ancient world.

But perhaps the most popular scriptural metaphor to be translated into images by the early Church was that of the Good Shepherd. The consoling verses of Psalm 23 had long been known and loved:

> *The Lord is my shepherd; I shall not want.*
> *He maketh me to lie down in green pastures: he leadeth me beside*
> *the still waters.*

21 Detail of grapevine and birds, apse mosaics, San Vitale, Ravenna, *c.* 547

*He restoreth my soul: he leadeth me in the paths of righteousness
for his name's sake.*
*Yea, though I walk through the valley of the shadow of death,
I will fear no evil: for thou art with me; thy rod and thy staff they
comfort me.*
*Thou preparest a table before me in the presence of mine enemies:
thou anointest my head with oil; my cup runneth over.*
*Surely goodness and mercy shall follow me all the days of my life:
and I will dwell in the house of the Lord for ever.*

In the ancient world, the Good Shepherd was invoked not only by the Jews: he
can be found in funerary monuments that are clearly pagan, bringing his promise
of comfort. But in the Gospel of St John, Christ had sharpened and elaborated the
metaphor giving it a new dimension.

*I am the good shepherd, and know my sheep, and am known of mine.
As the Father knoweth me, even so know I the Father: and I lay
down my life for the sheep ...
My sheep hear my voice, and I know them, and they follow me:
And I give unto them eternal life; and they shall never perish, neither
shall any man pluck them out of my hand.*
JOHN 10:14–15, 27–8

The image of the Good Shepherd who lays down his life for his sheep appears
over and over in the catacombs reassuring those who waited with the sleeping
dead for the new life in God. When Christianity became a state religion, the Good
Shepherd was carved on marble sarcophagi; we find it encrusted in lavish mosaic
on the wall of an imperial chapel at Ravenna. In the Catacomb of Priscilla, a
woman buried in a small chamber is portrayed raising her arms in prayer to
a Good Shepherd on the ceiling vault [PLATE 22].

The figure is undoubtedly meant to represent Christ, but it is still only that
of any good shepherd. Like fishermen, shepherds were a staple of pagan decora-
tion, which filled Roman town houses with idyllic vignettes of rural life – and this
shepherd is no different. He is young and beardless, dressed in the short tunic
of a Roman farm labourer; wallets or baskets are slung about his body, and he
carries a sheep across his shoulders, while two more stand at his sides. Birds sing
in the trees. Only the context identifies him as not a labourer but the Saviour: the
praying woman; and four peacocks framing the scene, symbols of immortality

because peacocks' flesh was believed not to rot. In such early Christian images of the Good Shepherd, the trusting sheep are patently Christ's followers, whom he knows and who know him; he has retrieved the lost sheep, and is bringing it back to the fold, as he will carry home the souls of the faithful.

It is one of the great paradoxes of Christian imagery, both in biblical texts and in art from the earliest times, that Christ is not only the shepherd, he is also the sheep. Mosaics and carved marble sarcophagi in early imperial and papal churches often show him as a majestic ram, standing on a mount over the four rivers of the Gospels, surrounded by rams symbolizing the Apostles. At San Vitale in Ravenna he is shown as the worthy Lamb appearing in triumph in the spangled mosaic heaven above the altar [PLATE 4]. But since St Francis's ministry in the thirteenth century, the triumphant apocalyptic Lamb of Revelation has generally been replaced by the humble, suffering Passover sacrifice, 'the Lamb of God, which taketh away the sin of the world' (John 1:29).

We most readily grasp this meaning in images like that of the Lamb who stands, bleeding into a chalice, with John the Baptist at the foot of the Cross, in the *Crucifixion* by the German sixteenth-century painter Grünewald [PLATE 41]. But a startling picture by Zurbarán, painted in the 1630s, returns to the less overt symbolism of the catacombs, albeit in a spirit of penitence and lamentation quite foreign to the early Christians [PLATE 23]. In this astonishing work of the Spanish Catholic Reformation, it is up to the viewer to provide the context that explains the image. Only because of what we already know, and know in our hearts, do we recognize in this woolly lamb, bound and patiently waiting on a slab for the butcher's knife, the Saviour on the altar, the Son of Man suffering in atonement for our sins: 'He was led as a sheep to the slaughter; and like a lamb dumb before his shearer, so opened he not his mouth' (Acts 8:32).

Other biblical metaphors for Christ are harder to represent than the vine, the shepherd or the sheep, and for this reason we do not find them in the catacombs. Unlike the suffering lamb, they had to wait, not for a different sort of religious feeling but for a different kind of art. The most important of these figures of speech is surely that of light: 'Then spake Jesus again unto them, saying, I am the light of the world: he that followeth me shall not walk in darkness, but shall have the light of life' (John 8:12).

Throughout the Bible, God's glory is likened to the radiance of the sun. Christ could be, and occasionally was, represented as a sun god – as in the third-century mosaics of a cemetery under St Peter's in the Vatican – but this, among people who still worshipped Apollo and others, was apt to be misunderstood (the image in the Vatican mosaic is surrounded by a profusion of vines to make the

22 *The Good Shepherd*, vault of Capella Greca, Catacomb of Priscilla, Rome, *c.* 250

23 FRANCISCO DE ZURBARÁN *Bound Lamb* or *Agnus Dei*, 1630s

new God's identity quite clear). Rays of light could be shown to issue from him, and the glitter of gold mosaic could surround him; a gold halo could outline his head, but early Christian art had no way of picturing the kind of incorporeal light that pierces through darkness. It could not be done convincingly until the development of oil painting in the fifteenth century, when artists working in slow-drying, translucent oil paints could reveal form gradually emerging from shadow, and indicate the source of brightness. That is why La Tour can shade the midwife's candle to reflect on the baby [PLATE 12], and Rembrandt make the Christ Child glow in the night [PLATE 16]. With the new medium of oil, the first chapter of St John's Gospel, the light shining in the darkness, could at last be painted.

By the nineteenth century, painters may have had the skill to paint light, but they could be less sure of their viewers' capacity to understand symbols. This must be why one of the most popular English pictures of that time – and of ours – does not rely on symbolism alone. Holman Hunt's *The Light of the World* [PLATE 24] uses biblical text (as an inscription on the original frame), a halo, a crown of thorns, wounds in the hands and feet, a royal or ecclesiastical mantle, a 'timeless' white tunic, and the accepted likeness of Christ, which evolved, as we shall see, over centuries, to identify the figure with the lantern as Christ. Striving for a real-istic depiction of night time, Hunt took a large horn-lantern out on a 'beautiful moonlight night, but fearfully cold' in November to see the effect he wanted. He began the picture at midnight, in a hut specially constructed in the orchard of Worcester Park Farm, 'by a lantern from some contorted apple tree trunks, washed with the phosphor light of a perfect moon', and continued painting the landscape from nine at night until five in the morning when the moon was full. He finished the figure, drawn from a mannequin draped in a white tablecloth, in the studio, having rigged up 'an elaborate arrangement of screens and curtains' to block out the daylight. He felt 'very determined to make the figure mystic in aspect'; the face is a composite taken from several male sitters and 'many departed heroes in effigy' – that is, from earlier art.

A pedantic observer might argue that it is not Christ who is the Light of the World here, but the lantern. Hunt had an answer to this. The Christ he shows is the risen Lord after the Crucifixion, and, wrote the artist, 'He who when in body was the LIGHT OF THE WORLD [e.g. John 8:12] could not be unprovided when in the Spirit, with the means of guiding His followers when it was night.' In a picture already dense with image, text and symbol, Hunt provides the picture with yet another meaning in addition to the one in his title. Christ is shown knocking at a door (in fact, the door of an abandoned hut in the orchard) and Hunt's inscription is from Revelation 3:20: 'Behold, I stand at the door, and knock: if any

man hear my voice, and open the door, I will come unto him, and will sup with him, and he with me.'

But in the Bible, just as he is both shepherd and sheep, Christ not only knocks at the door; he is himself the door: 'I am the door of the sheep ... I am the door: by me if any man enter in, he shall be saved, and shall go in and out and find pasture' (John 10:7, 9). Christ the door works better as a verbal than a visual image, and it comes as no surprise that neither the artists of the catacombs, nor even Holman Hunt, attempted to interpret this particular metaphor in paint. Hunt's literal-mindedness, his seeming need to construct a narrative, gilding every textual lily, would seem to disqualify him from painting *any* symbolic Christian image. Nothing could be further than this picture from the crude pictographs of the catacombs, or the works by La Tour, Rembrandt and Zurbarán, in which the living Christ unaffectedly moves among us, in our own world and time, appealing directly to our most fundamental needs and feelings. But perhaps it was precisely its wealth of only partly relevant realistic detail, the obvious artificiality of its central figure, and an abundance of pedantic explication that made *The Light of the World* so popular to Victorian spectators, reassuringly textual to a Protestant Church still nervous of 'Roman' imagery. This is a Christ viewers can at once identify, but are not asked to identify with, who remains at a distance from daily life; it is a Christian image for a world that feels itself bereft of Christ. The picture had a colossal public success, and Hunt later made a larger replica, which toured the British Empire in 1905–7. Suitably for a work that by then had become a 'Protestant icon', this second version was, in 1908, presented to St Paul's Cathedral in London.

As we have seen, the painters of the catacombs frequently illustrated biblical stories along with the signs and symbols of Christ. These were chosen to strengthen faith in resurrection and the afterlife, and they tend to show God triumphantly intervening to save those who believe in him: Moses striking water from the rock; the three youths saved from the burning fiery furnace; Susanna rescued from the machinations of the perfidious elders. Abraham is stopped by an angel from killing his son Isaac, and, in the Christian cemeteries, Jonah is many times spewed safe and sound from the belly of a fantastical, dragon-like whale. It is in this company of miraculous salvation that we find the earliest known representations of the adult Christ's deeds, which form the core of the Gospel narrative.

Surprisingly for us today, perhaps, even here the question of likeness seems to have troubled no one. Christ's appearance is only ever sketchily suggested; he is clean-shaven, but with no consistent, recognizable facial features, and he wears

24 WILLIAM HOLMAN HUNT *The Light of the World*, 1853

the smart toga of a Roman gentleman. In the scene of the Raising of Lazarus, which appears again and again in Christian burial places, the small shrouded figure of the dead man rising up in his tomb can only be Lazarus, and so we know it can only be Christ who calls him forth. A man carrying his bed on his back can only be the healed paralytic, so the well-dressed person gesturing to him must once again be Christ.

The painters of these subjects, like the unknown catacomb artist in the Capella Greca *Adoration of the Magi* [PLATE 3], were not aiming to illustrate the life of Christ, but to show his divinity. His miracles were included as instances of divine intervention. The invisible God of the Old Testament acts through angelic or human agents, as in the stories of Abraham and Isaac, Moses striking the rock, and Susanna; he remains invisible even when intervening to save Jonah from the whale or the boys in the burning fiery furnace. The New Testament God, made man in Jesus Christ, acts visibly and in his own person. Unlike the patriarch Abraham with his long white beard, he is clean-shaven, the stereotype of a youthful Roman, because as a man he did not survive into old age. What was important to this community of believers was not what he looked like, but what he had done – heal the paralytic, raise Lazarus; and what he would do in the future – like a good shepherd, care for us, seek us out and save us. At this stage of Christian art, every Christ looks different. It is his acts, not his appearance, that allow us to recognize him for what he is.

It is a convention of disregard for likeness that was to last for centuries. Armed with early Christian images of the face of Christ as the Good Shepherd, Christ raising Lazarus or healing the paralytic, you could not possibly recognize this man if you bumped into him out of context, or even if you went specifically to meet him off a train at Victoria station.

The stirrings of concern over what Christ actually looked like arose in large measure from the problem of his dual nature. For the earliest Christians, as for Christian churches today, Jesus Christ was the second of three persons making up one God – the Trinity of Father, Son and Holy Spirit – and was therefore at once divine and human. This concept is so difficult to grasp that, as Christianity was emancipated, then became a state religion, theologians increasingly tried to define it according to the rules of secular logic. What was the balance between Christ's human and divine natures? Was the balance between them constant? How could they be recognized? Many hairs were split. Councils of the Church were called, attended by bishops and clerics from most or all of the Christian sees, to formulate a creed acceptable to all; but they frequently revealed, indeed even fomented, dissent, as different opinions were voiced until the definitive statement of Christ,

fully human and fully divine, was formulated by Pope Leo the Great at the Council of Chalcedon in 451.

Of the many heresies on this inexhaustibly complex topic, the most widely disseminated, the longest lived, and the one that most affected visual art was Arianism, the doctrine of the fourth-century Libyan theologian Arius. Condemned at the Council of Nicaea summoned by the Emperor Constantine in 325 (which gave us the Nicene Creed), Arius's teachings became after Constantine's death the accepted doctrine in much of the Greek part of the Empire, and from there spread to the Germanic tribes in Central Western Europe. The heresy never took hold among the Latins in Italy, but as the Germans invaded the peninsula, they carried their Arian beliefs with them – and they illustrated them in spectacular works of art.

Arius maintained that God, who existed without beginning, created the Son out of nothing, even before the creation of time. 'Every one knows ... that the Father is greater, the Son subject ... that the Father has not a beginning, is invisible, immortal and impassible; that the Son is born from the Father, God from God, light from light ... that from the Virgin Mary [the Son] took man, by means of which he shared in suffering.' Very crudely resumed, the Son of God was not eternal, not God by nature; his divinity was conferred upon him. If this is hard to understand, it is easier to see in the mosaics of the great churches of Ravenna.

In common with other Germanic tribes, the Ostrogoths who conquered Ravenna in the fifth century had been baptized as Arians. They cohabited peacefully, but as distinct nations, with the local Latin Christians; each community had its own tribunals and laws, and throughout most of Theodoric's reign each enjoyed full religious autonomy. The king naturally ensured that his Arian people had their own places of worship, whose decoration would express the doctrines of their faith.

The mosaics of Theodoric's Arian church of Sant'Apollinare Nuovo run along either side of the nave – and thus they offered the perfect twin vehicle for artists wanting to distinguish the two (for the Arians) separable natures of Jesus Christ, human and divine. The sides of the nave were already differentiated by gender: during services, women stood on the north side and in the main register of decoration above them, female saints are led by the Magi to adore the Christ Child in the Virgin's lap [PLATE 8]. Men stood on the south side, below a procession of male saints, going forward to worship the adult Christ, the King and judge. Above this register, in a series of small scenes, the artists tackled what was for them the key issue about the image of Christ: not his likeness, not the story of his life, but what was made manifest in his life. On the one side, we see Christ preaching and healing, on the other are the scenes of his Passion.

The miracles and the teachings reveal his divine nature, but it is as a man that Christ is betrayed, judged and led to his death. And, startlingly, each nature has a different physical appearance. Like the Christ of the catacombs, he is youthful and clean-shaven when divine, but he is older, and bearded as a Palestinian might have been, when his human nature is being emphasized [PLATE 38].

The mosaics of Sant'Apollinare Nuovo are not biography and even less are they portraiture. Rather, they are a visual Christology, a study of the essential nature of Christ. After the king who commissioned them had died, the Byzantine Christians who took over the church effaced his likeness and that of his courtiers. The political power of the Arians was thus eliminated. But they did not destroy these mosaics, perhaps because they found them too beautiful, perhaps finding ultimately acceptable their representation of the dual nature of Christ.

Sant'Apollinare Nuovo represents a magnificent theological and artistic achievement: a formula for holding in balance the two aspects, human and divine, of Christ's nature, visible at different moments in different events. But there is a moment in Christ's earthly life when the two natures have to be equally visible at once: the Baptism, when John the Baptist saw the Holy Spirit descend on Jesus. In the dome mosaic of Theodoric's Arian Baptistery, it posed the artists a huge problem – how to show a man both human and divine. To solve the problem, the artists exploited – one might almost say ransacked – the vocabulary of pagan sculpture [PLATE 25], although, of course, in view of the Church's continuing fear of idolatry, translating it into a two-dimensional medium.

The River Jordan sits on the left – in the form of an ancient Roman river god with his symbolic rush sceptre in his hand and an improbable crayfish headdress. In the middle, up to his waist in water, completely naked, stands Christ. The artist has wanted to show that he is not just a man, and he looks uncannily like a statue of a youthful pagan divinity, of the sort you can still see in Rome: the statues of Castor and Pollux now on the Capitoline Hill, half human and half divine, may have seemed natural models to turn to. What other language, indeed, could the artist have used? On the right, even John the Baptist has not escaped the touch of paganism, for he does not wear the biblical camel skin, but has borrowed the leopard skin of the old god of wine, Bacchus.

We are not shown the Baptism by water. John merely touches Jesus's head with his hand: it is the Spirit, which pours down from the dove, which confers divinity. The Arian beholder can watch the human nature of Jesus being made divine.

To see where the dove comes from, we must turn around and change our point of view. When we walk to the other side of the Baptistery and look up, we

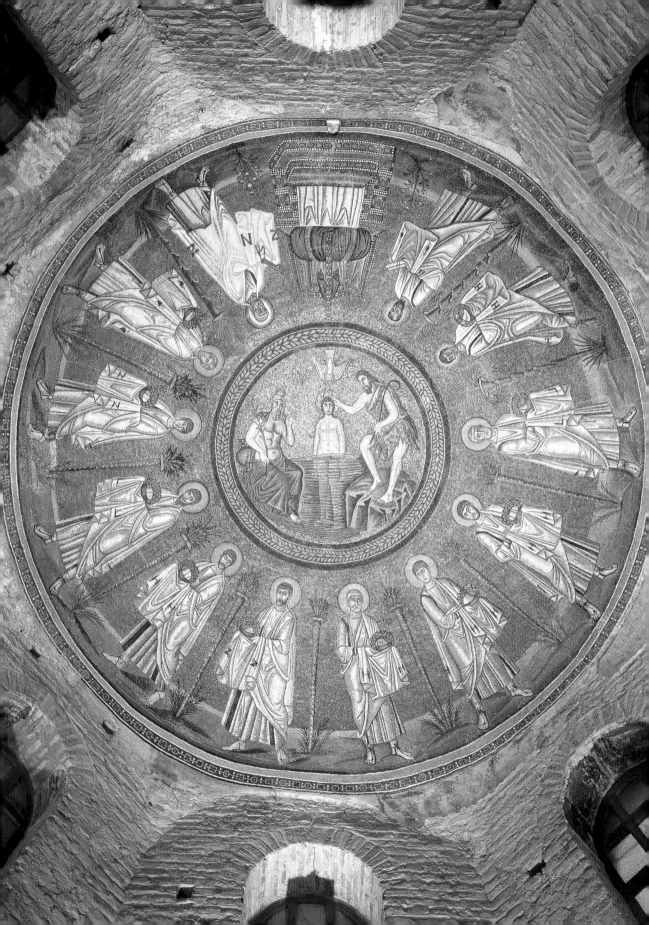

find an imperial throne lavishly jewelled and empty save for a purple cushion on which stands the glorious Cross of Christ's triumph over death [PLATE 37]. This is the emblem of God, for we on earth cannot yet see God face to face. It is towards this invisible presence that Paul holding his Epistles and Peter with the keys lead the Apostles, all dressed like Roman senators and holding victors' crowns.

The dome of the Arian Baptistery is a dazzlingly subtle piece of visualized theology. We cannot see God, but when we have changed our point of view we can behold the Son of God incarnate on earth, his divine nature manifest in the only form the artist at this date had at his disposal: that of a pagan divinity. It is also the clearest possible demonstration of the continuing tension between the Jewish-derived tradition of a God that must not be represented, and a pagan culture accustomed daily to seeing its gods in images displayed throughout its cities.

25 (OPPOSITE) *The Baptism of Christ, the Apostles and the Empty Throne,* dome of the Arian Baptistery, Ravenna, 493–526

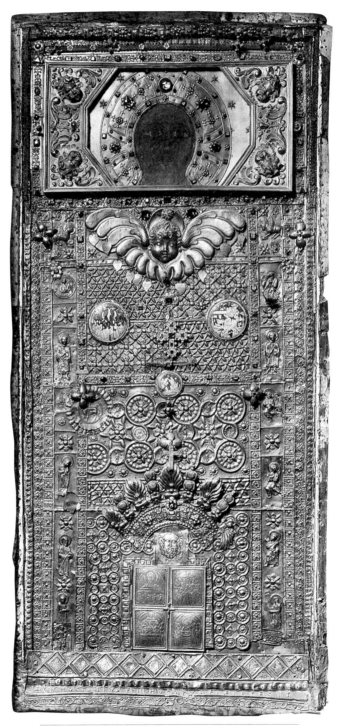

26 *Acheiropoieton*, or 'image not made by human hands',
icon *c.* 600, silver casing, *c.* 1200

THE QUEST FOR THE TRUE LIKENESS

At Ravenna, the conflict between the desire to see God and the fear of representing him had (just) been held in check. But beyond the sea in Constantinople, it intensified steadily, eventually erupting into open warfare.

The political situation in the East was grave. Egypt and Syria had been conquered for Islam in 681. The heartland of the Byzantine empire was threatened by continuous raids of non-Christian nomadic tribes – Slavs and Bulgars as well as Arabs. In the Balkans religious and educational institutions, more closely identified with the imperial court than in the Latin empire, were in disarray. Christianity, as practised by a demoralized population, was in danger of becoming a miscellany of debased superstitions. Many found it intellectually and morally inferior to Islamic monotheism, with its firm insistence on holy writ and a strict taboo on images.

The situation was saved, or so it seemed, when in 716, a Byzantine general from Isauria in Asia Minor seized the Byzantine crown, assumed the imperial throne as Leo III, and in 718 repulsed a formidable attack by Islamic Saracens. In 726 he issued an edict prohibiting the use of images in public worship. Throughout the Eastern empire, mosaics and pictures were smashed. A fleet was despatched to the harbour of Ravenna, with instructions to destroy the mosaics there. Luckily – from the point of view of Western art – that particular fleet never arrived.

The appearance of the Iconoclasts, or Image-breakers, in Italy stirred the local population to ferocious resistance. The Byzantine-held cities rebelled; and in 728 Ravenna was lost to Byzantium. In Rome, Pope Gregory II denounced Leo's edict, and the controversy over images split Christendom and divided the Byzantine empire for over a century.

Byzantine iconoclasm, several times condemned as heresy and repealed, was not finally defeated until 843. Since then, both Eastern and Western churches have admitted images. But the passions the dispute aroused profoundly and enduringly affected the way both churches thought about representing Christ.

The main argument in favour of representation asserts that, because God had chosen to make man 'in his image', it must be permissible for men in their turn to make images. Since Christ was incarnate as man, it was proper to show him as a man. And as man's image already reflected God's, an image of the incarnate Christ showed him as both human and divine. 'From physical signs,' averred the champions of images, 'we are led to the contemplation of spiritual things.'

In Rome, where this argument seemed particularly persuasive, there was a long tradition both of images of the gods and portraits of the mighty – and in a city now ruled by the pope in Christ's name, it must have seemed unimaginable that no portrait of the supreme authority should exist. But there were, of course, no contemporary portraits of the Jewish-born Jesus, and the Gospels gave no indication of his appearance. How could this difficulty be got round?

Half the answer can be found in a chapel in one of the oldest churches in Rome, Santa Maria Maggiore, and, as you might expect, it begins with a legend. It is said that the Virgin Mary, while still nursing the Christ Child, sat to St Luke for her portrait. St Luke, the physician Evangelist, would, like all doctors of the day have had access to drugs, spices and pigments, and thus it seemed entirely likely that he should also have practised as a 'Sunday painter'. This was, of course, a story that particularly appealed to painters. On the strength of it, they chose Luke as their patron saint, while the holy portrait-sitting itself became an extremely popular subject in Western art.

Pictures of the Virgin and Child that came to the West from the Eastern empire were often identified as portraits by St Luke himself. There were many of them, but none enjoyed a greater celebrity than the silver-cased, heavily repainted image now in the basilica of Santa Maria Maggiore, so venerated that in the nineteenth century it received the title of *Salus Populi Romani*, the Salvation of the Roman People. For centuries, every year on 15 August, the day on which the Roman Catholic Church celebrates the Virgin's Assumption into Heaven, this much revered image came out of her church to welcome an effigy of her son. She was said to stir in her chapel the night before; and when they finally met, the two images solemnly bowed to each other.

The image of Christ that was carried in procession through the streets of early medieval Rome to meet his mother has been known since the eighth century, and still survives, although it has been venerated almost to extinction [PLATE 26]. The *Acheiropoieton*, or 'image not made by human hands', is housed in what was once the popes' private chapel in the Lateran Palace, a place furnished with so many relics that it is for this reason called the Sancta Sanctorum, the Holy of Holies.

27 Unknown artist *Mandylion of Edessa with Scenes of the Legend of King Abgar*, eighteenth century

Centuries of pious kissing and touching have all but destroyed the image of Christ preserved in the Sancta Sanctorum. Worshippers are now allowed to see only the face, and even that is not the original, but a late repainting on a separate piece of cloth. The rest of the panel was concealed in the thirteenth century by a richly jewelled silver casing, at the bottom of which little doors open to allow for ceremonial washing of the feet. After centuries of such ministrations, very little of the original paint survives. In its sumptuous metal cladding the whole object now hardly looks like an image at all, and it is very hard to read, but a much later fresco on the wall above gives us some idea of what it once looked like: it was an almost life-size picture of Christ the King, solemnly enthroned.

While the Virgin's portrait was the work of a human, albeit saintly painter, this likeness of Christ had even grander origins. Begun by St Luke at the request of the Virgin and the Apostles, so the story goes, it was completed by angels. Now the involvement of angels dealt this image two winning cards. First, even the sternest iconoclast could hardly object to a representation miraculously made by the agents of the divine will. And second, as angels look daily upon the face of God, it could safely be assumed this was an authentic likeness of Christ, incarnate, resurrected and ascended.

It was, however, possible to conceive of an image made by an artist more distinguished than St Luke or even than the angels – Christ himself. And in the Eastern Church they did. It is called the Mandylion, from the Greek word for a cloth kerchief, and it is believed to show a portrait of Christ. It is one of the key images of Greek Orthodox Christianity and, as we shall see, it played a major part in Western religious art. Replicas of it abound. The one in the Queen's Collection at Buckingham Palace, probably painted in the seventeenth century, is surrounded by captioned images recounting the story of the Mandylion's miraculous origin [PLATE 27].

The legend was recorded in 945 when the Mandylion was brought from the ancient Syrian city of Edessa to the imperial court at Constantinople. It runs as follows.

A servant of King Abgar, ruler of Edessa, was travelling through Palestine to Egypt,

> *when he saw Christ in the distance, drawing the people away from error by his words and performing incredible miracles. When he had completed his journey to Egypt and discharged his duties, he returned to his lord. He knew that Abgar was crippled with chronic arthritis and eaten by black leprosy, and that he was in constant pain suffering from this*

double burden or rather many-sided disease … He was also ashamed of his disfigurement on account of which he would scarcely let himself be seen by men.

The servant having informed King Abgar of the miracles wrought by Christ, the sick king despatched him with the following letter:

Abgar the Toparch [ruler] of Edessa sends his greetings to Jesus the Saviour who has come to light as a good physician in the city of Jerusalem.

Your deeds have come to my notice and your healings performed without either medicine or herbs. For as rumour has it, you make the blind see, the lame walk, you cure lepers and drive out unclean spirits and demons, you heal those who are tortured by chronic illnesses, and you raise the dead. Having heard all these deeds of yours, I have thought of two possible explanations: either that you are God and have come down from heaven and do these things, or that you do these things because you are the Son of God. For this reason I have written to you to ask you to take the trouble to come to me and cure me of my disease. For I have also heard that the Jews murmur against you and want to harm you. I have a very small city, but it is stately and will be sufficient for us both to live in peace.

King Abgar, being a realist and guessing that Jesus might not be persuaded to break off his ministry in Palestine to come to Edessa, charged his servant at least to return with an accurate portrait. When the servant returned to Judaea, he found Jesus but was unable to approach him through the crowds surrounding him. When he sat down to draw his likeness on a piece of paper, Jesus realized what was happening 'through divine inspiration', and sent for him. Declining Abgar's invitation to visit, he despatched the servant home with a letter to the king.

There are two versions of what happened next. In one, the Saviour washes his face in water then and there, wipes off the moisture on a linen towel, miraculously imprinting his likeness on the cloth, which he sends back to King Abgar with the letter. In the alternative version, Christ merely promises his likeness to Abgar in the letter, but imprints it – only later – on the cloth with which he wipes the sweat off his face in the Garden of Gethsemane, charging Thaddeus to bring it to Abgar after the Crucifixion. When Thaddeus first approaches the king with the portrait, Abgar is dazzled by the 'unbearable glow of the brightness'.

In both versions, as you would expect, the miraculous image – not made of 'earthly colours' – performs miracles. It heals King Abgar and many others. It preserves the city of Edessa, converted to Christianity, from harm and from attack; and finally, after many miraculous adventures, it is brought to the emperor's court in Constantinople, where it became the object of the most fervent veneration.

At various points in the legend, the image imprinted on cloth by Christ himself miraculously replicated itself on other supports. These miraculous replicas being in turn replicated by artists, the likeness continued to multiply, the relatively unvarying formulae of Byzantine art guaranteeing, for the faithful of the Eastern Church, its authenticity to this day. The original Mandylion disappeared from Constantinople during the Crusades, to reappear around 1240 as one of the relics in King Louis IX's Sainte Chapelle in Paris, from where to vanish for ever in the church-hating relic-smashing violence of the French Revolution. But the Mandylion image, the likeness of Christ it had made familiar, marched on through the Orthodox world – indeed literally so, for it was reproduced on the banners carried by the armies of the Russian tsars until the early twentieth century.

Early copies of the Mandylion were brought or sent as gifts to the West and a particularly impressive one is still being held in Genoa. Ownership of so prestigious a relic conferred great status on Byzantium and the Roman Church was, not unnaturally, eager to have its own authentic likeness of Christ imprinted on a cloth by his divine agency. Fortunately – perhaps miraculously – some time around 1200 a cloth in St Peter's, long believed to have been used by Christ during the Agony in the Garden to wipe the sweat from his brow, was found to have his features impressed on it: it was given the name of the *Vera Icon* or True Image, and a garbled version of this name, Veronica, was bestowed on the woman by whose action, according to a new legend, the image had come into being.

The story of Veronica, the woman who took pity on Christ on the road to Calvary and wiped his face with a kerchief, is familiar to us from the innumerable works of art it inspired [PLATE 28]. But this story is a latecomer; it was written down only about 1300, probably first in France. Before then, legends circulated of a pious woman friend of Jesus's, Berenice or Veronica, who desired to have his portrait. By various miraculous means, which recall the origins of the Mandylion, her wish was ultimately granted. Sometimes Veronica is identified with the woman with an issue of blood, said in three of the Gospels to have been healed by Christ. In her gratitude, the legend goes on, she erected a bronze statue of Christ, and sent the miraculous likeness he had impressed on her kerchief to the Emperor Tiberius to cure him of leprosy.

Our Veronica, the one in this painting, is the creation of a slightly different

28 RIDOLFO GHIRLANDAIO *Procession to Calvary, c.* 1505

legend, prompted by the fact that since the twelfth century there had existed in Jerusalem a *via sacra*, *crucis* or *dolorosa*, allegedly the holy road which led from Pilate's palace to the site of the cross on Golgotha and thus thought to correspond to Christ's last walk on earth. We shall return to it in Chapter Eight. Under the custody of the Franciscans, it became an obligatory itinerary of pilgrims to the Holy Land – and as they were shown along the route, with stops for the several Stations of the Cross, Jesus's pious woman friend must have been transmuted into a tearful spectator of his sufferings, full of compassion, love and grief. Fearing the parting that his death will bring, she desires a portrait to make sure that she never forgets his face.

The cloth kept in St Peter's since at least the eleventh century was not originally related to the legends of Berenice/Veronica. Known as the *sudarium*, Latin for a cloth used to wipe sweat, it was no more than just that, and it was thought to show only some marks of Christ's sweat, not a likeness of him. But once the *sudarium* was declared to be in fact a portrait, and was linked to the Via Crucis, it came to be thought of as one of the key relics of Christ's Passion. Veronica images were often differentiated from Mandylion ones by a crown of thorns and greater marks of suffering. And soon, as the result of a dramatic development in the use of religious images, the Veronica eclipsed the fame of the Mandylion in the West.

In 1216 Pope Innocent III (the same who licensed Francis of Assisi's rule, and had enclosed the Sancta Sanctorum image in its precious silver casing) declared that a prayer said in front of a Veronica image would earn for the person who said it an indulgence, i.e. a reduction – in this case ten days – off their time in Purgatory.

This astonishing innovation, the first such indulgence linked to an image which could be copied, explains why, of all the 'True Likenesses' of Christ, it is this one which became by far the most important for Western art. Pilgrims flocked to Rome to see it. Small Veronica images were made as badges to sew on hats; Chaucer describes his Pardoner with such a 'vernicle'. 'Veronica painters' mass-produced such pictures, and they found a ready market. At times there were up to a million pilgrims in Rome when the Veronica was shown. According to an English pilgrims' guidebook of 1370, Roman residents could at such times obtain three thousand years' indulgence for their sins, Italians nine thousand years, and foreigners twelve thousand years for having come the furthest to venerate the relic.

But the Veronica's impact was not limited to the city. Across Western Europe, the faithful prayed in front of copies of the image. And from now on, wherever the Roman Church went, the Veronica would go with it.

This special veneration brought the image of Christ into people's homes. The Netherlandish young man portrayed with his prayerbook around 1450 has a Veronica tacked on the wall of his room on an illuminated paper or parchment [PLATE 29]. The Latin words of the prayer that would earn him his indulgence are perfectly legible. They translate as follows:

> *Prayer to the Holy Sudarium. Hail, holy face of our Redeemer, shining with the vision of divine splendour which was imprinted on the white cloth given to Veronica as a token of love. Hail, our glory in this hard life of ours – fraught, fragile and soon to be over – lead us, wonderful image, to our true homeland, that we may see the face of Christ himself. Hail Sudarium, excellent jewel, be our solace and reminder. No human hand depicted, carved or polished you, as the heavenly Artist knows who made you as you are. Be to us, we beg, a trusty help, a sweet comfort and consolation, that the enemy's aggression may do us no harm, but we may enjoy rest. Let us together say amen.*

The 'aggressive enemy' is of course Satan, the harm Hell, and the rest prayed for is in Heaven. And the young man's effigy will be praying in front of the Veronica for as long as the picture survives, inviting attentive viewers to do likewise.

How the likeness of Christ in the Mandylion is authenticated through miraculous replication, unswervingly repeated by Byzantine painters and their heirs, may make a modern Western reader smile. But here we have something almost stranger. Petrus Christus, the painter of the portrait, has painted a picture of a picture of the Veronica – a picture that makes little pretence of being a replica of the miraculous imprint then in Rome. Yet its efficacy in devotion is virtually the same, hence the legible prayer.

Indeed, the more widespread the devotion to the Veronica became, the more the image was copied and disseminated, the less did the Veronica paintings and prints look the same, although they always maintained a strong family resemblance to each other. Some, like the one here, were shown bareheaded, others with a crown of thorns. Many, Petrus Christus's among them, seemed more like portraits of a living person than images of an image. But it was the family resemblance that mattered: by the end of the fifteenth century there was an agreed likeness of Christ; 'everyone' throughout Europe 'knew' what he looked like. (For one thing, he wore a beard.) His appearance varied, but only as the appearance of someone we know varies in photographs. And when the Veronica disappeared during the Sack of Rome in 1527, put up for sale in a tavern by Lutheran soldiers

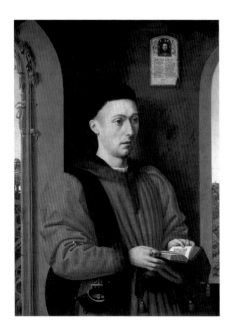

29 (ABOVE LEFT) PETRUS CHRISTUS *Portrait of a Young Man*, 1450–60
(ABOVE) Detail showing *Veronica Image and Prayer*

30 Volto Santo, Cathedral, Lucca, eleventh century?

(to be rediscovered again, and re-enshrined at the Vatican, although its image is said no longer to be visible) the loss was of the same order as the loss of the Mandylion: a relic was gone (and for pilgrims that was grave) but the likeness remained, and the fervour of the prayer it could arouse was undimmed.

While the Mandylion and its progeny remained the one authentic portrait of Christ in the East, the Veronica, although the most widely promulgated and the most influential, was not the only miraculously made True Likeness venerated in the West. Any old Byzantine icon was liable to be thought miraculous in origin, and we can still find them enshrined in churches throughout Europe, even in Rome itself. But there is one exceptional Eastern work, probably made in Syria – and certainly not in Constantinople, where monumental three-dimensional images were not tolerated – whose renown in the West for many centuries matched that of the Veronica. It is known as the Volto Santo, or Holy Face, of Lucca, despite the fact that it is a full-length life-size figure, sculpted in wood, of the crucified Christ [PLATE 30].

The fame of the Volto Santo originated in the fact that Lucca was a favourite stopping place on one of the main pilgrimage routes to Rome: the ancient Via Francigena or Romea, which linked Rome via France to the North Sea. One of the most welcome of its eighty staging posts must have been Lucca, lying on a fertile plain beyond the dangerous passes and torrents of the Tuscan-Emilian Appenines. Pilgrims rested there from an exhausting journey, and each of the town's many churches had its hospice to receive them. But what really detained the pilgrim was Lucca's miraculous Christ, today enclosed in a graceful wrought-iron Renaissance shrine in the cathedral of San Martino, where the statue is almost hidden under rich ornaments. It was more accessible to view – and to touch – in the Middle Ages, when there was only a crown on its head, and, on certain feast days, silver shoes put on its feet to protect them from pilgrims' kisses.

Of course, the statue has its legend. It was the work of Nicodemus, the Pharisee who 'came to Jesus by night' (John 3:1) to be taught by him, and who later assisted at his burial. Nicodemus was held to be a sculptor as St Luke had been a painter. Having seen Christ on the Cross, he tried to make a statue that would preserve the image for future generations, but the task was beyond human capacity. Waking up one day exhausted beside his unfinished crucifix, he found that an angel had completed the work. The statue was widely venerated, but when the Iconoclasts in the East threatened to destroy it, it set out for the safer shores of Italy, alone, in a boat without crew, pilot or other passengers. At last, in 742, it put in on the Tuscan coast. Once ashore, the statue was taken at once, in a chariot drawn by white oxen, to the cathedral city of Lucca.

What was most striking about the Volto Santo is not his dark colouring, Christ's radiant face having been marked by the sufferings caused by 'our foul, black, shameful deeds', as the mystic Julian of Norwich understood. The odd thing about this statue is that it shows Christ on the Cross wearing not just the loincloth familiar in Western Europe, but an ankle-length, long-sleeved tunic tied at the waist. And this, combined with the severe, crudely carved and painted features and the protuberant open eyes, gave him an air of alien majesty, an incontrovertible power which strongly affected those who saw the sculpture.

This alternative regal 'True Likeness' could hardly have been more different in aspect than the pitiful Veronica, and the divergent emotions they aroused in spectators were spelled out around 1390, by the theologian Matthew of Janov:

> Nor is it without a special reason that only two portraits of Christ are famous in the church, one in Rome by the name of the Veronica, which has a gentle and friendly appearance … and one in Lucca … the Volto Santo, the face of which is terrible to behold, a commanding, majestic image. From this I conclude that the Lord Jesus, who will come a second time into the world and show himself to all, has left behind an image of his two manifestations.
>
> I can bear witness to this myself. Whenever I have seen this image, a kind of copy of the image, on a great flag in Lucca that was repeatedly raised in the air, I have always been terrified, my hair stood on end, because I thought of the coming of Christ to sit in judgment.
>
> Thus the names of the images were apt, for the facies in Rome reminds us of the face that is mild and full of mercy, while the vultus [countenance] in Lucca hints at the furor that is delineated terribly in the face. Thus the images match Christian doctrine, in that one recalls the gracious mercy and the other the rigorous justice of God.

As early as the eleventh century, William Rufus, King of England, swore by the Volto Santo; by the late twelfth century, the era of the great pilgrimages, the fame of the terrible Christ of Lucca was assured throughout Europe. Chapels were dedicated to the statue's painted image, and even to exact copies in wood, made, we may presume, by artists who looked closely at the original. One such wooden sculpture is still venerated in Amiens Cathedral, where it is the subject of a local legend: this Christ was said to have bowed one day when the relics of St Honoré were carried by. Even copies can perform miracles, and this one is recorded in stone on the south portal of the cathedral.

The subsequent history of the Volto Santo north of the Alps offers a fascinating case study of the dangers of imagery, though not quite in the sense that the iconoclasts understood them. Lead badges of the statue were brought home by pilgrims on their hats and tunics, and other equally crudely made small copies circulated widely, rather like models of the Eiffel Tower or the Leaning Tower of Pisa bought by tourists today. Now these seemed very strange to people who had never seen either the Volto Santo or a crucified Christ clothed in a long robe. They were soon taken to be figures of a woman, a fully dressed bearded woman stretched out on the cross. But why would a bearded woman be crucified? A legend was constructed to give a rational basis for this figment of pious popular imagination.

She was named differently in various places and tongues: St Wilgefortis, from the Latin *Virgo Fortis*, Strong Virgin; St Liberata, Ontcommer or Uncumber, Virgin delivered; St Kümmernis, from a German word meaning grief or pain, because she resembled Christ suffering on the Cross. She was said to have been a Portuguese princess, the daughter of a pagan king but herself secretly a Christian, and vowed to perpetual virginity. Having been betrothed by her father to the pagan king of Sicily, but not wishing to renounce her vow, she prayed to God to make her ugly and repellent to the would-be husband. In answer to her prayer, a profuse beard grew on her chin. The cruel father, infuriated, had her nailed to a cross. The puzzling skirted figure now made perfect sense, and a new virgin and martyr was born.

The cult of St Wilgefortis goes back to the fifteenth century, and seems to have originated in the Netherlands, a frequent destination of merchants from Lucca, who may unwittingly have contributed to it, by wearing badges or venerating images of their native town's Volto Santo. One of her earliest known effigies can be seen today at Westminster Abbey, in a niche of King Henry VII's chapel. She stands gravely on a column, using her cross as a lectern to support an open book. Like all the other virgin martyrs represented in the chapel, she is both educated and well born. An elegantly trimmed but very full beard adorns her chin.

The story of Wilgefortis or Uncumber reminds us of images' essential ambiguity. All images need to be decoded. When viewers lack the key to the intended meaning, it does not follow that the image will have *no* meaning for them. An interested viewer will always supply a meaning, but one that may be very far removed from the point the artist wished to make. It was to be one of the main arguments the Protestants used against having any images at all.

We long to touch what we love. There can be no doubt that part of the power of both the Mandylion and Veronica was that they were believed to be images made by physical contact with Christ: it was possible, therefore, to touch

something that had touched him. Relics of Christ were, of course, rare. Since he was resurrected, and ascended bodily to Heaven, he had left no physical remains, no bones, like those of the Three Kings, that could become the focus of a cult – and bring pilgrims and prosperity to the church and town where they were venerated. True, one part of Christ's body must have been left on earth and several places boasted of having the infant Jesus's foreskin. Yet, although the Circumcision was the first shedding of Christ's blood, prefiguring his later sufferings, this was not the kind of relic that could sustain wide and profound devotion. And the objects used in the Passion – wood from the True Cross, nails, thorns from the crown of thorns – although profoundly venerated, could hardly compete with the Veronica, which as well as being a relic showed Christ's own countenance as it appeared on the day he was crucified.

There was only one object which could match the Veronica: the linen shroud wrapped about Christ's body for his burial. And it was discovered in France in the fourteenth century. Or rather, several shrouds were discovered, but one quickly predominated and it was to achieve a new fame in our own day – after the invention of photography made it possible to enhance, and widely reproduce, the image of Christ's face and body impressed on it. We know it now as the Turin Shroud [PLATE 31]. The intensity with which it is still venerated today gives us a glimpse of the enormous power that must in the Middle Ages have attached to a likeness of Christ that was also a relic, an image made by contact with his body.

The recorded history of the shroud begins with some indignant letters written in 1389 by Pierre d'Arcis, Bishop of Troyes, to the pope, at that time resident at Avignon. The bishop accused the 'greedy clergy' of the collegiate church at Lirey of making money from a 'cunning trick': pretending to the public that a painted cloth was the actual shroud of Christ – despite its previous unmasking as a fraud, some thirty-four years before, by an earlier Bishop of Troyes, who claimed to have tracked down the artist responsible.

The shroud, Pierre d'Arcis explained, had been put back on display in 1389 with the permission of the papal nuncio, obtained through the intervention of the local lord. This lord was apparently the shroud's owner. The shroud was now referred to only as a 'picture or figure' of Christ – but it was displayed between two priests in liturgical vestments and on a platform with candles 'so that it looked more holy than the display of the Host in the Eucharist'.

When Bishop Pierre had forbidden the clergy to display the shroud, they had refused, accusing him of wanting, through jealous cupidity, to confiscate it for his own use. The bishop had gone to the civil courts and had had the shroud taken into custody. He was now asking for support from the pope. The pope's answer

31 Giuseppe Enrie, photographic negative, 1931, detail of the Turin Shroud showing Christ's face

was circumspect: the cloth, whether painted or not, deserved veneration as an image of the shroud of Christ.

In 1453 the shroud came into the possession of the Dukes of Savoy and was housed in a chapel in their capital at Chambéry, where in 1516 and again in 1532 it was damaged by fire, so that patches and a backing cloth had to be sewn on by Franciscan nuns. Promoted by the dukes, however, the shroud continued to rise in status and prestige. Pope Sixtus IV spoke of it as 'coloured with the blood of Christ'; Pope Julius II instituted a feast day of the Holy Shroud.

After the energetic Duke Emanuele Filiberto moved his capital to Turin in 1563, he naturally transferred the family's precious relic there, intending to erect a new church for its cult. In the event the shroud came to rest in 1694 in a sumptuous, geometrically complex black and gold chapel, itself the size of an ordinary church, appended to the east end of Turin Cathedral by Guarino Guarini.

On special occasions, such as Savoy family weddings, Savoy military victories or the birth of Savoy heirs, the cloth was taken out of its reliquary, unrolled, and – held by ecclesiastical dignitaries – displayed to crowds on the steps of the cathedral or on a vast outdoor stage constructed in front of the Ducal Palace. Engravings record every one of these displays, and each shows an image of the body of Christ as it might have been imprinted on a fourteen-foot-long sheet, laid on the ground underneath his body and then folded back until it covered his head: there is therefore both a frontal view of face and body, and a back view. These prints, and paintings commissioned by the shroud's owners, certainly conditioned what viewers thought they could see in the faint stains on the charred and patched cloth itself.

In 1861 Victor Emmanuel II, Duke of Savoy and – as he then was – King of Sardinia, became the monarch of a united Kingdom of Italy. The shroud remained the private property of the crown, but it was now also brought out and displayed on national occasions. At a display in 1898 King Umberto I was reluctantly persuaded to allow the shroud to be photographed. What was faint on the cloth emerged with greater clarity on the photographic negative. This was shown, back-lit in a darkened room, to members of the court and princes of the church. An aristocratic journalist broke the news to the public: 'The picture makes an indelible impression ... the long and thin face of Our Lord, the tortured body and the long thin hands are evident. They are revealed to us after centuries, nobody having seen them since the Ascension into Heaven ... I do not want to delay a minute in giving this news.'

These early photographs were superseded by ones taken in 1931 when the shroud was exhibited to celebrate the marriage of Crown Prince Umberto. And it

is on these photographic negatives, once again more easily decipherable than the positives, that the world's knowledge of the shroud is based. As Ian Wilson, the author of a monograph on the shroud published in 1978, writes: 'The face and body *are not* lifelike on the cloth itself; they *become* lifelike when their light values are reversed by a photographic negative.'

In 1983 the shroud, for so long private Savoy property, was bequeathed to the Catholic Church by the deposed last king of Italy, Umberto II. It has been subjected to scientific analysis. The cloth itself is thought by many to be of early medieval date, but the likeness itself remains profoundly mysterious. Although experts disagree – some finding traces of artists' pigments, others of blood – it has still not been established how the image on the shroud was produced.

What *is* clear is how, and to a great extent why, the shroud acquired its renown as a true image of the crucified Christ. It is not, I believe, excessively cynical to suggest that the shroud has over centuries been promoted by a combination of secular and ecclesiastical authorities, dynastic desire for divine legitimatization, civic and national pride, and the power of reproductive imagery. Yet these are by no means the whole story.

Guarini's chapel was virtually destroyed by fire in 1997 (it is being rebuilt as an exact copy). The shroud was rescued, and in 1998 was once again displayed in Turin Cathedral. I went to see it. It was saved by a heroic Turinese fireman, Mario Trematore, grandson of a Communist and himself never previously a practising Christian. A student of architecture, he felt he had rushed to the fire to save an architectural masterpiece:

'I wasn't really thinking about the shroud, it was *later* that I began to think, not about the shroud, but about those who believed in the shroud. In other words, I said to myself, I must save it for them, not for myself.' He carried out the heavy case containing the roll of cloth: 'Today they have told me it weighs about twenty-five to twenty-seven kilos, but when I was holding it in my arms, it seemed to weigh nothing at all. I felt as if I was carrying a baby.'

I asked the fireman in what way contemplation of the shroud could affect one's life and one's faith. He replied:

'That is a most interesting and most beautiful question ... I've just spent ten days down in Sarno, at the site of the avalanche [a mud slide that buried much of the town], and if you can be affected by the face of the shroud, which is the face of suffering, then once in a while you see a man and you are able to understand his suffering and help him ... That is the extraordinary gift which the shroud can give you: the ability to understand others ... The universal nature of pain in the face of others ... after that I was no longer capable of harming anyone.'

The official view of the Church in Turin was expressed to me by Monsignor Don Ghiberti, organizer of the shroud's display on this occasion, and spokesman for the Cardinal of Turin. He spoke both of what the shroud is and what it represents.

'The material aspect of the shroud is easy to describe. A winding sheet measuring four metres and thirty-seven or six centimetres in length … one metre ten, eleven centimetres wide – and this sheet is made from beautiful antique, herringbone weave linen with an image impressed on it. This image was made after the sheet, but cannot be separated from it and is far more important than the sheet itself, despite the fact that the two items present the same problems, such as the problem of dating them … Without a shadow of a doubt, this image depicts a human figure of the male sex, who died, who definitely died from the torture of crucifixion.'

Don Ghiberti then went on to describe other signs visible on the linen cloth, stains suggesting that the victim was tortured by having a crown – or helmet – of thorns forced down upon his head, and that a cut in his side was inflicted after death. These are of course details that square with the Gospel stories of the Passion of Christ.

'And this turns the image [on the shroud] into an echo of the New Testament story … The reminder of the Gospels brings us into contact with the pain of an innocent man. Why did an innocent man have to suffer so greatly? Faith suggests … Could I by chance be involved in causing such suffering? And in this way the whole range of themes running through the Christian faith unfolds: Christ's love, which knew no bounds, the sins of mankind, which were the cause of his suffering, and the fact that this suffering, accepted for love, is an invitation to us to convert.

'I believe that it is a matter of humanity, to approach a symbol such as this, which speaks to us, and then to ask ourselves: "What about suffering in the world today, which is so often the suffering of the innocent?" It becomes a starting point for a re-evaluation … of what you do and what you are in the face of this suffering that exists around us.'

The Church then still officially claims neither that the Turin Shroud is a relic, nor that it is a miraculously made likeness of Christ. But it can call us to a new or a deeper faith and a better life. To that extent, it functions like any man-made religious image.

I don't know what it was I saw when I filed past the altar and stood before the linen cloth with its scorch marks, its patches and its fearfully suggestive stains. But having spoken to Mario Trematore and Don Ghiberti, I watched the reactions

of those around me, and I was deeply moved. Whatever it may be in substance, this object draws many to a contemplation of Christ.

A weeping woman in the crowd said to me afterwards: 'I have seen my God.'

'If an image has an effect,' wrote Matthew of Janov in the fourteenth century, 'it is not because of the hand of the artist but because of the pious disposition of the beholder.'

The Turin Shroud has not been influential on Western art, because it was widely accepted as a True Likeness too late to affect the greatest inventors of Christian imagery. Indeed, those who believe in the shroud's authenticity do so largely *because* the image imprinted on it, when reproduced photographically, seems to resemble the likeness of Christ known to us through the Veronica and promulgated by famous artists of the past.

After the Veronica, perhaps no likeness of Christ has been given greater or wider currency than Leonardo da Vinci's *Last Supper* painted in the refectory of the Dominican convent in Milan [PLATE 32].

Leonardo had offered his services to Ludovico Sforza, Duke of Milan, as a civil engineer, a designer of lethal machines of war, of amusing mechanical toys, above all as a sculptor who could construct an equestrian statue commemorating the duke's father – and, almost incidentally – as a painter. (The letter from Leonardo enumerating these many skills may be a forgery, but its burden must, in essence, be true.) The Duke put Leonardo to work on the mighty Sforza Horse, as it was called, but he also commissioned him to paint a mural for the Dominican friars under his patronage. Their church was Santa Maria delle Grazie, which Ludovico conceived as a Sforza mausoleum; several of the family's tombs were already there.

The tradition of painting the Last Supper on the end walls of conventual refectories was already well established in Florence. As early as the mid-fourteenth century, Taddeo Gaddi had represented the scene for the Franciscans at Santa Croce – and he had made Christ and the disciples seem alive, sharing, as it were assisting in the friars' every meal.

Leonardo brought this Florentine convention to Milan. In 1498, after four years' work, he completed the great mural. Since then it has been copied and reproduced so many times that we feel we have known it for ever. Most of us – from whichever Christian tradition we may come, or none – if we think of the Last Supper, we think of this.

Fifty years after it was made, the painting was already described as half-ruined, and it has subsequently been much damaged – by damp, and worse – and often restored. Yet when the latest restoration was unveiled in 1999, all hell broke

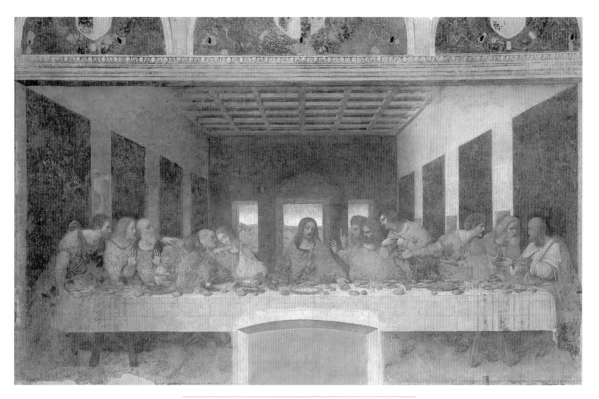

32 LEONARDO DA VINCI *The Last Supper, c.* 1495–8

loose, and the admirably scrupulous restorer in charge was vilified in much of the world's press.

Why?

Critics of the restoration alleged that Leonardo's masterpiece had been seriously compromised. Yet more of Leonardo's original paint is now visible than for many centuries: details of the still-life on the table, for example, with their subtle play of reflection and shadow, and the luminous landscape of the background.

Among the wilder accusations, fears were expressed that the face of Christ had been altered. Happily, these proved to be groundless, but it is nevertheless true that the removal of later retouchings (added, of course, long after Leonardo's death) has somewhat changed Christ's appearance. This, I believe, is what caused the furore: more than any other representation of the Last Supper, it is Leonardo's that has long come to seem an authentic re-creation of the event – and a truthful record of Christ himself. Like the greatest portraits, it appears both to be historically true and to transcend time. And restorers' alterations to this image are distressing, for they remind us of its physical fragility, of its origins in the work of merely human hands busied with paints and brushes.

In a single image, Leonardo simultaneously captures the momentary human drama of Christ's imminent betrayal and the timeless divine significance of the institution of the Eucharist. Jesus has just told his disciples that one of them will betray him. 'And they were exceeding sorrowful, and began every one of them to say unto him, Lord, is it I?' (Matthew 26:22). Each disciple reacts differently, according to his temperament. On Christ's right Judas, clutching the money-bag, recoils into shadow. His hand reaches out for the traitor's sop, as Christ's hand extends towards him in blessing. The human event is played out horizontally, the disciples grouped in threes on either side of Christ. His isolated figure is at once the source of their distress and the focus of their concern.

But if Christ is at the heart of this human turmoil, he is also literally shown in another dimension. The 'upper room' taken for the Passover meal is made to extend far back in space behind the figures – so far, in fact, that the receding parallel lines of ceiling beams and tapestry edges seem about to meet in the distance like railway tracks on the horizon. And at this point of convergence is the head of Christ, doubly the focus of our gaze. Indeed, since in this kind of perspective the vanishing point is always directly related to the viewer's eye, we seem to gaze at Christ as we are told we shall one day see him: face to face.

Christ's right hand is extended to bless, while his left hand is opened in acceptance. The will of his Father must be done, and he will be crucified on a hill outside the city, like the hills we see through the windows behind him. Himself the

Passover sacrifice, he gestures to both bread and wine: this is my body, this is my blood of the new covenant. Leonardo's Christ is also the Christ of the Eucharist.

He is eating with us. He is familiar to us. This is the Christ whose features we have come to know, and the familiarity of such an agreed likeness of Christ, its physical omnipresence, is its greatest strength. It brings us uniquely close to the incarnate God, and it allows a remarkably deep, utterly personal engagement between viewer and Saviour.

The Franciscan innovation of the Christmas crib led artists, as we have seen, to contemplate the mystery of the Incarnation; Rembrandt and Georges de La Tour – among innumerable others – painted their own contemporaries in wonder and adoration before the Christ Child. Human sinfulness causes, aggravates and prolongs Christ's pains, and his agony is emblematic of universal suffering: this makes it proper to represent the Crucifixion taking place at all times and everywhere. Leonardo's distillation of the tradition of the True Likeness in *The Last Supper* enabled artists to show Christ in other contexts, with some certainty that he would be recognized. It particularly freed them to depict the contemporary relevance of his teachings, by placing him in settings where his presence would startle us into attention. Two examples from the nineteenth century will make the point.

The Scottish painter William Dyce was an older contemporary of Holman Hunt and an influential supporter of the Pre-Raphaelite Brotherhood which Hunt helped to found. A devout and active High Church Anglican, he came under the influence in Rome of a group of idealistic Austrian and German artists, derisively called 'the Nazarenes' (like Jesus of Nazareth) because of their affectation of biblical dress and hairstyles. Influenced both by late medieval German art and the early Italian Renaissance, they aimed to revive the working methods and spiritual sincerity of the Middle Ages, in the belief that art should serve a religious and moral purpose.

In addition to practising as a painter, designer – and that new-fangled Victorian personage, as an art educator and arts administrator – Dyce, whose father had been a lecturer in medicine, was a keen amateur scientist. The new scientific disciplines, Tennyson's 'Terrible Muses', seemed to the Victorians to threaten the authority of the Bible. Dyce's painting of Christ as *The Man of Sorrows* [PLATE 33] was exhibited in 1860, a year after the publication of Darwin's *Origin of Species*, but it alludes rather to contemporary studies in geology: the dating of rock formations and fossils made a literal reading of the creation of the world in seven days unsustainable, just as much as did Darwin's theories of evolution.

33 WILLIAM DYCE *The Man of Sorrows*, 1860

34 JEAN BÉRAUD *Christ in the House of the Pharisee*, 1891

The 'Man of Sorrows' of Dyce's title was the normal way of referring to a medieval devotional image, made to stimulate meditation on the sufferings of Christ. He is usually shown standing in an open tomb, or sitting on its edge, wearing the crown of thorns and displaying the wounds in his hands and side.

But there is nothing medieval about Dyce's Christ, who is closer to Leonardo's familiar image in dress as well as in facial resemblance. He sits, terribly alone, in a rocky waste. One of the startling achievements of the 'True Likeness' is that we can recognize Christ anywhere, even if we come across him in the Highlands of Scotland. A poem by Dyce's friend John Keble was inscribed on the frame, and printed in the exhibition catalogue:

> As, *when upon His drooping head*
> *His Father's light was pour'd from heaven,*
> *What time, unsheltered and unfed,*
> *Far in the wild His steps were driven,*
> *High thoughts were with Him in that hour,*
> *Untold, unspeakable on earth.*

As Keble indicates, the painting was inspired by the Gospel story of Christ's fast of forty days and forty nights in the wilderness, and his temptation there by the devil :

> *And when the tempter came to him, he said, If thou be the Son of God,*
> *command that these stones be made bread.*
> *But he answered and said, It is written, Man shall not live by bread*
> *alone, but by every word that proceedeth out of the mouth of God.*
> MATTHEW 4:3–4

Dyce, painting rocks and stones as if for a geological handbook, is not preaching the return to a word-for-word reading of scripture. The rocky waste in which Christ grieves stands for the stony hardness of the world, where God's word, Christ's message of unbounded love, goes unheard. It is also a minutely detailed description of a desolate moor near Dyce's native Aberdeen. The realism of the face and the landscape makes a powerful point: it is not *the* world that is inhospitable to Christ's charity, it is *our* world.

While Dyce's portrayal of Christ in mid-nineteenth-century Scotland produces, to my mind, an evocative and moving Christian image, such transplantations are a high-risk strategy. Jean Béraud's *Christ in the House of the Pharisee*

[PLATE 34] relocated to high bourgeois Paris, is a case in point.

The story is told in St Luke's Gospel:

And one of the Pharisees desired him that he would eat with him. And he went into the Pharisee's house, and sat down to meat.

And, behold, a woman in the city, which was a sinner, when she knew that Jesus sat at meat in the Pharisee's house, brought an alabaster box of ointment.

And stood at his feet behind him weeping, and began to wash his feet with tears, and did wipe them with the hairs of her head, and kissed his feet, and anointed them with the ointment.

Now when the Pharisee which had bidden him saw it, he spake within himself, saying, This man, if he were a prophet, would have known who and what manner of woman this is that toucheth him: for she is a sinner.

And Jesus answering said unto him, Simon, I have something to say unto thee. And he saith, Master, say on.

There was a certain creditor which had two debtors: the one owed five hundred pence, and the other fifty.

And when they had nothing to pay, he frankly forgave them both. Tell me therefore, which of them will love him most?

Simon answered and said, I suppose that he, to whom he forgave most. And he said unto him, Thou hast rightly judged.

And he turned to the woman, and said unto Simon, Seest thou this woman? I entered into thine house, thou gavest me no water for my feet: but she hath washed my feet with tears, and wiped them with the hairs of her head.

Thou gavest me no kiss: but this woman since the time I came in hath not ceased to kiss my feet.

My head with oil thou didst not anoint: but this woman hath anointed my feet with ointment.

Wherefore I say unto thee, Her sins, which are many, are forgiven; for she loved much: but to whom little is forgiven, the same loveth little.

And he said unto her, Thy sins are forgiven.

And they that sat at meat with him began to say within themselves, Who is this that forgiveth sins also?

And he said to the woman, Thy faith hath saved thee; go in peace.

LUKE 7:36–50

Part of the poignancy of this story derives from the fact that the penitent woman's anointing of Christ's feet is meant to prefigure the anointing of his dead body for burial. That is why tradition conflated this nameless sinner with Mary Magdalene, who witnessed the Crucifixion, assisted at Christ's Entombment, came 'the first day of the week early' only to find the tomb empty, and was the first person to see him when he rose from the dead. Funereal though Béraud's colour scheme appears – dictated by the conventions of smart modern evening dress – it is difficult to recall this here.

It is indeed difficult to avoid asking oneself foolish questions such as, why is Christ wearing a nightgown to dine with these smug businessmen and politicians? How did the elegant *demi-mondaine* get into this house, so obviously well furnished with butlers and footmen, when the dinner was for men only? Is she the mistress of one or more of them? Less foolishly – who are we meant to identify with?

Béraud presumably meant his viewers to identify with the Pharisees – for no nineteenth-century male or respectable female could possibly identify with the sinful woman – but what is the moral they are meant to draw? And if we identify with none of them, what moral are *we* meant to take to heart?

What is this picture *for*, exactly? Béraud brings Christ into the contemporary world, and in part because of the True Likeness we recognize him. But the Gospel message of redemptive love and forgiveness is opaque. What works for the desolate figure of Christ alone in the wilderness, even a plainly Scottish wilderness, seems not to work here.

While there were nineteenth-century artists other than Dyce who could make it work – choosing, with better judgment than Béraud, symbolic scenes that brought Christ into the homes of the poor, or among those oppressed by tyranny – the device fell into disrepute. To paint stories from the earthly life of Christ, showing him as the familiar recognizable figure with long hair and beard, in biblical dress among people realistically depicted in modern fashions in a modern setting, became unthinkable for most serious artists. It was to be revived again in the mid-twentieth century: Stanley Spencer, for one, renewed archaic forms in a modern key – but it remains a rare and eccentric choice.

Twentieth-century figurative artists generally favour other ways of bringing us face to face with Christ. One of these – to find him in the suffering of our contemporaries, as was suggested by those close to the Turin Shroud – we will consider more fully in Chapter Eleven.

An alternative is to reject the traditional, familiar likeness, to accept that we cannot know what the historic Christ looked like and come to the problem fresh. But the weight of tradition is not so easily discarded.

35 (OPPOSITE) MARK WALLINGER *Ecce Homo*, 1999

Mark Wallinger's *Ecce Homo* was installed in July 1999 on a plinth in the north-west corner of Trafalgar Square [PLATE 35], across the street from the National Gallery. The plinth, nearly fifteen feet high on the street side and twenty-four feet high when viewed from the sunken square, was originally intended for William IV, who died without leaving funds for the provision of his statue; it has been empty since the square was opened in 1843. The other three plinths bear over-life-size statues of George IV and two Victorian military heroes of the British Raj, Sir Henry Havelock and General Sir Charles James Napier. In the centre of the square, of course, Nelson's giant effigy stares from his column with his one seeing eye.

Wallinger's statue is the first of three new works to be displayed on the plinth for a brief period. It was chosen to be shown over the turn of the millennium, to mark – whatever the historical fact, and however we compute it – the two thousandth anniversary of the birth of Christ.

Ecce Homo, Latin for 'Behold the man', are words spoken by Pontius Pilate after the crowd votes to free Barabbas the robber:

> *Then Pilate therefore took Jesus, and scourged him.*
> *And the soldiers platted a crown of thorns, and put it on his head, and they put on him a purple robe.*
> *And said, Hail, King of the Jews! and they smote him with their hands.*
> *Pilate therefore went forth again, and saith unto them, Behold, I bring him forth to you, that ye may know that I find no fault in him.*
> *Then came Jesus forth, wearing the crown of thorns, and the purple robe. And Pilate saith unto them, Behold the man!*
> *When the chief priests therefore and officers saw him, they cried out, saying, Crucify him, crucify him.*
> JOHN 19:1–6

The title is applied to images of Christ shown to the people, and it implies that the viewer is one of those that see and condemn him: Crucify him, crucify him! As a theme in art it was hardly known before the fifteenth century, and it became popular all over Europe only later. Artists treated it in two quite distinct ways: as a devotional image where Christ appears alone, or as a narrative depiction of the whole scene – but the message is always the same: Behold the man!

Wallinger's *Ecce Homo* is not a conventional sculpture: it is a cast, in synthetic resin mixed with white marble dust, of the whole body of a clean-shaven

former art student employed in the casting workshop. That makes the figure, by definition, life-size. The young man wore a rubber bathing cap during the casting, so this Christ seems to be bald as well as beardless. He had to keep his eyes shut. According to one journalist, 'the sculpture's enigmatic … expression is … a matter of the model's stoical endurance during the lengthy casting process'. The figure's hands are tied behind its back. There is no mock-royal robe, only a loincloth cast from a towel around the naked body. A crown of gold-plated barbed wire encircles the head.

Standing at the very edge of the plinth, facing across Trafalgar Square, the statue is dwarfed by the triumphal overscale sculptures, monarchs and heroes of empire who are its neighbours. Cars and buses judder by; ice cream and hot dogs are sold, pigeons fed; and the passers-by and tourists who notice the small, frail-looking figure above them can hardly believe their eyes.

This is a figure of the historic Christ – not a Christ perceived in the victim of some contemporary disaster – but it is at the same time the figure of an anonymous, an ordinary young man. His face is not a True Likeness; it owes nothing to the Mandylion, the Veronica or to Leonardo. Yet if Christ were a prisoner led to his execution today, might he not look like this? Behold the man!

Reactions have been mixed. 'Profoundly moving,' said the Bishop of London, and the Catholic Bishop of Westminster was also moved by 'his very human scale among all this grandeur'. Two young students decided it was 'the best thing that has happened in art'.

Others were less sure. 'If that's Jesus Christ, it's a bloody miracle,' a man is reported to have said (they seem to have interviewed no women). 'You couldn't put your faith in someone like that, he's as weak as a kitten.' 'You can't have a Christ figure like this,' said another. 'Where is his robe? Where is his beard? Where is his cross?' An ice cream seller pointed out, 'He doesn't have long hair.'

We all still know what Christ looks like.

Mark Wallinger is quoted in the press release issued when the statue was installed: 'Whether or not we regard Jesus as a deity, he was at the very least a political leader of an oppressed people. The sculpture alludes to the recent historical past and its sad record of religious and racial intolerance.'

There is a Christ for every age.

But the *Ecce Homo* in Trafalgar Square reminds us also that in every age we, like the crowd that stood in the square in Jerusalem, must make our choice between Barabbas and Christ.

PART THREE

THE
SUFFERING
GOD

But he was wounded for our transgressions,
he was bruised for our iniquities:
the chastisement of our peace was upon him;
and with his stripes we are healed.

ISAIAH 53:5

FROM VICTORY TO ATONEMENT

Images of Christ and his Cross are among the most familiar of European civilization; we see them everywhere. In the streets of a Spanish Catholic city like Seville, we walk past them almost without noticing – 'Another crucifix.' But it can never be just that. The Crucifixion is a theme too rich and too deep to become commonplace, and every religious image is an attempt by the artist to engage us at the deepest level, an invitation to meditate on the universal significance of a particular aspect of belief.

Addressing the questions raised by the Protestant Reformation, the Catholic Church, in the middle of the sixteenth century, considered how art could more powerfully be deployed to strengthen faith. The Council of Trent, which sat from 1545 to 1563, recommended that artists follow the biblical texts more closely, and reduce the number of figures that might distract the viewer's attention. Partly in response to this, painters tended less often to paint crowded panoramic Crucifixion scenes, concentrating instead on the lone crucifix. Christ on the Cross in isolation seemed to provide a surer basis for meditation by the viewer. And, I must confess, so it proved for me, when I stood for a long time in front of a large seventeenth-century canvas in Seville, by one of the city's greatest artists, Francisco de Zurbarán [PLATE 36].

In brilliant light and in a void of darkness, Christ is alone on the Cross. He is still alive: there is no wound in the side; he lifts his head; his lips are open; he is clearly speaking. Can we guess what he might be saying?

Now the Gospels tell us that Christ spoke seven times from the Cross, but I believe Zurbarán has illustrated only one of these. Christ is not looking down, so he cannot be commending his mother to St John (John 19:25–7). Nor is it likely he is saying, 'I thirst', to the others at the foot of the Cross (John 19:28). He is not looking to one side, so he is surely not telling the trusting thief that they will soon be together in Paradise (Luke 23:40–43).

His eyes are turned upwards; he is speaking to his father in heaven. What is he saying? Is it the despairing cry reported by Mark (15:34) and Matthew (27:46),

'My God, my God, why has thou forsaken me?' or the more tranquil, 'Into thy hands I commend my spirit', that Luke gives us (23:46)?

I think it is none of these. These are words spoken in anguish and near the end. But here the beautiful body shows as yet few signs of physical distress. The agony of crucifixion seems to be only beginning. And Zurbarán is surely showing us the first of all the words from the Cross: 'Father forgive them, for they know not what they do' (Luke 23:34). Christ is praying – for us.

Pain makes most of us selfish – releasing us, we like to think, from any wider obligations – but not here. In the throes of his agony, this man achieves the divine. He intercedes for the salvation of others.

And this, I think, is the point of the picture. The artist has contrived that we seem to stand at the foot of the Cross, closest to the brutally nailed feet, looking up at the body in pain, and we witness the very act of redemption, when Christ's suffering is most clearly revealed as a supreme gesture of love for us.

Crucifixes may seem commonplace – but when we stop to look closely at any one of them, particularly one by an artist as great as Zurbarán, we are drawn to the central mystery of the Christian faith: Christ as Sacrifice and Saviour.

The Church's endless pondering on this theme endowed European art with an enduring vocabulary of sacrifice and redemption. For hundreds of years it was possible to investigate all human distress through the figure of the dying Saviour. Even when, in the recent past, the redemptive power of suffering *per se* was questioned, the image of Christ crucified could still speak, even to non-believers, of selfless, self-sacrificing love:

> *One ever hangs where shelled roads part,*
> *In this war He too lost a limb,*
> *But His disciples hide apart;*
> *And now the Soldiers bear with Him.*
>
> *Near Golgotha strolls many a priest,*
> *And in their faces there is pride*
> *That they were flesh-marked by the Beast*
> *By whom the gentle Christ's denied.*
>
> *The scribes on all the people shove*
> *And bawl allegiance to the state,*
> *But they who love the greater love*
> *Lay down their life; they do not hate.*

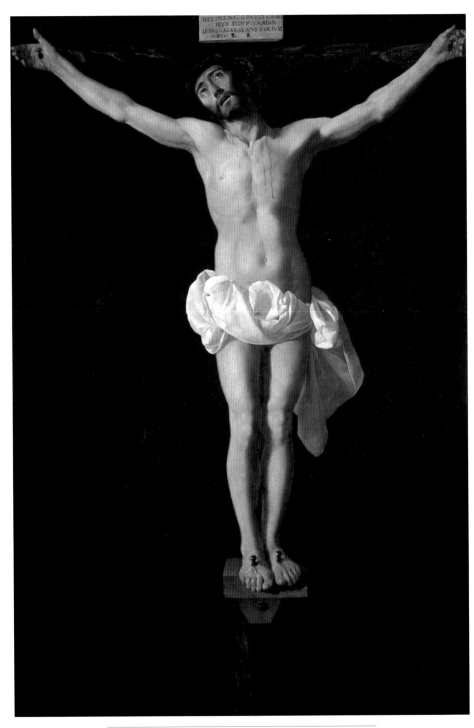

36 FRANCISCO DE ZURBARÁN *Christ on the Cross, c.* 1632–4

Wilfred Owen's famous and subversive First World War poem, *At a Calvary near the Ancre*, was inspired by one of the many crucifixes that still stand at crossroads in Belgium and northern France. They were particularly striking to the British troops, since nothing like them could be seen on the rural roads they knew, back home in a Protestant country. But there was another, grimmer, reason why the image of crucifixion made such an impact on British soldiers. The penalty for petty infractions by Other Ranks was 'Field Punishment No.1'. This consisted of being tied spread-eagled to some immobilized object, like a large spoked wheel. 'Wouldn't the army do well,' it was asked, 'to avoid punishments which remind men of the Crucifixion?' The soldier's humiliation was disconcertingly close to Christ's.

The crucifix in Owen's poem has been mutilated by artillery fire. Christ's frightened disciples have forsaken him, but soldiers bear the Cross, suffer and die in the trenches and on the battlefields. The priests commissioned as officers to minister to them escape with flesh wounds – superficial wounds that are also the deeper sign of a pact with the devil: supporting the war against Germany and, with the established Church, with the State teaching and urging hatred. One of Owen's letters, written on 2 May 1917, makes even clearer the message of the last two stanzas:

> Already I have comprehended a light which will never filter into the dogma of any national church: namely, that one of Christ's essential commands was, Passivity at any price! Suffer dishonour and disgrace, but never resort to arms. Be bullied, be outraged, be killed; but do not kill …
> Christ is literally in no man's land. There men often hear his voice. Greater love hath no man than this, that a man lay down his life – for a friend.
> Is it spoken in English only and French? I do not believe so.

The bare crosses which mark the graves of the dead soldiers fallen in Flanders fields were set there as emblems of faith in Christ's promise in the Resurrection of the flesh. Yet by most people, believers and unbelievers, they are now more often construed as reminders of political injustice and ineptitude. Their ordered ranks still speak to us of suffering endured and of the futile slaughter of both sides. The dead of France and Germany alike are marked by a simple cross, eloquent of desolation and loss, of what Siegfried Sassoon called

> The unreturning army that was youth;
> The legions who have suffered and are dust.

Yet even a symbol as elementary as a bare cross has shifted its meaning through the centuries. The tragic way in which most of us now read these crosses is by no means the only way.

In Christ's own time, crucifixion had been the most painful and ignominious form of execution, reserved for rebellious slaves and criminals. The painters of the catacombs did not picture Christ crucified. When the Cross does appear alone, it is not as an apparatus of torture but transformed, usually into the shape of an anchor, symbol of hope. In the years after 500 Christianity had for nearly two centuries been the state religion of the Roman empire, and the old significance of the Cross had been largely superseded. In imperial Ravenna, as we have seen, the instrument of Christ's redemptive death stands alone less as the emblem of his suffering than as the glorious sign of his victory over death [PLATE 37]. The dome mosaics of the Arian Baptistery show the Cross enthroned on a cushioned imperial throne – the heavenly throne that seats a God who cannot be represented, but also the empty throne that awaits the Second Coming, the return of Christ in glory to judge the quick and the dead.

In the early centuries the Church seems rarely, if ever, to have asked artists to focus on the suffering of Christ. In the narrative mosaic cycle of Sant' Apollinare Nuovo in Ravenna, what strikes the modern eye is the utterly dispassionate nature of the Passion. While Pilate washes his hands, Christ stands calmly before him, condemned to death yet visibly more in command of the situation than the cowardly Roman governor. Even in *The Road to Calvary*, where later centuries were to picture extremes of suffering and humiliation, this sixth-century Christ shows no sign of having been mocked and scourged, no trace of the crown of thorns, no exhaustion of body or spirit [PLATE 38]. Like a king he moves forwards with dignity, while the Cross, far too light and slender for anybody to be nailed to, is carried for him – with little apparent effort, in fact with just one hand – by a Simon who could almost be his page: it is indeed more like a royal emblem than a badge of shame and an instrument of torture. Astonishingly to our eyes, in this Passion narrative, the Crucifixion itself is not even represented; the story moves directly from the Road to Calvary to the scene of the women coming to Christ's empty tomb.

On the rare occasions when the early Church did represent Christ on the Cross, it was not to dwell on his suffering. The earliest known depiction of the Crucifixion within the story of Christ's Passion is a tiny ivory relief [PLATE 39], one of four made in Rome about 420 as part of a precious casket.

On the first plaque, Christ carries the Cross while Pilate washes his hands. Immediately to the right is the scene of Peter's denial, when the maidservant

accuses him of being one of Jesus's followers (Matthew 26:69–75; Mark 14:66–72; Luke 22:54–62; John 18:25–7). Above Peter's head the cock crows, fulfilling Christ's prediction, 'That this day, even in this night, before the cock crow twice, thou shalt deny me thrice' (Mark 14:30).

It is the second carving that shows Christ crucified. But the carver has shown him standing upright on the Cross, eyes open, body unmarked by suffering: a victor over death. Mary and John are on his right, while to the left the centurion, arm raised in wonder, acknowledges him: 'Truly this man was the Son of God' (Mark 15:39). The Cross even at this moment of darkness is the Tree of Life, in stark contrast to the tree on which Judas, who betrayed Christ for thirty pieces of silver, has hanged himself in despair. The coins spill out from a sack at his feet. Denial of Christ as the Son of God has brought about Judas's death, but even here, the artist has added a beautiful note of hope: in the branch that reaches out to the Cross, and symbolizing its life-giving power, a bird lovingly feeds her young. The contrast between the left and right sides of the plaque are carefully judged and deftly realized.

On the third plaque we see Christ's empty tomb. We shall return to this scene in Chapter Ten.

Christ's Resurrection in the flesh is attested on the fourth plaque, where he appears miraculously amid the Apostles. It is not entirely clear what scene is being represented: either Thomas, doubting, is being urged to thrust his hand into Christ's side (John 20:25–9), or Christ is instructing the Apostles to go and preach and baptize throughout the world (Matthew 28:16–20).

The little ivory box recalls the faithful to their obligation to witness and to proclaim Christ's victory over death. Those who betray that obligation are lost, but those who give their allegiance can be confident of being saved. The carver of the ivory box, like the painters in the catacombs and the mosaicists at Ravenna, saw his job as reinforcing that confidence by helping us to believe. We cannot thrust our hand into Christ's side with Thomas, but, even in moments of doubt, we can see Thomas doing so. And we can preach our own faith. These images are visible proof that Christ is God. And nowhere is that message clearer than in this scene of the *Crucifixion*, where the Saviour's life-giving Cross confronts Judas's lethal tree.

While the fifth-century ivory *Crucifixion* is about demonstrating victory and urging us to witness, Zurbarán's painting over a thousand years later seeks instead to evoke our pity and gratitude [PLATE 36]. The symbol is effectively the same, but its meaning is much changed. Salvation is not merely the consequence of Christ's divine nature, shared with God the Father; it has been achieved through his

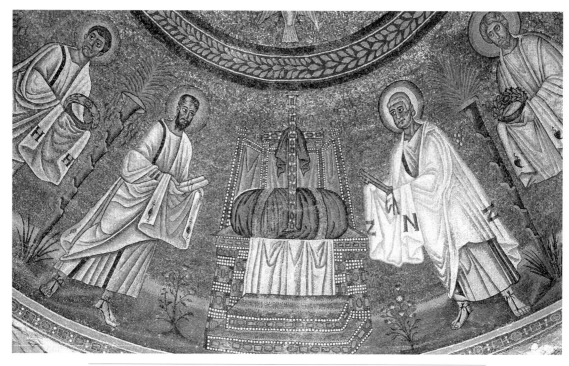

37 Detail of PLATE 25, showing *The Empty Throne*, Arian Baptistery, Ravenna, 493–526

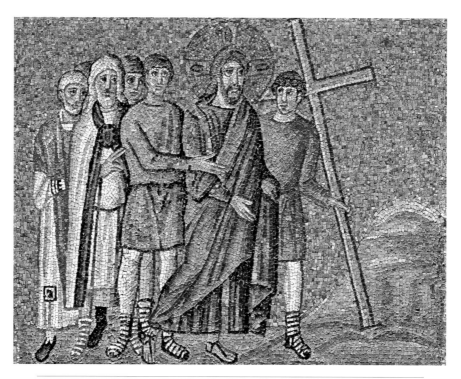

38 *The Road to Calvary*, mosaic, Sant'Apollinare Nuovo, Ravenna, early sixth century

39 *Scenes from Christ's Passion*, ivory plaques, 420–30

suffering which we behold. And by 1918 the crucified Christ had become an image of all men's suffering, of selfless love and grief. How did this revolution in theology come about?

The monks who in the cloister redirected devotion from Adoration to Nativity, from the Child King to the Child born to die, proposed a whole new vision of man's relationship to God. God the Father is all-powerful, yet wills his only Son to atone for our sins through his suffering. Crudely put, we are saved less by the power of God than by the weakness of Christ. It is Christ's willingness to be weak for our sake and his acceptance of suffering that save us. When the monks' disciple, Brother Francis of Assisi, decided to follow in Christ's footsteps, he allied himself with society's weak and despised. And when Francis's followers spoke of the saint's resemblance to Christ, they cited his humility, his child-like innocence, his physical privations and sufferings, and the stigmata – the five wounds of Christ – imprinted on his body and discovered after his early death.

Once the notion of salvation had been refocused in this way from the intervention of God the Father to the physical suffering of the Son, the art of Western Christendom changed dramatically. As we saw in the imagery of Christ's birth and infancy, it now often depicted the horror of the Incarnation as much as its miraculous aspect. Yet along with the horror it set out also to evoke love, that boundless love the Incarnation signifies and requires: God's love and our own.

A newly reunited diptych – two panels hinged to open and close like a book – now at the National Gallery in London makes the point [PLATE 40]. It was painted a little before 1300 by an unknown master probably working in Umbria – St Francis's native region, where he found his earliest and most fervent disciples. A small diptych like this could function somewhat like an altar, a book, or a pair of photographs framed together: as the portable focus of private worship, perhaps while travelling; or as an object from which to draw information and food for thought; to remind us of those we love.

This diptych is the earliest known example of a type that, under Franciscan influence, was to become extremely popular. The left-hand panel shows the *Virgin and Child*. The image of Christ on the right represents *The Man of Sorrows*. While angels mourn, we see the dead Christ in front of the Cross, his head inclined towards the Mother and Child. When the diptych was closed, or opened part-way to stand on a supporting surface, the two images faced each other.

I have learnt from John Drury – priest, scholar and inspired viewer of Christian art – to ask, what *is* the hinge between the two panels of a diptych? One answer, here, must surely be the Incarnation. These are the two forms in which God became man. The loving and beloved child is the mirror image of the

wounded man; the man's tortured body reflects the child's tenderness. As the mother embraces the child, she foresees her embrace of his dead body. Her joy in the one is exactly matched by the sorrow evoked by the other, and the emotions are not contradictory: who does not love cannot grieve, and it was for love that this man suffered. The two panels are like the alpha and omega of the Greek alphabet, the first and last letters between which early Christians inscribed the monogram of Christ (see p. 68; PLATE 19).

The right-hand panel does not show Jesus Christ on the Cross: its image is that of the famous vision of the dead Christ that appeared to St Gregory on the altar as he was celebrating Mass. St Francis, in a different vision, saw the flesh-and-blood infant Christ in the Host of the Eucharist; on another occasion, a woman in the congregation fainted when he took communion, for he seemed to be eating a live baby. The diptych does not record some past moment of history, any more than framed studio photographs of our loved ones do. The artist is showing us, through the lens of the new theology, the Christ who is always among us, in need of our protection as a baby, dying for us as a man. It is, in every sense, a vision of God.

Atonement means to pay a debt. In the new theology that Francis inherited, and taught to the whole of Europe, our debt of sin is paid through Christ's sufferings, and as the number and scale of our wrongdoings grow, so, necessarily, do his sufferings.

The artist now has the task of showing the direct link between our sin and Christ's pain, reminding us that if Christ is on the Cross, it is our fault. How can so complex an idea be made visible?

A life-size crucifix now hangs above the altar in a chapel in Seville Cathedral [PLATE 43]. Carved by Juan Martínez Montañés, an older contemporary of Zurbarán, and possibly Spain's greatest sculptor, it is a delicate conflation of Flemish realism with Italianate idealization, entirely characteristic of the artist. Christ's slender body remains beautiful in agony; the loincloth, tied in a looped knot inherited from Gothic art, gathers gracefully about the figure. Velázquez's teacher, the Sevillian painter Francisco Pacheco, boasted in his treatise *El Arte de la Pintura*, published in 1649, that he painted the sculpture in matt colours – which he claimed to have been the first to use – to make it seem more natural, warming the pallor of the skin, marked with trickles of blood.

Christ's head, crowned with thorns, falls to one side, and from the entrance to the chapel he appears to be dead. Yet he is not; the sculptor precisely followed his patron's instructions, and we, luckily, still have the contract recording them.

The crucifix, known as the *Christ of Clemency*, was commissioned on
5 April 1603, by Mateo Vázquez de Leca, Archdeacon of Carmona Cathedral. In
spite of being in holy orders, he had led a dissolute life until his sudden conver-
sion on the feast of Corpus Christi 1602. At dusk on that day, a woman wrapped
in a cloak is said to have approached him and beckoned him to follow her.
Hoping for a conquest, he asked her to uncover her face. She loosened her cloak
and revealed – a skeleton.

Vázquez de Leca stipulated that the crucified Christ was

> *to be alive, before He had died, with the head inclined towards the
> right side, looking to any person who might be praying at the foot of
> the crucifix, as if Christ Himself were speaking to him and reproaching
> him because what He is suffering is for the person who is praying; and
> therefore the eyes and the face must have a rather severe expression,
> and the eyes must be completely open.*

Montañés was inspired by the commission. He says in the contract: 'I have a great
desire to complete and make a work like this to remain in Spain and not be taken
to the Indies [South America] nor to any other country, to the renown of the
master who made it for the glory of God.' The crucifix was placed in Vázquez de
Leca's private chapel. We can easily imagine him praying at its feet, looking up at
Christ's 'rather severe expression', at the eyes whose dark pupils Pacheco picked
out with highlights. Standing there today, we do indeed seem to see Christ look-
ing down and reproaching us. We can almost hear the Reproaches still used every
Good Friday in the Roman liturgy, in which Christ recounts God's blessings on
his people, and how they have repaid good with evil:

> *O my people,*
> *What have I done unto thee?*
> *And wherein have I wearied thee?*
> *Answer me ...*
>
> *I crowned you with a royal sceptre,*
> *Yet you plaited a crown of thorns ...*
>
> *I gave you an arm of strength,*
> *Yet you dealt me a cross of shame ...*

The *Christ of Clemency* speaks powerfully, even today. The contract makes it plain that the sculptor considered it as a work of both art and devotion. And for the patron who commissioned it, its value as a work of art resided above all in its ability to communicate directly with him, and to bring him in to dialogue with Christ himself.

Montañés's Christ reminds us gently of our role in his pain. But there were tougher, much tougher, ways of making the same point, and they were favoured especially by artists in Northern Europe. Less influenced than Italians by ancient Roman sculpture that equated divinity with bodily beauty, Northern artists had no qualms in picturing a Christ disfigured by suffering, the 'man of sorrows', that 'righteous servant' who 'hath no form nor comeliness' of Isaiah's prophecy (Isaiah 53).

Between 1510 and 1516 the enigmatic German master Mathis, now called Grünewald, painted a large and complex folding altarpiece for the Antonine canons of Isenheim, a small locality in Alsace. The altarpiece, saved from destruction but dismembered when religious orders were suppressed during the French Revolution, is now in the Musée des Beaux-Arts at Colmar, and one of its panels shows perhaps the most terrifying Crucifixion in Western art [PLATE 41].

Other than his paintings, we have no contemporary record of Master Mathis, but we know a great deal about the Antonines who commissioned him. The Order's patron saint was Antony Abbot, a legendary fourth-century hermit who retired in penance to the Egyptian desert. There, like any holy hermit, he was assailed by lurid temptations – but also by demons who, taking the shape of wild animals, painfully clawed and tore his flesh. By association, the relics of St Antony, brought around 1083 from Constantinople to France, were thought to have effected miracles in curing diseases that attacked the skin, and it was to care for the victims of these that first a confraternity of laymen, then, in 1202, the religious Order of the Antonines, were constituted.

The Antonines sheltered pilgrims; they nursed lepers and victims of the plague, but above all they specialized in the treatment of St Antony's Fire. This was the name given both to erysipelas, a streptococcal inflammation of the skin, and to the more dreadful and often fatal ergotism, caused – as we now know – by a fungus that attacks rye, the staple cereal of Northern Europe. In times of famine, mouldy rye would be milled into flour along with the healthy grain, contaminating the bread eaten by an already weakened population. The result was recurring epidemics, in which the skin of those affected itched and burned, then turned black and gangrenous until limbs were literally detached from the body. All this was naturally accompanied by excruciating pain, and frequently by hallucinations.

40 (ABOVE AND OPPOSITE) Unknown Umbrian Master *The Virgin and Child* and *The Man of Sorrows, c.* 1260

The regime in Antonine hospitals consisted in feeding the sick, administering anaesthetic salves and potions – the statutes of the Order mention a 'holy vinegar' in which the saint's relics were dipped – and, in extreme cases, amputating gangrenous limbs. But the patients were also comforted and consoled through prayer. Those who could be were led into the church, before the altar in the choir – not in expectation of a miracle, but to help them come to terms with their suffering and prepare themselves for possibly imminent death.

It is for these purposes that the Isenheim Antonines, enriched by many donations, commissioned a monumental and extremely complex altarpiece, part sculpted and part painted, for their church.

The elaborate ways in which this altarpiece originally functioned can be reconstructed from its parts, now mounted separately in new frames. The central portion was hinged left and right, and supported by a base or predella. Two sets of wings or shutters, each painted on both sides, were hung on the hinges, so that they opened out from, or closed over, the centre. There were in addition two fixed, outer wings visible only when the altarpiece was fully closed. The predella or base itself had a painted cover in two panels, which slid open to reveal a sculpture inside. This is all difficult to put into words, and not easy to imagine. In practice the altarpiece had three distinct aspects: closed, opened once, then opened again. It is not known precisely how it was used at Isenheim, or on what occasions the different views were revealed. As the *Crucifixion* (flanked by the two outer shutters, one showing St Sebastian and the other St Antony) was visible when the altar was closed, we can assume that this was the most frequently seen aspect. But the scene must be understood in the context of the other openings, for – as in the Franciscan diptych [PLATE 40] – its account of Christ's agony is only part of a whole theology of the Incarnation and our Salvation.

When the altarpiece was fully opened the central portion visible was three-dimensional: an architectural structure with figures sculpted in wood. Their ample vestments and the objects they hold are gilded, and the general effect is still dazzling.

Flanked by two saints, a majestic St Antony sits enthroned in the centre, between two small kneeling figures offering gifts in kind, like those donated to the hospital – one brings a piglet, the other a hen. (Antony himself is often represented with a pig, for the Antonines had the exclusive right of keeping, and herding, pigs in towns.)

The predella of this opening holds sculpted half-figures of Christ and the twelve Apostles, painted and gilded like the figures above.

The hinged shutters on either side were painted by Grünewald with scenes

from the life of St Antony: his demonic visitations on the right, and his meeting with another holy hermit, St Paul, on the left. Symptoms of St Antony's Fire have been recognized in the bloated and marked body of a demon in the foreground of the first, and some of the medicinal herbs used by the Antonines can be identified in the second of these panels.

It is clear that this 'deepest level' of the altar, the final opening, is dedicated to St Antony – and it is likely that it was shown on the feast days the Antonines celebrated. But it also alludes to other Catholic tenets. Christ, in the centre of the predella now visible, is the foundation on which this Church was built, but the Apostles on either side of him spread his Gospel and founded churches; the saints above them continue their work – and it is these saints, through their exemplary lives and trials, who can intercede with Christ on our behalf.

When the first hinged shutters were closed over the sculptures, and the predella cover in place, all the parts of the altarpiece that could then be seen were painted. The reverses of the two scenes from the life of St Antony now met in the centre to form the single scene of a mystic *Nativity*, and the second pair of hinged shutters now revealed the *Annunciation* on the left, and the *Resurrection of Christ* [PLATE 58] on the right. The predella now showed the *Entombment*. It is on this middle opening of the Isenheim Altar that the theology of the Incarnation and the Atonement begins to unfold.

The Archangel Gabriel swoops down from Heaven, hair and drapery flying. With a peremptory gesture of his right hand, he announces to the terrified Virgin Mary that she has been chosen to bear the Son of God. As so often in Western art, Grünewald's angel interrupts Mary's reading of Isaiah, 'Behold, a virgin shall conceive, and bear a son, and shall call his name Immanuel' (Isaiah 7:14).

The author of the 'Fifth Gospel' looks down at the fulfilment of his prophecy: Grünewald has painted Isaiah as a stone sculpture in the vaulting of the Gothic church in which the Virgin – herself often regarded as personifying the Church – receives the angel. Her Bible, we note, is propped on a coffin instead of the more usual lectern. The child being conceived, through the agency of the Holy Spirit descending as a dove from a keystone of the vault, will, we know, die. This is an Annunciation unusually full of drama and foreboding.

The two closed shutters in the centre showing the Nativity are no less idiosyncratic. Angels serenade the Virgin and Child. The angels – all melting translucency and variegated plumage – shelter in a kind of Gothic gazebo, animated with sculpted foliage and prophets, while the Virgin sits outdoors on a low stone wall, behind which grows a rosebush without thorns. Mary has been bathing the Child in a wooden washtub, and presently she will swaddle him again to lay him in his

cradle; at this moment they gaze lovingly into each other's eyes. He plays with her prayer beads; we shall see these fingers, curling like sea anemones, again. His plump naked body is at ease in the Virgin's arms, but the swaddling cloth on which it rests is strangely torn and frayed, and this too will presently reappear.

Scarcely visible in the distant landscape behind the Virgin, an angel brings the good news of Christ's birth to the shepherds, while from the radiance of Heaven God the Father sends down transparencies of angels.

I shall discuss the *Resurrection* on the right shutter more fully in Chapter Ten. For now, it is enough to say that this aspect of the Isenheim Altar is one of joy. Music, angels and light speed through the air; Christ is born and risen.

And now the hinged panels of *Annunciation* and *Resurrection* close over the glory and joy of the Incarnation to reveal its horror and grief in the *Crucifixion*.

There is no mistaking the Cross imagined by Grünewald for anything other than a hideous instrument of execution. On these rough-hewn timbers Christ's broken, elongated body has been nailed up to die – pierced with nails so huge that their blunted spikes protrude from the wood. He bears the marks of prolonged torture. The livid hands, drained of blood, are crisped in agony – writhing hands that once, small, white and delicate, played with a mother's beads. His head sags under the crown of thorns. Thorns, and the broken-off ends of twigs, are embedded in his cruelly scourged flesh. His loincloth has been torn to shreds in the violence of the Flagellation – and we recognize in it the prophetic swaddling cloth. Christ's feet twist around the ghastly pivot of a single nail, his blood still flowing down the unused, useless, wooden platform that was meant to take his weight. This *Crucifixion* is a world away from Zurbarán's (PLATE 36). That was an image of Christ praying for us; this is about Christ who died for us in supreme agony.

In the bleak darkness of the sixth hour, Christ's mother faints in anguish into the supporting arms of the beloved disciple, John. She clasps her hands in one of the most psychologically true gestures ever painted: partly in prayer, but mainly in desolation, as if to hold tight to what little there is left to her to hold, now her Son is dead. The penitent Magdalen weeps again at Christ's feet, lamenting, supplicating, reaching out, letting go.

Yet however closely it examines the complexities of real suffering, this is in no sense a realistic image. To our right there stands a figure beneath the Cross who could not have witnessed the historic Crucifixion: St John the Baptist, beheaded years before Christ's execution. He is a witness of another order: a witness to a timeless truth. Holding an open book in one hand, he points to Christ with another – the urgent gesture recalls the Angel Gabriel's in the *Annunciation*. Floating blood-red against the black sky appear the words he spoke when

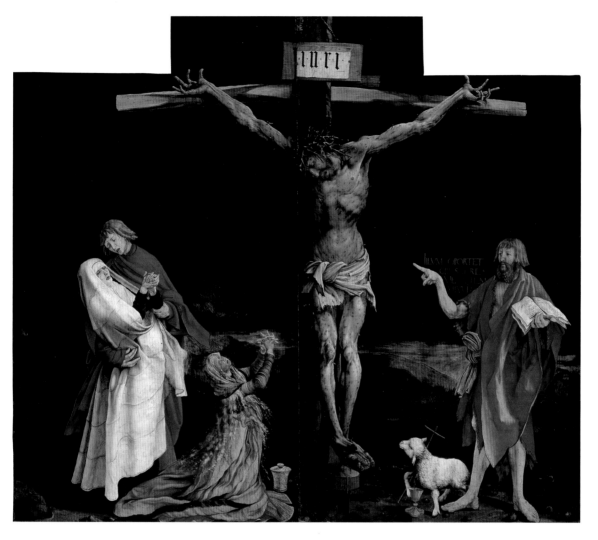

41 MATHIS GRÜNEWALD *The Crucifixion*, from the Isenheim Altarpiece, 1510–16

questioned about Jesus: 'He must increase, but I must decrease' (John 3:30). And indeed, Grünewald has painted the Baptist in the foreground smaller than the crucified Christ behind him.

At John's feet the lamb, his traditional attribute, holds the reed cross that artists also usually give to the saint. Blood gushes from his heart into a chalice – like the chalice of wine which would once have been drunk at the altar table below. And this, of course, makes concrete and visible John's words when, baptizing crowds in the River Jordan, he first saw Jesus: 'Behold the Lamb of God, which taketh away the sin of the world' (John 1:29).

Like so much else in the Gospels, this echoes Isaiah, and we can now cite the old prophet at greater length, for Grünewald's John the Baptist seems to be speaking in Isaiah's voice of Grünewald's Christ:

> ... *he hath no form nor comeliness; and when we shall see him, there is no beauty that we should desire him.*
>
> *He is despised and rejected of men; a man of sorrows, and acquainted with grief: and we hid as it were our faces from him; he was despised, and we esteemed him not.*
>
> *Surely he hath borne our griefs, and carried our sorrows: yet we did esteem him stricken, smitten of God, and afflicted.*
>
> *But he was wounded for our transgressions, he was bruised for our iniquities: the chastisement of our peace was upon him; and with his stripes we are healed.*
>
> ISAIAH 53:2–5

Christ is the man of sorrows, the slaughtered lamb who has atoned for our transgressions and redeemed us through his suffering. John baptized with water; Christ washes our sins away in his own blood.

In the *Entombment* on the predella beneath the *Crucifixion*, Mary, Mary Magdalene and the disciple John prepare Christ's body for burial [PLATE 56]. Comparing the body here with the body on the Cross, we are, I feel sure, meant to think how long it took them to remove every thorn, to clean out every wound. And many of those praying in front of this altar would have spent their lives tending the fearful wounds of the hospital's patients. They would know the real cost of this holy work of charity. Christ's feet are twisted like those of the victims of St Antony's Fire and – it has been suggested – the predella slides apart at the very point, below Christ's knees, where their gangrenous limbs were amputated. Not all the tears and unguents can make this tormented body whole again.

On the fixed shutters either side of the *Crucifixion*, St Sebastian and St Antony Abbot bear witness; they are often shown together, and logically so in an Antonine hospital. A Roman officer, Sebastian was martyred for his Christian faith by being shot with arrows. Pagan tradition had already associated the angry gods' poisoned arrows with bubonic plague, and Sebastian became the Christian's saint intercessor in epidemics of this much-feared disease.

Again and again, our eyes return to Grünewald's Christ. He horrifies us as no other Christ does. It is a horror with a purpose – to teach us one understanding of the theology of the Crucifixion. He suffers so much, because he loves us so much. The pain Christ endures has to be great enough to redeem the sins of the whole world, past, present and future. The conclusion is simple: the more we sin, the more he must suffer in order to save us. And the speed with which we grasp the enormity of that equation is the measure of Grünewald's achievement.

But there is also consolation here. Christ's sufferings and ours merge. In the hospital for the afflicted he joins the afflicted, entering our pain. But we can also enter his, following his steps on the way to Calvary. Suffering as intense as this need not isolate us, but can draw us together in love. And this is surely why patients were brought to stand before Grünewald's altar as part of their treatment and a step in their cure.

This companionship in sacrifice is one message of Wilfred Owen's *At a Calvary near the Ancre*: the Calvary of which he writes is both Christ's and the soldiers' (see p. 119). And it is no coincidence that perhaps the greatest painting to record the sufferings of soldiers in the First World War, a secular triptych by the German artist Otto Dix [PLATE 70], took Grünewald's *Crucifixion* as its point of departure.

For many Christians in the past, however, contemplating a representation of Calvary was not enough – as indeed it is not for many people now. They wanted not just to look but to act. To understand fully Christ's sufferings, it was felt necessary in some measure to experience them as he had; how this could be done and how artists could shape and intensify the experience is the subject of the next chapter.

PASSION AND COMPASSION

The desire for close identification with the suffering of Christ led many in the Middle Ages to make the long and dangerous pilgrimage to the Holy Land. There, under the guidance of the Franciscan custodians of the holy sites, the faithful could retrace Christ's painful journey from the moment of his arrest, through his various trials, to his conviction and final ascent to Calvary. Of course, all pilgrimages are part holy, part holiday, as Chaucer perhaps made clearer than anybody; but the purpose of such a journey was mainly a pious one. By identifying more closely with Christ, pilgrims hoped to be able to pray more fervently and more effectively. It was, however, possible to follow in Christ's footsteps without travelling any further than Rome. And, as usual, this was the result of a complex blend of history and legend.

In the fourth century, when the Emperor Constantine concluded the Roman state's 'treaty of peace' with the Christian Church, he donated a vast estate south of the centre of Rome to the city's Christian bishop. The estate, inherited by Constantine's wife, consisted of lands and buildings once belonging to a rich and noble family, the Laterani – and it was here that Rome's cathedral, St John Lateran, was built. The bishops of Rome, their papal authority ever more confidently asserted, took up residence here, re-using existing architecture to erect the pontifical palace. Successive popes amplified and embellished the rambling complex, seeking to make the Lateran a centre of Christian Rome. By the thirteenth century this quasi-autonomous papal estate, its perimeter defended by stout walls, housed some twenty thousand people, with their own workshops, eating places and hospices for pilgrims.

Yet Rome itself continued to develop to the north, and the Lateran became increasingly isolated from the rest of the city During the popes' exile in Avignon from 1305 to 1376, the abandoned Lateran Palace was several times subject to disastrous fires. It was so badly damaged that on his return to Rome Pope Gregory XI transferred the papal court to the thirteenth-century Vatican Palace. From that time the Lateran complex fell into total disrepair. In the late 1500s Pope

Sixtus V had virtually all the buildings demolished, and the entire area remodelled according to the latest fashion in architecture and urban planning.

The only structure spared was the old papal private chapel, the Sancta Sanctorum, housing the miraculous True Likeness of Christ [PLATE 26] discussed in Chapter Six. Leading to the entrance, directly in front of the image, was placed a venerable stone staircase, vaulted over and encased in an elaborate modern shell with flanking staircases, corridors and rooms.

These ancient stairs, known as the Scala Santa, may, as legend had it, have been brought to Rome by Constantine's mother, St Helena, from Pontius Pilate's palace in Jerusalem. Alternatively, as most archaeologists believe, they could be stairs preserved from the earliest papal palace at the Lateran, which a verbal slip transformed from the 'stairs of the palace' (*scala palatii*) to the 'stairs of Pilate' (*scala Pilati*). Whatever their precise origins, by the early Middle Ages they were believed to be the very steps, stained indeed with his innocent blood, which Christ had walked up on his way to be condemned by Pilate.

Pope Sixtus V had been, before his election, a Franciscan friar, so he well understood the spiritual power that a physical reminder of Christ's sacrifice could exercise on the minds of the faithful. Accordingly, he re-installed the steps here as a focus of penitence and meditation. They are still reserved for those mounting them on their knees, reciting prayers as they contemplate, and share in, Christ's Passion, literally following in his footsteps.

The Scala Santa offers an intense experience, but a partial one. For a more extended reliving of the events of the Passion, the faithful could go north from Rome to the Italian foothills of the Alps. Terrorism has always discouraged tourism in the Middle East, and by 1490 pilgrimages to the Holy Land had become extremely dangerous – you ran a considerable risk of being killed or enslaved by pirates or Turks. For women, the risks were even more terrifying. So a Franciscan friar, Bernardino Caimi, returning from a tour of duty as rector of the holy sites in Palestine, decided to reconstruct the stages of Christ's Passion on a mountaintop behind the little town of Varallo in the valley of the River Sesia, north of Milan.

The Franciscans had just settled there, and were energetically expanding throughout the region. In these mountain valleys, far from the large cities of the plains, lived a sparse population often deprived of even minimal pastoral care. Villages unable to support a parish church were cut off, by winter snows and spring floods, from the visits of perambulating priests; the population was much in need of spiritual comfort, and in danger of heresy, particularly as the valleys carried the roads to the German-speaking, free-thinking lands in the north.

Around 1490 a Franciscan convent was established on the outskirts of Varallo, at the foot of the mountain that would become Caimi's Sacro Monte, his Holy Mountain. It is one of the most extraordinary achievements of Christian art. Architecture, sculpture and painting combine to produce dozens of stage-sets in separate little chapels. In small compass you can go on the greatest of spiritual journeys, and see for yourself how your Saviour died.

Besides being a devout Franciscan, Caimi was also a man of the world. Vicar of the province of Milan, he was an intimate of Leonardo da Vinci's patron, Duke Ludovico Sforza, and the confessor of his duchess Beatrice d'Este. He had been an ambassador to the court of Spain. He conceived his great idea of bringing Jerusalem to Lombardy as the Franciscan convent of Varallo was nearing completion, and he realized the scheme expeditiously and with great diplomatic finesse. On 14 April 1493 a contract was drawn up, signed by the friars, the civic authorities, and the heads of all the families of Varallo, ceding the mountain behind the convent to the Franciscans for the purpose of erecting the sanctuary, to be financed with the help of local magnates.

Among the first buildings to be constructed was that of the Holy Sepulchre, whose measurements exactly correspond to Christ's supposed tomb in Jerusalem. A wooden effigy of his dead body, adapted from a crucified Christ with movable arms, sculpted and polychromed by an outstanding local artist, Gaudenzio Ferrari, lies in a coffin-like niche inside. On the wall above Gaudenzio painted an image of the resurrected Christ. The illusion of reality was to be reinforced by the inclusion of real relics: a niche on the outside wall of the chapel contains the stone lid of a sarcophagus, with a Latin inscription which translates: 'Stone from the Holy Sepulchre of our Lord Jesus Christ, which is in Jerusalem, from there transported and erected here in remembrance.'

Caimi's skull has been laid to rest in a second, smaller niche. Under his direction and, after his death in 1499, that of his successors – Franciscans equally familiar with the Holy Land – the Sacro Monte at Varallo had by 1514 been endowed with over twenty-one chapels. These were furnished with paintings and sculptures, re-creating all the sites connected with Christ's Passion and – anatomizing the Gospels – every event that took place at each. On 'Gethsemane', for example, stood the chapels of the Agony in the Garden, of Jesus waking the disciples who did not watch with him, and of Christ's arrest and Judas's kiss.

The Sacro Monte was radically transformed over succeeding centuries. Some of the old chapels were destroyed, others added, so that the sanctuary came to illustrate Jesus's whole life, and its place in the cosmic scheme of redemption: the first chapel the visitor now sees shows the Temptation, and the Fall of Adam and

Eve in the Garden of Eden – the Original Sin from which Christ's birth and suffering redeemed us. The original chapels allowed pilgrims to mingle freely with the figures, among the props and against the frescoed backdrops; wrought-iron grilles now separate us from the scenes. Yet when we walk from chapel to chapel and peer through the viewing holes specially provided in the grilles, the immediacy of what we see takes our breath away. We witness a three-dimensional re-enactment of the last days of Christ's life on earth. The wooden, terracotta and chalk sculptures are painted, bewigged and dressed, in many cases, in real fabrics. Their glass eyes catch the light as they grimace and gesture, shout and weep. And the people who put Christ to death are, disconcertingly, people just like us. Local types appear among the more idealized and grander figures. One of Christ's persecutors is the famous man with a goitre – a swelling of the thyroid glands caused by deficiency of iodine, until recently endemic in mountain regions where sea salt was unavailable. In another scene a man in local mountain costume – felt hat, short jerkin, leather belt and all – stands at the foot of the Cross (in which fragments of the True Cross are said to be embedded) with a set of workmanlike carpenter's tools.

Other great artists succeeded Gaudenzio Ferrari, and their names are a roll call of some of the best – if to us unfamiliar – that Lombardy produced: the painter Tanzio da Varallo and his sculptor brother Giovanni d'Enrico; Morazzone, il Ceranino among them. Still others – even greater artists – were influenced by the hypnotic realism of these chapels, where three-dimensional figures and objects merge imperceptibly with painted two-dimensional crowds and architecture, where everything seems alive, in the throes of powerful yet familiar emotions. The mixture of everyday life with melodrama, which made Caravaggio's religious paintings in/famous in Rome and throughout Europe – his agitated plebeian Apostles, a dead Virgin Mary said to look like a well-known prostitute who had drowned and been fished out of the Tiber, pilgrims with dirty feet – originated here, in the great 'mountain theatre', the Christian theme park where everyone – the unlettered and the poor, children and women along with great prelates – could participate in the Passion of Christ.

Although over the centuries the scope of the sanctuary expanded, the Passion always remained its focus. At the heart of the complex stands a miniature town square designed by the great sixteenth-century architect Galeazzo Alessi. It is a small-scale Jerusalem, with Solomon's Temple and the four palaces to which Christ was taken on the night of his arrest – those of his Jewish judges, Annas and Caiaphas, and those of King Herod and of the Roman governor Pontius Pilate. One of the staircases ascending to Pilate's palace is a faithful reconstruction of the

Scala Santa in the Lateran in Rome, so that here too we can exactly follow Christ's painful footsteps.

One of the most vivid chapels here is that of the *Ecce Homo* [PLATE 42]. Above the grille through which we look into the courtyard of the palace an inscription cites Isaiah's haunting passage on the Man of Sorrows, followed by a verse from St John's Gospel (19:5): 'Then came Jesus forth, wearing the crown of thorns, and the purple robe. And Pilate saith unto them: Behold the man!' Nothing is left to imagination. We see precisely what is going on and how everybody is reacting. It is as though we were not just watching a newsreel, but taking part in it. Pilate has a tough political decision to make. If he now sets Christ free, he risks provoking a riot. But to play it safe means condemning to death a man in whom he can find no fault. Like the deft politician he is, he chooses to leave it to the people.

And it is we, standing with the crowd here in the courtyard of Roman headquarters in Jerusalem, who must now decide.

The great lesson the Franciscans hoped to teach at Varallo is that this is a drama to which we cannot remain indifferent. Following in the footsteps of Christ does not let us off the hook; feeling compassion is not enough. We can never only identify with the innocent – we must also see through the eyes of the guilty. For we, like them, have rejected him.

Placed on the boundary between Latin and German Europe, Varallo is a powerful mix of different aesthetic traditions: the engaging realism of the North here has been put to the service of the emotional rhetoric of Italian art. Working in two registers at once, this can, at its best, deliver a knock-out blow. We find a very similar mixture in Spain, where commercial and political ties to both the Low Countries and Italy produced work which, in its impact, can often be compared with Varallo. One of the things the Spaniards inherited from Northern artists was a taste for gilded or polychromed wooden sculpture, and religious statues colourfully painted to look as life-like as possible are still made in Spain to this day. These statues are uniquely suited to the forms of piety promoted by the Franciscans, and the Franciscans were extremely active in Spain and in its empire in the New World.

The great sixteenth-century Spanish mystic and religious reformer, Teresa of Avila, influenced by the writings of a Sevillian Franciscan, Fray Bernardino de Laredo, credits her conversion, and her gift of focused prayer, to just such life-like images. It is precisely the kind of response which the founder of Varallo hoped to achieve in his Sacro Monte, and the account she gives in her *Life* (Chapter IX) is worth quoting to show how powerfully these works of art could change lives.

42 (OPPOSITE) MORAZZONE and GIOVANNI D'ENRICO *Ecce Homo*, Chapel 33, Sacro Monte, 1603–16

*It happened that, entering the oratory one day, I saw an image which
had been procured for a certain festival that was observed in the house
and had been taken there to be kept for that purpose. It represented
Christ sorely wounded; and so conducive was it to devotion that when
I looked at it I was deeply moved to see him thus, so well did it picture
what he suffered for us. So great was my distress when I thought how
ill I had repaid Him for those wounds that I felt as if my heart were
breaking, and I threw myself down beside Him, shedding floods of tears
and begging Him to give me strength once for all so that I might not
offend Him.*

When distracted from prayer, looking 'at a field, or water or flowers' reminded
her of her Creator, and of her own 'ingratitude and sins',

*But when it came to heavenly things, or to any sublime subject, my
mind was so stupid that I could never imagine them at all, until the
Lord showed them to me in another way.*

*I had so little ability for picturing things in my mind that if I did
not actually see a thing I could not use my imagination, as other
people do, who can make pictures to themselves and so become
recollected. Of Christ as Man I could only think: however much I
read about His beauty and however often I looked at pictures of Him,
I could never form any picture of Him myself. I was like a person
who is blind, or in the dark: he may be talking to someone, and know
that he is with him, because he is quite sure he is there – I mean, he
understands and believes he is there – but he cannot see him. Thus it
was with me when I thought of Our Lord. It was for this reason that
I was so fond of pictures. Unhappy are those who through their own
fault lose this blessing!* [She means, of course, Protestant Iconoclasts,
who in northern Europe were busy smashing sacred images.] *It really
looks as if they do not love the Lord, for if they loved Him they
would delight in looking at pictures of Him, just as they take pleasure
in seeing pictures of anyone else whom they love.*

The effigy that operated St Teresa's conversion had, she writes, been 'procured for
a certain festival'; it may have been one of the statues re-enacting Christ's Passion
that Spanish penitential confraternities (groups of laymen devoted to prayer and
good works) have, since the sixteenth century, carried in procession through the

streets during Holy Week. These confraternities were – and remain – each devoted to a specific moment of the Passion derived, as in the chapels at Varallo, from a minute dissection of the Gospel texts. The earliest of the Spanish brotherhoods, the confraternities of the Vera Cruz or True Cross, were founded in Franciscan convents and with the support of the friars; they adopted the Franciscans' knotted cord belt for their hooded penitential vestments. As in the penitential confraternities sponsored by Franciscans in Italy, the Spanish brothers walked barefoot and performed 'acts of discipline' – that is, flagellated themselves – during processions.

Like most of the carved figures at Varallo, the life-size processional sculptures carried by the confraternities are dressed in real clothes (the mother of the present King of Spain, for example, donated her wedding dress to a figure of the Virgin). They may wear wigs and elaborate jewellery. Some have glass eyes. Their limbs are hinged so they can assume different poses, and the carving of the parts of the body normally covered by clothes is summary, for they were never meant to be seen. The most famous were made in Seville, where the confraternities remain particularly active – and they do not always impress foreign visitors favourably. Mme d'Aulnoy, who – with a Frenchwoman's eye for couture – witnessed the Holy Week processions in Seville in 1679, reported: 'The figures are of human scale and very badly made and very badly clothed.' Writing in 1912, the English art historian Albert Calvert equally deplored the clothing of a processional sculpture he otherwise admired: 'The face has splendid dignity. But the statue has been disfigured by the barbaric custom of dressing the figure in elaborate robes entirely out of harmony with the subject.' And even Spanish scholars now deprecate what they see as the degradation of 'pure' sculpture:

> *The fictitious came to acquire such a vivid sense of life that it seemed to be reality, and this was done with such zeal that, as the seventeenth century advanced, use was made of such unsculptural devices as sized cloth for the draperies, glass eyes and tears and even false hair, all abuses which contributed to the decline of sculpture, as did the lay figures intended for dressing up.*

But it was precisely their 'vivid sense of life' that attracted public and artists to these processional figures. Pacheco, the artist who painted the statues carved by Martínez Montañés, wrote: 'Sculpture has existence, painting has appearance.' Or, we might say, sculpture *is*, while painting *appears* to be. For precisely the same reasons that the early Church mistrusted three-dimensional imagery, the Franciscans now promoted it – the more real the better. Confusion between the

representation and the thing it represents can be spiritually fruitful, even if dangerous. And although voices within the Spanish Church were raised against the Holy Week spectacles, they remained the prime vehicle for popular devotion. Even austere churchmen preferred the sculpted figures to the live actors who had earlier moved audiences in Passion plays:

> *If there is anything in Spain that offends pious foreigners and natives in this celebration, it is seeing that vile and infamous men, accustomed to enacting vulgar and offensive things all their lives, represent such lofty and ineffable mysteries, and that the woman that represents the vulgarities of Venus, in theatrical productions as in her own life, represents the purity of the Sovereign Virgin in such a solemn and divine act.*

It should not, therefore, surprise us that Martínez Montañés, the sculptor of the refined *Christ of Clemency* [PLATE 43], should have accepted a commission from the penitential Confraternity of the Martyrdoms and Blood of Our Lord Jesus Christ, founded in Seville in 1531 in the Convent of Our Lady of Mercies, for a processional statue of Christ carrying the Cross: *Jesús de la Pasión* [PLATE 44]. The confraternity, relocated and merged with another, still exists, and the statue is normally venerated in the chapel of the Sacrament in the grand parish church of El Salvador, the Divine Saviour. As it was designed to be carried through the streets, it is both coarser and more expressive than the *Christ of Clemency*, the boldness of the carving and the polychromy make the face – with lowered eyes, open mouth and blood running down from the crown of thorns – and the veined hands and feet, clearly legible from a distance. The body is always hidden under a velvet robe, but we know from photographs taken during restoration that it is more like a mannequin than a 'pure' sculpture. The arms are hinged at the shoulders and elbows, so that the angle of the cross can be adjusted.

Behind the altar of its chapel, in front of a dazzling silver reredos, with elaborate gold metal rays issuing from behind its head, and a spotless lace altar cloth before it, this suffering Christ is a powerful yet incongruous figure – an embodiment of pain in spotless, almost stifling opulence.

But during Holy Week the *Jesús de la Pasión* comes into his own – and unto his own – as he has for over three hundred years, and carries his Cross through the streets of Seville. The faithful here do not have to go on pilgrimage – to Palestine, to Rome or to Varallo – they can follow the footsteps of Christ as they come out of their own front doors. They can look up to him from the pavement, or watch him from their balconies. They can see him appearing from a distance,

43 (OPPOSITE) JUAN MARTÍNEZ MONTAÑÉS *Christ of Clemency*, Cathedral, Seville, 1603

44 JUAN MARTÍNEZ MONTAÑÉS *Jesús de la Pasión*, San Salvador, Seville, *c.* 1619

passing by, disappearing around a corner like a real person. Those that carry him used to spill their own blood to mingle with his; now they still walk barefoot, as he walks barefoot, and some collapse under the huge weight of the figure on its silver platform on their shoulders, as he collapsed under the weight of his Cross.

The *Jesús de la Pasión* is a great work of art still performing exactly the function for which it was made, reminding the citizens of Seville that Christ is still among them, in their streets with them, suffering and dying for them.

It is said that when Martínez Montañés saw the sculpture carried in procession for the first time, he followed it through the streets marvelling that he had been able to create such a prodigy.

To give an idea of how strengthening such acts of empathy can be, we need look no further than St Teresa of Avila's account of her much-loved father's last illness:

> *His chief ailment was a most acute pain in the back, which never left him: at times it was so severe that it caused him great anguish. I said to him that, as he used to think so devoutly of the Lord carrying the Cross on His back, he must suppose His Majesty wished him to feel something of what He Himself had suffered under that trial. This comforted him so much that I do not think I ever heard him complain again.*

By the sixteenth century, the road that winds up from Jerusalem to Golgotha, leading Christ to his death, could pass through Rome and Varallo, the streets of Seville and indeed the innermost places of the New World.

The Franciscans, like all the religious orders who accompanied the Spaniards in their conquest of the Americas, have a problematic inheritance. Having first evangelized the native population at the point of a lance, they then became the stoutest and most courageous champions of these new Christians who had been so brutally dispossessed. That solidarity with the poor and the weak has more recently found form in campaigns for social justice, but in earlier centuries it was asserted above all, as in Europe, through the figure of the suffering Christ.

Even now the crucified Christ is carried every year on his Cross high in the Peruvian Andes. In Cuzco, the ancient capital of the Inca empire, the descendants of that conquered people, of the Spanish *conquistadores* and of imported African slaves, organize the city's collective worship of the slain Saviour. But just as those afflicted with St Antony's Fire saw their own Christ in Grünewald's altar [PLATE 41], Wilfred Owen his in the shattered crucifix near the Ancre (p. 119) and St Teresa's father his in a Christ carrying the Cross, so the people of Cuzco see theirs

in a dark crucifix in Cuzco Cathedral: the *Señor de los Temblores*, the Lord of the Earthquakes. It is a Christ clearly in the tradition of Spanish processional images, but who still carries with him more than an echo of the earlier religion which the missionaries sought to suppress.

No one knows for certain how and when the crucifix came here. According to legend, the statue was one of three sent to Peru by the King of Spain. As they were being transported inland through jungle and across mountains, each one decided on its own resting place by becoming too heavy to be carried any further, and only this one reached Cuzco. But even the first part of the legend is unlikely to be true, for the Cuzco crucifix shows signs of having been made in Peru: it is lined in llama hide, and has parts made of local woods. The dark skin colour is the result of centuries of candle smoke, but the roughly carved features may have been inflected to recall those of the native population. His head falls to one side, and his eyes appear to be closed in death. Huge drops of blood, painted and sculpted, fall from under the crown of thorns, and the thin limbs are painfully taut, stretched by the weight of the tortured body and the agony of his suffering.

A darkened old painting in Cuzco Cathedral explains, with the help of a long inscription, why this Christ is Cuzco's own [PLATE 45]. On Thursday 31 March 1650, at half past one in the afternoon, Cuzco was hit by a particularly violent earthquake. Houses collapsed and caught fire, and the aftershocks continued for days. As the town panicked and prayed, all the cathedral's statues were carried out in procession into the main square. When this particular – and never before noticed – crucifix emerged, the earthquakes miraculously stopped.

From that moment, the Christ on this crucifix became the protector and patron of Cuzco, and as the Lord of the Earthquakes he appears in devotional paintings found throughout the city. Every year, to commemorate the miracle, it is carried through the streets. As the date always falls near Easter, the procession is inevitably subsumed into the events of Holy Week.

Rare red flowers picked on the mountains once holy to the Incas are thrown over him, and made into garlands that are hung on his crucified arms as he passes, so that when he re-enters the cathedral at a moment timed to coincide with moon-rise he seems dripping with blood. Special hymns are sung to him in Quechua, the native tongue, by women dedicated to this service. They call themselves in Spanish the *pajaritos*, the little birds, of the Lord, and their high trebles indeed resemble birdsong – though the melodies they sing and the titles they confer on the Christ of the Earthquakes are Andean, indeed Inca, and infinitely nostalgic.

Like an Andean god, and like the God of the Old Testament, this Lord of the Earthquakes must be propitiated – for being their Lord he can provoke

45 Unknown Cuzcanian artist *'El Señor de los Temblores' carried in Procession during the Earthquake of 1650*, detail, seventeenth century

earthquakes as well as stop or prevent them. Old beliefs cling to him: as he passes, elderly men shield their face from his gaze with their hats, for to catch his eye was once said to court death within the year.

The crucifix stops in every church along its route, where its ornate skirt-like loincloth is changed. The bearers also change over, during the procession as well as in church, so that every association in town has a chance to carry him: all the devotional confraternities, but also the various unions of Christian workers, civil servants and boy scouts. He is accompanied by a platoon of soldiers in battle dress, bayonets drawn, and a military brass band, playing his own Andean songs – and all around them men, women and children, gathering in ever greater numbers, in ever greater excitement. Although the centre of Cuzco is tiny, the procession lasts for hours.

When at last, having slowly climbed the steps, the crucified Christ heavy with blood-red flowers stands in front of the cathedral doors, he bows three times to the crowds massed in the square below. It is difficult to see the bearers straining beneath him, so vivid is this effect of a martyred god saluting his people as he re-enters his temple. Civilians – many carrying candles, for it is now night – and clergy kneel; the military salute. And all the sirens of all the fire engines of Cuzco, gathered together in the old sacred centre of the Inca realm, sound an unearthly wail.

What seems to me to make this event so extraordinary is the evident conviction of the people here that their divine protector is among them – and it is clear that he is both the Christian Redeemer brought by the Spaniards four centuries ago, and the timeless all-powerful protective spirit of the Incas.

If the Franciscans promoted spiritual engagement with Christ through the senses – by physically following in his footsteps – other, more thoughtful, *stiller* ways had been developed in monastic cloisters. And these were given wider currency through the Franciscans' great rivals, the mendicant Order of Preachers or Dominicans.

The Order was founded in 1215, some five years after Francis of Assisi and his disciples had gained papal approval for their rule, by the Spaniard Domingo de Guzmán. A priest, more learned and more austere than Francis, St Dominic never achieved the popularity with the wider public of his Italian contemporary. Their aims were similar – to minister above all to the population of the growing towns and cities, above all through preaching. Their approach, however, was different. The Dominicans were from the beginning more intellectual and book-ish; although a mendicant (begging) order, they did not advocate absolute poverty as Francis and his closest followers did. They maintained libraries in their

convents. Above all, although all Dominicans were meant to model themselves on Dominic, in practice the Order did not depend as heavily as did the Franciscans on the central authority of a charismatic founder/leader. Within their general rule, Dominican convents had a certain autonomy; changes in the constitution of the Order were decided by general councils at which priors had their say. Consequently, whereas the Franciscans were riven by deep divisions, which continued even after Francis himself was removed from the generalship of the Order, the Dominicans were able to maintain a certain flexible cohesion. Even movements for reform, a return to the purity of first principles, could be accommodated. Those friars who wished were free to gather together in more austere Observant Dominican convents without, like the Franciscans, leaving their Order altogether to found a new one.

It is in one of these Observant Dominican houses – the convent of San Marco in Florence, sponsored by Cosimo de'Medici – that some of the most celebrated paintings in Western art were created. But I should like to look at a few of them not principally as objects of beauty, but as visual instruments of instruction; for these frescoes form a kind of manual to prepare the friars who lived here to preach the Passion of Our Lord and Saviour, Jesus Christ. The artist chosen to paint them was himself a member of a sister Observant Dominican convent in Fiesole: Fra Giovanni, Brother John, better known to us as Fra Angelico – the Angelic Friar.

The first picture you see on entering San Marco is a large fresco in the cloister of St Dominic, in the black and white habit of his Order, embracing the foot of the Cross, down which the blood of Christ is still flowing [PLATE 46].

Dominic died in 1221, but we see him as though witnessing the actual moment of the Crucifixion. The scene is bare, with only sky-blue for background, and no other participants but ourselves. And although Christ looks down at the friar, Dominic's eyes do not meet his, but are fixed on some indeterminate distance, like those of a man lost in thought. An eyewitness account of Dominic relates that he used to pray before a sculpted crucifix, weeping for his sins and with love for Christ. But Fra Angelico has not pictured an anecdote from the life of St Dominic any more than he has painted the actual Crucifixion. This is not a carved crucifix but the living Christ – and the two figures inhabit the essence of a landscape rather than a convent interior. What is shown is the object of Dominic's prayerful meditation. We are allowed to see what he sees in his mind's eye, so that his example can be followed by all the members of his Order – a message even more clearly spelled out inside the convent, in the frescoes painted in the cells of novices, the apprentice Dominicans.

Dominicans, unlike the members of some other orders, did not sleep in

communal dormitories but in individual cells, which they were also expected to use for solitary study and meditation. So the decoration of the novices' cells could be expected to provide the clearest example of how to become a good Dominican: and each of these cells contains an image of Dominic at the foot of the Cross, like the one that greets us in the cloister.

At first sight, all appear to be identical. Only when we look more closely do we notice that in each one the saint is shown in a slightly different pose. In a treatise intended for use by Dominicans, an eyewitness of Dominic's devotions recounts the founder's nine different modes of prayer. Eight were silent, so that only through his gestures was it possible to know what was in his mind. Fra Angelico's frescoes closely follow the painted illustrations in the manuscripts of this treatise – and both illustrations and frescoes are clearly based on a simple theory of imitation. Dominic's states of mind can more easily be evoked and re-created in the viewer if he can replicate the appropriate gestures.

These gestures reveal that the saint is engaged in different kinds of devotion: Cell 15 shows rapture in prayer, while Cell 18 depicts humble reverence, and Cell 19 meditative reading of a holy text. The stress on meditation, on *thinking* rather than *feeling* the Passion of Christ, is even more obvious in the clerics' cells, where the decoration is mostly based on biblical events that are major liturgical feasts of the Church.

The fresco of Cell 7 depicts the *Mocking of Christ* [PLATE 47]. But this is in no sense like a chapel at Varallo, a realistic rendering of the incident. Beneath a schematized selection of aspects of the event, we see Dominic, not looking at Christ in his humiliation, but meditating on a *written* account of the Mocking of Christ. This is an art at several removes from observed reality, a vision already distilled by analysis and long reflection. So Dominic does not witness the actual event, but systematically visualizes each separate moment, each cruel act, from the torturer's tipping his hat in mockery as he spits at Christ, to the buffet of one dis-embodied hand and the blow of another holding a wooden rod. The blindfolded Christ, enthroned in derision, is a real King and Judge; he is not shown in the purple robe of the Gospels but in the spotless white of an innocent victim. Like the blindfolded Christ, we apprehend the assaults individually, as disembodied incidents, unable to see or consider them all at once.

In the same thought-space as St Dominic, but on the opposite side of the picture, sits the Virgin Mary, patron of the Dominican Order. As her sorrowful pose makes clear, she – unlike the friar – apprehends her martyred son's pain directly, without the intervention of a text. As the preachers think, Mary feels.

In these cells built for silent study and prayer, the ultimate purpose of the

46 (OPPOSITE) FRA ANGELICO *St Dominic at the Foot of the Cross, c.* 1441–3, in the cloister of San Marco, Florence

exemplary images that Fra Angelico and his assistants painted was not private spiritual growth. It was to train the Dominican friar to meditate on and to write about the sufferings of Christ, and to equip him for active apostolic service preaching to others, in accordance with the Order's motto: 'Things contemplated are to be passed on to others.'

In their dramatic reconstructions of the Passion, the Franciscans re-created in their totality separate *moments* from the biblical accounts; processional sculptures might reduce these to single *figures*, such as Christ carrying the Cross, Christ dying or dead on the Cross, Christ entombed. But the aim was always to induce viewers to feel compassion for Christ by imagining or reliving his sufferings in their own bodies. Properly guided physical activity – whether travelling in peril and discomfort to the Holy Land, bruising one's knees on a steep staircase in Rome, climbing to a rocky site in Varallo, or scourging oneself barefoot in the streets of Seville – would, with God's help, induce spiritual change. And although spiritual change is always a matter for the individual soul, the physical activities fostered by the Franciscans were also calculated to produce – in the French sense of the phrase – *esprit de corps*. Pilgrims necessarily travelled in groups, one is never alone on the Scala Santa, and processions are by definition communal enterprises; devotional confraternities cut across occupational groups, economic status and social class, and a city's divine protector protects all its inhabitants. For the Franciscans, engagement in Christ's sufferings was also a means of bringing about the brotherhood of man. Understanding the Redeemer's Passion would lead all to heed his words: 'This is my commandment, That ye love one another, as I have loved you' (John 15:12).

Of course, in this view, the brotherhood of man included only those who acknowledged that Jesus *was* the Redeemer – and it is not a coincidence that Franciscan friars were among the first to pervert the lovingkindness of their founder, fostering social cohesion by inciting hostility against the minority who resisted conversion. The segregation of Jews in ghettos, their mass expulsions, and the pogroms of medieval Europe were frequently inspired, and sometimes even organized, by some of the same friars who taught Europe to weep on the road to Calvary. Adept at arousing and manipulating the emotions of the masses, it was the Franciscans' propensity to foment popular uprisings that frequently caused civil authorities to expel these devout loose cannons from their territories.

The historic reproach against the Dominicans – that of staffing the Inquisition – originates in their contrasting concern with individuals, with study and the written word. The Inquisition was an ecclesiastical court first established in the thirteenth century, but its notorious excesses date only from its use by the

Spanish crown in the late fifteenth century, first against converts from Islam and Judaism, whose loyalty to the Church was suspect, and later against Protestants. It was to combat Protestantism that in 1542 it was assigned to a Church department by Pope Paul III. Its aim was also to promote social cohesion through religious unity, and it worked closely with the secular authority. It never sought to reinforce orthodoxy with popular uprisings against minority groups. Rather, legal proceedings were instituted against individuals suspected of heresy – torture was an integral part of the judicial procedure of the time – and religious texts carefully examined before receiving the imprimatur, the official church licence to print.

As we saw at San Marco, Dominican imagery was specifically adapted for use by individuals in solitary meditation and study. Dominicans subdivided biblical accounts of the Passion, and other exemplary texts, into self-standing fragments: a single hand raised in fury against Christ, a derisive salute, a stream of spittle. Such particles had a very different function from the scenes and figures of Franciscan drama.

In order to be able to argue complex cases cogently, over long hours in public speaking or in court without reference to notes, ancient orators had developed a systematic technique for training and directing 'natural memory', a technique that came to be called the 'art of memory'. Transmitted through classical texts, it was revived in the Middle Ages for the use of preachers and also as an aid to contemplation. Simply described, the 'artificial memory' is a method of attaching to striking images in the mind the ideas or the steps in an argument we wish to memorize. A complex but familiar space – a picture gallery, say – is then mentally furnished with the images in the desired order, so that by walking through it in imagination we can recall each item in turn.

The Dominican images at San Marco differ from the images of the classical art of memory in two very important ways: they are not 'mental' but actually exist as paintings; and they are not, as in antiquity, invented by the person using them, but part of a wide and pre-established tradition. Yet both rely on the notion that striking images are easily recollected – and both allow the viewer to rearrange them as he or she chooses, even if the Christian contemplative will do so within narrower boundaries. A Dominican contemplating Fra Angelico's *Mocking of Christ* [PLATE 47] for example, could one day focus his entire meditation on the long-suffering patience of the afflicted Christ. Another day could be spent on what it means to spit in the face of God. A third might consider the wooden rod striking Christ, remembering Christ's reproach to his people in the Good Friday liturgy: 'For you I smote the Kings of the Canaanites, and you smote my head with a rod.'

The effect of this training in analytic memory is profound. Far from being

47 FRA ANGELICO *The Mocking of Christ, c.* 1441–3

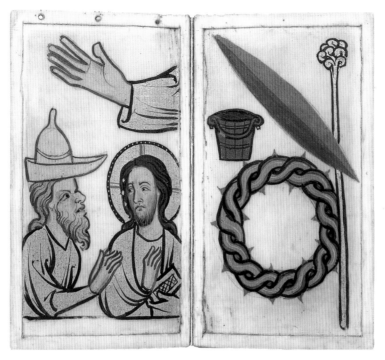

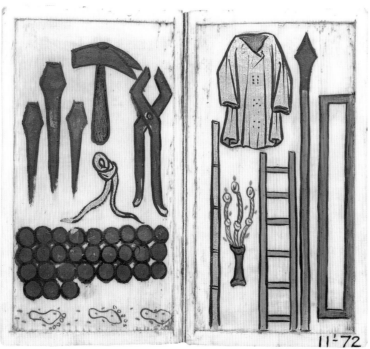

48 *Elements of the Passion*, pages from an ivory devotional book, *c.* 1330–40

swept up in collective states of religious exaltation, we are drawn through these images even deeper into our own hearts and minds, and these become permeated with Christ, according to our capacity and inclination. Partly through the agency of the Dominicans, images of this kind developed for contemplative monks and friars were brought out of the cloister and made available to men and women everywhere who wanted to be helped to meditate on their Salvation.

Some of these 'art of memory' images gave rise to their own specific devotions. The best known is the *Arma Christi*, the heraldic device of Christ, arranged like a coat of arms on a shield. They comprise the Instruments of Christ's Passion – the lanterns the soldiers carried the night he was arrested, Judas's kiss, the column of the Flagellation, the scourges and rods with which Christ was beaten, the crown of thorns, the Cross, the nails, the sponge on which he was given vinegar to drink, the lance with which his side was pierced, even the cock that crowed when Peter denied him. Veronica's veil imprinted with his likeness is sometimes also included among them.

Thousands upon thousands of prints, paintings and sculptures of the *Arma Christi* survive, and we have little difficulty in imagining how they might have been used in meditation. They are an international equivalent of Varallo, a solitary, mental walk to Calvary in the steps of Jesus.

Among the most intriguing examples of this tradition is a tiny devotional booklet made around 1330 near Cologne in Germany [PLATE 48]. The booklet, made up of ivory leaves rather than parchment or paper, was surely designed for a prosperous but not necessarily learned user – it 'tells' the story of the Passion in pictures. Two of these towards the back of the book have disembodied references to Christ mocked and buffeted, the crown of thorns, the sponge and the bucket of vinegar and the large, red diagonal representing the wound in Christ's side.

Within the many mansions of the Church, a number of structures were set up to enable individuals and communities to engage ever more deeply with the Passion of Christ and with their own role in it. And over centuries artists devised ever more effective ways of helping them achieve this aim. What this came to mean is that an artist working within the Western tradition might well himself become in a very real sense a theologian. We know that Zurbarán was devout, Fra Angelico was himself an Observant Dominican, but even European artists involved less directly with religious institutions could also be moved to reflect in their works on the agony and death of the Saviour. Two of the most celebrated, the Protestant Rembrandt and the troubled Catholic Michelangelo, created great works on the theme, perhaps intending less to shape viewers' meditations than their own – working out in their art their own personal visions of Salvation.

CHAPTER NINE

REMBRANDT *Three Crosses*
and
MICHELANGELO *Pietà*

It was difficult, if you were Dutch in the seventeenth century, to be an ambitious artist in the established Western tradition. As a consequence of the Reformation, a painter working in Holland could no longer take on his predecessors and peers in Catholic countries, for he could no longer enter the public arena with monumental altarpieces that would both express his own beliefs and move viewers to tears and conversion. Rembrandt, in other words, could not compete with Rubens. He minded greatly. He studied the great Flemish painter's Passion scenes through prints [PLATE 57], but he could emulate them only in small format for the Prince of Orange's private chapel. And for the majority of Rembrandt's clients, even such works were undesirable; if they wanted religious paintings at all, they wanted paintings of Jesus that did not so closely reflect the mystery of the Eucharist or other dangerously Catholic topics – but small paintings for domestic viewing, like Rembrandt's *Adoration of the Shepherds* [PLATE 16].

Rembrandt, however, had another outlet for his beliefs and his ambitions. He was a master etcher, a medium that was still so new that he could be a technical innovator. Nor did he need to wait for commissions: discerning collectors were eager to buy any print he produced, and they welcomed – as print collectors have always done – the personal and the imaginative, looking closely and with sympathy at each individual exemplar. As a print, he could sell virtually any subject he chose to depict: even an old-fashioned panoramic Crucifixion like the *Three Crosses* [PLATES 49 and 50].

Rembrandt worked and reworked this etching in a way that has given it a unique status in the history of printmaking. He altered the large copper plate no fewer than five times, scratching the design directly into the metal as well as drawing on the thin layer of waxy ground that protected the plate from the etching acid. More remarkably, he completely transformed the composition between the third [PLATE 49] and fourth [PLATE 50] changes to the plate, some time after signing and dating it in 1653. At each stage, he experimented ceaselessly during printing – a manual process which produced one print only at a time – to achieve

different pictorial effects. He used many different kinds of paper, including imported Japanese rice paper, and even parchment, all of which absorbed the ink differently. He also inked the plate more or less heavily, or wiped it with uneven pressure, leaving a film of ink over the smooth metal as well as in the etched lines. Each impression, each print, thus became a unique work of art, a different interpretation of the subject, like a different performance of the same piece of music. And it is a work of such complexity that each spectator must also play a part in the interpretation.

In the first three stages, Rembrandt shows a crowded historical drama, based mainly on St Luke's Gospel [PLATE 49]:

> *And it was about the sixth hour, and there was darkness over all the earth until the ninth hour.*
>
> *And the sun was darkened, and the veil of the temple was rent in the midst.*
>
> *And when Jesus had cried with a loud voice, he said, Father, into thy hands I commend my spirit: and having said thus, he gave up the ghost.*
> LUKE 23:44–6

The darkness of the sky is pierced by a cone of bright light in the centre; its beams illuminate Christ on the Cross, the anguished mourners at his feet, mounted lance-bearers, and the centurion Longinus who has suddenly got off his horse to fall to his knees, and recognize that he has just put an innocent man to death: 'Now when the centurion saw what was done, he glorified God, saying, Certainly this was a righteous man' (Luke 23:47). But St Mark's account of the centurion's conversion is the one that sticks in the memory, and surely the one that Rembrandt had in mind: 'And when the centurion, which stood over against him, saw that he so cried out, and gave up the ghost, he said, Truly this man was the Son of God' (Mark 15:39).

Most people would expect the Good Thief, who is nearly always shown on Christ's right, to be in the light; yet Rembrandt illumines the Bad Thief, crucified on his left. This is not as perverse as it seems. We understand that what saves us is not to be in the light, but to be able to see it, to recognize the presence of God. The Bad Thief cannot see the light that surrounds him, for he is blindfolded – a physical indication of his spiritual blindness. As he dies he writhes in anguish.

> *And one of the malefactors which were hanged railed on him, saying, If thou be Christ, save thyself and us.*

But the other answering rebuked him, saying, Dost not thou fear
God, seeing thou art in the same condemnation?
And we indeed justly; for we receive the due reward of our deeds:
but this man has done nothing amiss.
And he said unto Jesus, Lord, remember me when thou comest into
thy kingdom.
And Jesus said unto him, Verily I say unto thee, Today shalt thou be
with me in paradise.
LUKE 23:39–43

At the outer edges of the print a dog (it must be barking in distress) runs across the foreground, while the figures cast into darkness on the left hide their faces, or are led away in shock: 'And all the people that came together to that sight, beholding the things which were done, smote their breasts, and returned' (Luke 23:48).

Two turbaned men in the foreground stride towards the dark abyss of a tomb in the rock. They are not, I think, running away, but acting in love, for they are surely Joseph of Arimathaea and the Pharisee Nicodemus, hurrying to arrange for the burial of Christ 'so that his body should not remain upon the cross on the sabbath day' (John 19:31).

And, behold, there was a man named Joseph, a counsellor; and he
was a good man, and a just:
(The same had not consented to the counsel and deed of them;)
he was of Arimathaea, a city of the Jews: who also himself waited for
the kingdom of God.
This man went unto Pilate, and begged the body of Jesus.
LUKE 23:50–52

Christ's achingly stretched body is erect in death, but his face is calm. Through pain, he is victorious over fear and chaos. Those who believe in him may grieve, but in this confusion of suffering and despair the light falls on him from Heaven, and if they have eyes to see it they will be redeemed. This is, I think, an image of hope.

When Rembrandt repolished and recut the old copper plate, perhaps because it had worn out in the printing press, he changed not only the appearance but also the meaning of the image [PLATE 50]. The light struggles down from Heaven, and to little effect. The whole print is now engulfed in darkness, virtually hiding the cross on Christ's left, bearing down on the mourners below, encroaching on Christ himself. But there is enough light to see that this is a Christ slowly dying in

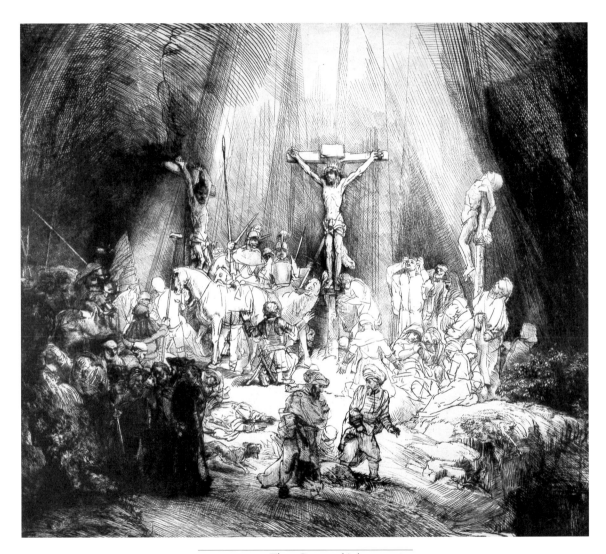

49 REMBRANDT *Three Crosses*, third state, 1653

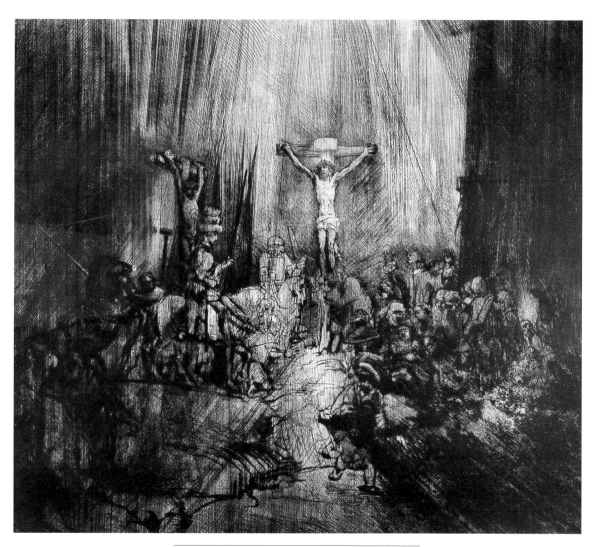

50 REMBRANDT *Three Crosses*, fourth state, after 1653

anguish, not a Christ dead in the certainty of victory. The figure of the centurion Longinus has been nearly effaced, and his place in the drama taken by a man in a tall three-tiered hat, carrying a long baton of command and mounted on a horse.

The exotic rider derives from a famous fifteenth-century medal designed by Pisanello and cast for the Duke of Mantua, which Rembrandt, an insatiable collector himself, probably owned. Here, the horseman must represent secular authority: 'And the people stood beholding. And the rulers also with them derided him' [Luke 23:35]. But, in a return to the tradition of Passion plays, he may be Pontius Pilate himself, shown as the military commander (whose part was after all a relatively humble one) of the occupying Roman forces. Both the centurion and Pilate were guilty of Christ's death. The centurion repented and bore witness. Pilate, on the other hand, though he believed Christ to be entirely innocent, had connived through weakness at great injustice, and condemned him to death. If he is Pilate, the mounted figure on the left can stand for the greatest human weakness: we could do something to prevent injustice and suffering, but choose not to.

While Rembrandt's subject in the earlier version of the *Three Crosses* was the redemptive power of the Crucifixion, symbolized by light, his theme now is, literally, darker: persistent human sinfulness, which prolongs Christ's suffering and dooms us to despair. One figure on the right can be made out, standing in the gloom, gazing at Jesus. It must be St John, and the etching could be a glimpse of the bleakest verse in his Gospel: 'And this is the condemnation, that light is come into the world, and men loved darkness rather than light, because their deeds were evil' (John 3:19–20).

We do not know whether Rembrandt's changes to the *Three Crosses* mirrored changes in his own state of mind in the troubled years towards the end of his life; the artist whose face is known to us more intimately than any other's kept his own counsel, and left no evidence beyond the etchings themselves.

We know a great deal, on the other hand, about what Michelangelo felt when, at the end of his life, he sculpted his two last great versions of the *Pietà*.

The Italian word *pietà* means both piety and pity; devotion and mercy. It is used in Italian art to designate images of the dead Christ lamented by his mother, alone or with others. But there are many different moments between the Crucifixion and the Entombment, and the theme can be richly inflected.

Michelangelo first addressed it when, as a young man of twenty-two, he was commissioned by a French cardinal, Jean Villier de la Grolaie, to sculpt a *Pietà* for his funerary chapel in St Peter's in the Vatican [PLATE 51]. Jacopo Galli, the go-between who organized the commission, asserted that it would be 'the most beautiful marble statue in Rome, and no living artist could better it'. Few

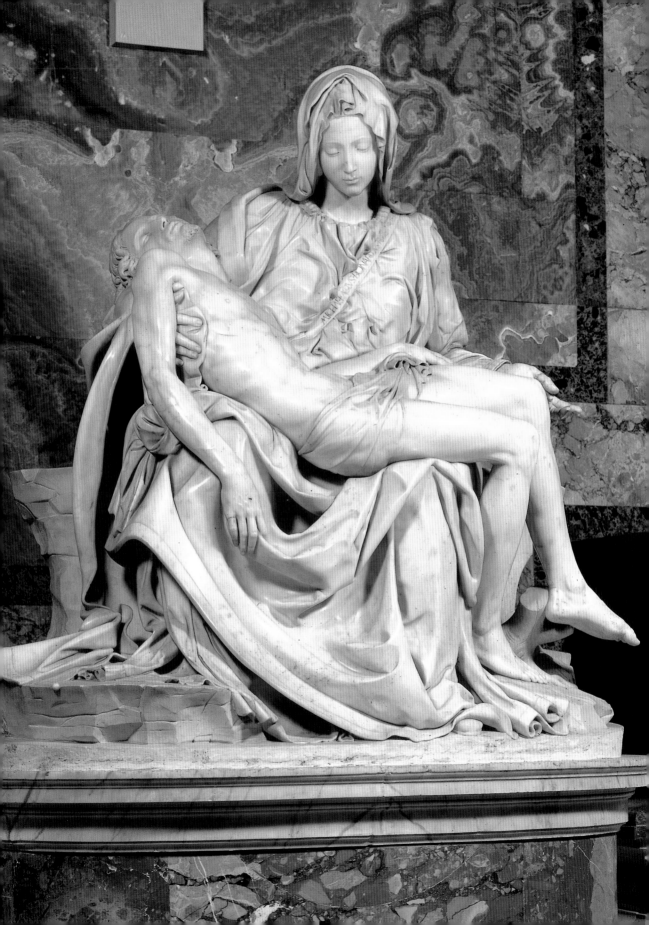

people today would disagree. What Leonardo's *Last Supper* is to the imagery of Christ's life, Michelangelo's Vatican *Pietà* is to his death. Innumerable reproductions have made this effigy familiar: and this is how most people, Catholics, Protestants and unbelievers, now imagine the Virgin Mary bidding farewell to her son before consigning him to the tomb.

Yet Michelangelo was doing something new, for this is the earliest Italian sculpture of this subject. Italian artists had been representing the Lamentation over the dead Christ since the thirteenth century, but always in scenes where Mary is joined by the disciple St John and the holy women. The independent effigy of the lamenting Virgin with her son was a German invention, intentionally recalling images of the Mother and Child. It spread as a focus of devotion, and as a funerary image, from Germany to the Netherlands, England, Spain and France, and it must have been the French Cardinal Villier who specified the two-figure group when he ordered a life-size marble version for his own tomb.

Mary sits on a rock, her right foot slightly raised, with the limp body of Christ on her lap. Vasari, the sixteenth-century painter, architect and art historian – and Michelangelo's fervent admirer – writes of it in his *Life of Michelangelo*:

> *No portrayal of a corpse can be more realistic, yet the limbs have a rare beauty, and the muscles, veins and nerves stand out to perfection from the bone-structure. The face bears an expression of infinite tenderness, and all the joints, especially those which link the arms and legs to the body, have a wonderful harmony. So superb is the tracery of veins beneath the skin that it is a source of never-ending wonder how an artist could achieve such divine beauty.*

The sculpture is not, however, an image of the dead Christ but of Mother and Son, together, undivided in the beauty of youthful death, and scholars have rightly, I believe, associated it with verses in Dante's *Divine Comedy* that purport to be a prayer by St Bernard addressed to the Virgin. The Italian is so beautiful that I will cite it in the original as well as in English translation:

> *Vergine madre, figlia del tuo figlio,*
> *Umile ed alta più che creatura,*
> *Termine fisso d'eterno consiglio.*
> *Tu sei colui che l'umana natura*
> *Nobilitasti sì, che il suo fattore*
> *Non disdegnò di farsi sua fattura.*

Virgin mother, daughter of your son,
Lowly and exalted more than any creature,
Fixed purpose of the eternal counsel,
You are she who so ennobled human nature
That its maker
Did not disdain to make himself of its making.

The Florentine Michelangelo was an ardent reader of Dante, the great Florentine poet, and knew long stretches of his *Divine Comedy* by heart; there is no reason to doubt that he had this celebrated passage in mind. It would explain what has seemed puzzling to many viewers: why the Virgin in the Vatican *Pietà* appears so young, and so beautiful at this moment of atrocious grief. When asked, Michelangelo, known for his gruff and ironic Florentine wit, is said to have replied: 'She has stayed young because she has stayed pure [i.e. a virgin].' But the youthful sculptor and student of antique statuary, who believed with the Neoplatonist philosophers of the Medici court that physical beauty is an emblem of the beauty of the soul, is more likely to have been inspired by Dante's theology. Michelangelo's Virgin is young and beautiful because his Christ must be young and beautiful – like a sculpted pagan divinity, say, the sun god Apollo; and Dante's verses stress the natural, familial likeness between Mary and her Son. The Vatican *Pietà*, although intended to be placed above an altar, where Christ's death will be regularly re-enacted, is a particular meditation on the Incarnation, when the beauty of God was made manifest on earth.

On the Virgin's sash the young prodigy proudly inscribed the words *Michel Angelus Buonarotus Florentinus faciebat*: 'Michelangelo Buonarroti, Florentine, made this'. It was to be the only time he signed his work.

Many decades later, when Michelangelo was in his seventies, obsessed with thoughts of mortality and sin, he returned to the theme of the dead Christ in a sculpture, this time made to stand on an altar above his own tomb. Exasperated with faults in the marble, and perhaps for other, more personal reasons, he left it unfinished and mutilated, with Christ's left leg broken off. Rescued from total destruction by friends of the sculptor, it is now in the museum of Florence Cathedral [PLATE 52].

The still moment of Lamentation is past. Michelangelo now shows us the more active Deposition or Entombment, and so he shifts the focus from the Virgin Mary, now a huddled figure on the right, to the body of Christ; from the mystery of the Incarnation to that of the Eucharist. For as Christ's gigantic body, broken in suffering and death, is lowered onto the altar, it becomes in every celebration

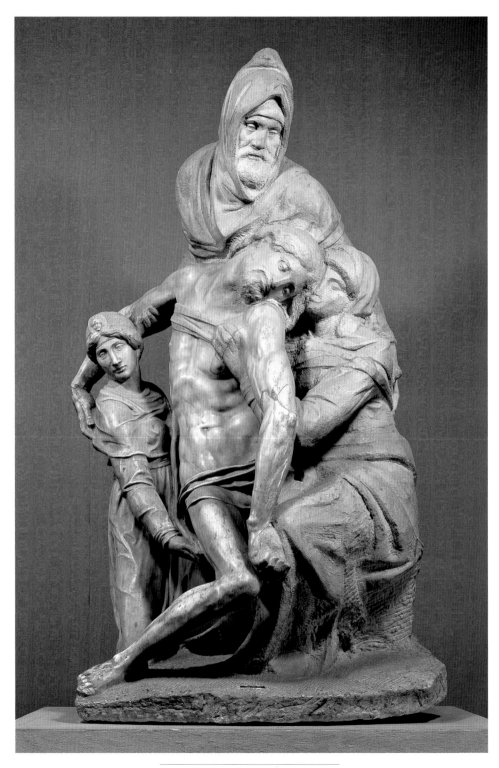

52 MICHELANGELO *Pietà*, begun *c.* 1545

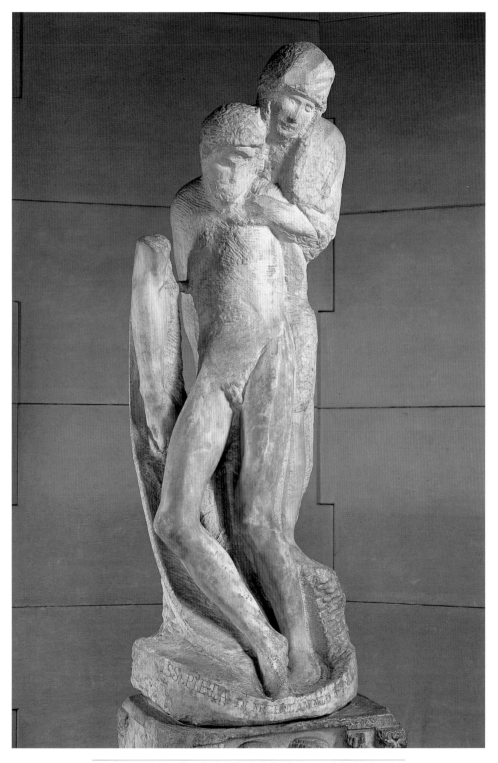

53 MICHELANGELO *Rondanini Pietà*, unfinished at artist's death, 1564

of the Mass, the 'bread of life' of his promise: 'If any man eat of this bread, he shall live for ever: and the bread that I will give is my flesh' (John 6:51).

On the left is one of the holy women, probably Mary Magdalene, attending the Virgin – a figure left unfinished by Michelangelo and later brought to chilly completion by another sculptor, Tiberio Calcagni. Behind and above, assisting the Virgin in supporting the dead Christ, is a tall hooded man with the distinctive broken nose and brooding face of Michelangelo himself. He could be Joseph of Arimathaea, the rich man who offered his own tomb for Christ's burial, but Michelangelo's pupil and biographer Condivi identifies him as Nicodemus, who provided a hundred pounds of myrrh and aloes to anoint the body of Jesus (John 19:39).

There are many reasons why Michelangelo may have wanted to identify himself with Nicodemus, the fearful Pharisee who in St John's Gospel comes to Jesus by night. In the conversation that St John records, one of the most extended dialogues in any of the Gospels, Jesus gives this one man an exalting vision of divine mercy. What might these words have meant to Michelangelo?

> *Verily, verily, I say unto thee, Except a man be born again, he cannot see the kingdom of God.*
>
> *Nicodemus saith unto him, How can a man be born when he is old? Can he enter the second time into his mother's womb, and be born?*
>
> *Jesus answered, Verily, verily, I say unto thee, Except a man be born of water and of the Spirit, he cannot enter into the kingdom of God.*
>
> *That which is born of the flesh is flesh; and that which is born of the Spirit is spirit.*
>
> *Marvel not that I say unto thee, Ye must be born again.*
>
> *The wind bloweth where it listeth, and thou hearest the sound thereof, but canst not tell whence it cometh, and whither it goeth: so is every one that is born of the Spirit.*
>
> *Nicodemus answered and said unto him, How can these things be?*
>
> *Jesus answered and said unto him, Art thou a master of Israel, and knowest not these things?*
>
> *Verily, verily, I say unto thee, We speak that we do know, and testify that we have seen; and ye receive not our witness.*
>
> *If I have told you earthly things, and ye believe not, how shall ye believe, if I tell you of heavenly things?*
>
> *And no man hath ascended up to heaven, but he that came down from heaven, even the Son of man which is in heaven.*

*And as Moses lifted up the serpent in the wilderness, even so must
the Son of man be lifted up:*

*That whosoever believeth in him should not perish, but have
eternal life.*

*For God so loved the world, that he gave his only begotten Son, that
whosoever believeth in him should not perish, but have everlasting life.*

*For God sent not his Son into the world to condemn the world; but
that the world through him might be saved.*

JOHN 3:3–17

To the artist at this stage of his life, tormented by doubt and fear, Jesus's assurance that an old man like Nicodemus could be born again, and saved, must have spoken powerfully and consolingly.

But Nicodemus, as we saw in Chapter Six, was according to legend also the sculptor of the *Volto Santo* [PLATE 30], a True Likeness of Christ. And it is surely in both aspects of Nicodemus, as artist and as anguished believer who anointed Christ for burial, that Michelangelo here plays his part in the Passion and makes ready for the tomb the body of his Saviour.

We know something of Michelangelo's state of mind while he worked from Vasari's *Life*, where the author writes of himself in the third person:

*Once Vasari was sent by [Pope] Julius III at the first hour of the night
to Michelangelo's house to fetch a design, and he found Michelangelo
working on the marble Pietà that he subsequently broke. Recognizing
who it was by the knock, Michelangelo left his work and met him with
a lamp in his hand…. Then Vasari's eye fell on the leg of the Christ on
which Michelangelo was working and making some alterations, and he
started to look closer. But to stop Vasari seeing it, Michelangelo let the
lamp fall from his hand, and they were left in darkness. Then he called
Urbino [Michelangelo's servant] to fetch a light, and meanwhile, coming
from the enclosure where he had been working, he said, 'I am so old
that death often tugs my cloak for me to go with him. One day my
body will fall just like that lamp, and my light will be put out.'*

By night, by lamplight, Michelangelo attacks the stone block to find in it figures bound together in love and sorrow, before Christ's body slides out of reach – hands wreathed about the great stone pyramid, comforting, reaching out, holding on, relinquishing.

In the crude urgent hatching of his claw chisels, in these unformed yet infi-
nitely expressive faces, we sense the old sculptor hastening to assert his faith in the
redeeming grace of his Saviour. For it is in front of this figure which he himself
has created, that he intends masses to be said for his soul.

Yet, in the end, the recalcitrant marble defeats him, and he rejects the never-
finished work, sets out to smash it utterly. Having, as a young man, sought God
in the radiant nudity of pagan gods and polished marble, Michelangelo could not,
even here, overcome the compulsion to interpret spiritual grace by physical
means. This dead Christ is no longer the youthful Apollo of the Vatican Pietà –
but it is nonetheless his perfectly muscled body, like that of an ancient athlete and
warrior, that signals the immensity of his suffering, the pathos of his sacrifice.

Having abandoned the Florentine *Pietà*, Michelangelo did not, however,
abandon the theme of the dead Christ. As Vasari tells us: 'It was now necessary
for him to find another block of marble, so that he could continue using his chisel
every day; so he found a far smaller block containing a *Pietà* already roughed out
and of a very different arrangement.' This work was bequeathed by Michelangelo
to a faithful servant and is now in the Castello Sforzesco, the city museum of
Milan; it is known as the *Rondanini Pietà*, after a Roman collector who once
owned it [PLATE 53]. We see it as it was on that Saturday in February 1564, when
a visitor – Michelangelo's young protégé the painter Daniele da Volterra – found
the eighty-nine-year-old sculptor standing all day working on the body of Christ.
Five days later the old man was dead.

Three versions at least of this group are visible in the one sculpture, of which
two were rejected and mutilated by Michelangelo himself. The polished legs of
Christ, and his detached right forearm, belong to the first version, begun perhaps
even before 1545, when he started work on the Florentine *Pietà*. But he must have
abandoned this conception, and carving deeper into the stone that remained, he
roughed out the forehead and hairline of another figure of Christ, above and to
the right of the present figure, and the forehead and eyes of another Virgin Mary.
These seem to belong to the early stages of a second version. That, in its turn,
seems to have been rejected. And what was left of the marble block was worked
for a third time, in pursuit of yet another vision of this moment of ultimate loss.

What remains now is Mary standing on a stone, embracing the lifeless but
upright body of her Son. She cannot be said to be holding him up: her left hand
rests on one of his shoulders, her barely visible right hand cradles his neck.
Christ's attenuated body has become weightless. His face has been broken off, but
in what little stone is left Michelangelo has incised eyes, a nose, a mouth – a face
inclined in death as the Virgin's is in sorrow, both looking down into the abyss.

It is the last time Mary will touch that limp, still yielding body of her body, that head carved out of her own right shoulder. All that the earth has of love for Christ grieves with her.

Michelangelo's emulation of ancient sculpture – heroism, physical beauty, the cunning balance of forms and voids, weights and counterweights – has been definitively cast aside. This is marble not so much carved as savaged. Nor does the sculptor show us a particular moment in the narrative drama of Christ's death and entombment. This is a private investigation of love and loss. This mutilated, fathomless relic of a *Pietà* resumes all partings: Michelangelo's farewell to marble; the Virgin's last embrace of her son; the soul's anguish at separation from Christ.

Michelangelo's wetnurse was married to a stone mason, and when grown he used to say he had imbibed stone carving with her milk. He had always seen form, art's equivalent to the spirit, imprisoned in the stone block, from which it was his task to free it with his chisel. Now at the very end of his life, he destroys the marble, the material work of art itself, to release the spirit, so that his own spirit may be released and redeemed.

PART FOUR

THE RISEN CHRIST

Jesus saith unto her, Touch me not:
for I am not yet ascended to my Father:
but go to my brethren, and say unto them,
I ascend unto my Father, and your Father;
and to my God, and your God.

JOHN 20:17

54 HANS HOLBEIN *Dead Christ*, 1521

55 KÄTHE KOLLWITZ *The Downtrodden*, 1900

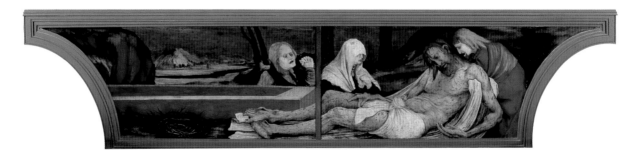

56 MATHIS GRÜNEWALD *The Entombment*, from the Isenheim Altarpiece, 1510–16

THE BODY LOWERED AND RAISED

The body of a thin bearded man, bruised and pierced, lies on a slab [PLATE 54]. His eyes stare upwards, the lower jaw, slack in death, hangs open, as if to echo those terrible last words: 'My God my God, why hast thou forsaken me?' and 'It is finished.' As the wounds in the bruised hands and feet make plain, this is the body of Jesus of Nazareth. His life has shrunk to six feet by one – the picture is the same size as a coffin. It is a coffin.

The Roman numerals and the initials painted above his feet tell us the date and author of this image: 1521, Hans Holbein. The angle of the inscription shows that it is written as though on the short inner side of a coffin; perspective makes it seem to slope away from us. The artist who would later, in England, immortalize the majesty of a king, here depicts another king – not just a dead man, but a dead God; Jesus, the Christ. God has become man, and man has just put God brutally to death.

We have no idea where this picture was commissioned for, or how it might originally have been seen. But I think we can be sure that, like all great works of art, Holbein's *Dead Christ* now speaks to us in ways the artist can hardly have imagined. For how we react to this horrifying image depends on what we believe.

For Christians, it remains what it was when Holbein painted it: the disciples' vision of the sepulchre on that bleak Saturday which followed the Crucifixion. The moment of absolute despair, which reminds us that we must die with Christ, but also the moment which will be obliterated by the dazzling light of the Resurrection.

Even for an age without faith, for whom not only Christ but God is dead, this painted corpse still has meaning. It comes at the end of a story – and what happened before in this story, or may happen after, affects our view of the image. It reappears at the end of the nineteenth century in an etching by Käthe Kollwitz, a German artist with strong moral and social convictions but professing no religious faith. And in her art, this corpse marks the tragic conclusion of a cycle of human suffering, a story that, in spite of striving and loving, ends in the grave.

Married to a doctor, Kollwitz moved with him to a densely populated
working district of Berlin, where his patients – tailors and their dependants
enrolled in a health insurance group – lived in cheaply built tenements, 'human
warrens' with little light and inadequate sanitation, that were breeding grounds of
misery and disease.

In February 1893 the twenty-five-year-old Kollwitz attended the opening of
a subversive new play and found a theme that enabled her to make a stunning
public début as an artist and as advocate for the downtrodden. Gerhart
Hauptmann's *The Weavers* was ostensibly based upon a historic uprising of
Silesian weavers in 1844, but it indirectly comments on the desperate contempo-
rary situation of industrial workers in Kaiser Wilhelm's Germany, and indeed
throughout industrialized Europe.

Kollwitz's cycle of etchings freely based on the play goes further, referring to
what she saw as the general, unchanging plight of the proletariat, and the contin-
ual nature of their protest. As a conclusion to a series of realistic images of
poverty, rebellion and death, she first designed the symbolic *From Many Wounds
You Bleed, O People*. A man with a sword bends over the corpse modelled on
Holbein's *Dead Christ*. Naked female figures bound to columns on either side
personify Poverty and Shame; suicide and prostitution.

Four years later, in 1900, she reworked the idea as an independent image,
The Downtrodden [PLATE 55]. The two allegorical female figures have been
moved to one side. On the other, realistically depicted, a mother cradles the head
of her dead child, a father dangles a hangman's noose, in a despairing recasting of
a Holy Family with Jesus, Mary and Joseph. For the poorest in Berlin, there is no
chance of a flight into Egypt; death – by disease or by suicide – is the only escape.

In Kollwitz's hands, Holbein's *Dead Christ* becomes a secular image. This
victim of injustice will not know resurrection. But the body of Christ here stands
for all the downtrodden of the world, and their lot can be transformed, not by
divine intervention, but by our social and political action. Although no longer
explicitly Christian, the purpose of this image, and the way it works, are, in fact,
very familiar. As in Franciscan Passion imagery, we are called to acts of charity;
like Pontius Pilate in Rembrandt's *Three Crosses*, we are confronted with the evil
we could prevent but do not.

For many centuries a secular response to Holbein's *Dead Christ* would have
been unthinkable. In the Christian view, the death of Jesus was, of course, only
part of the story of Christ. Christ's body, which he gave for the life of the world,
offered on the Cross and laid in the grave, became the living bread of the
Eucharist.

In the early Church, believers broke bread together to commemorate the Lord's Supper, to give thanks for Christ's sacrifice on their behalf, to celebrate their own fellowship with him and each other, as they together formed, in yet another sense, the body of Christ in the church.

Although in later centuries the bread shared at this communal meal was replaced by a specially consecrated bread or wafer, the Host, dispensed by a priest to a congregation, its meaning did not change. And it is this meaning, or complex of meanings, that altarpieces are made to communicate. They are designed to attract our eyes to the altar – in the Roman Catholic tradition both the place of sacrifice and the table of fellowship at which the Eucharist is administered – and to focus our attention on the Eucharist itself as it is elevated for worship during the service of Holy Communion.

One of the most profound and for me one of the most moving eucharistic altarpieces in Western art is an enormous triptych, a three-panelled folding painting, by Peter Paul Rubens, still on the altar in Antwerp Cathedral for which it was originally made [PLATE 57].

It was commissioned in 1611, soon after the artist's return home from an eight-year sojourn in Italy, and his appointment as court painter to the Archduke Albert and Isabella, Regents of the Southern Netherlands for the Crown of Spain. Rubens, who had learnt early in life to mistrust court life, obtained permission to reside in Antwerp rather than in Brussels, and with it the freedom to accept employment from others.

The Twelve Years' Truce had been signed in 1609, recognizing the break-away Protestant Dutch Republic of the Northern Netherlands. But with the recapture of Antwerp in 1585 the Southern Netherlands were secured for Spain and the Catholic Church, and one of the peace conditions was that the altars dismantled under the city's iconoclast Calvinist regime would be restored. A decree obliged the guilds, who each had an altar dedicated to their patron saint, to have the necessary work carried out – thus triggering a bonanza for masons, carpenters, sculptors, gilders and painters.

Rubens's patrons, the Guild of Arquebusiers, were late in ordering their new altar, and the chapter of the cathedral had had to press the matter several times before they finally did so. The arquebusiers were not a craft or merchants' guild but a civic militia (an arquebus is an early type of portable gun), and perhaps only after the truce was signed were its members able to buy themselves off from the obligation of active service, which was the guild's way of financing their altar-piece. Rubens was recommended to them by their head, his friend Nikolaas Rockox; as the garden of his new house also abutted the arquebusiers' shooting

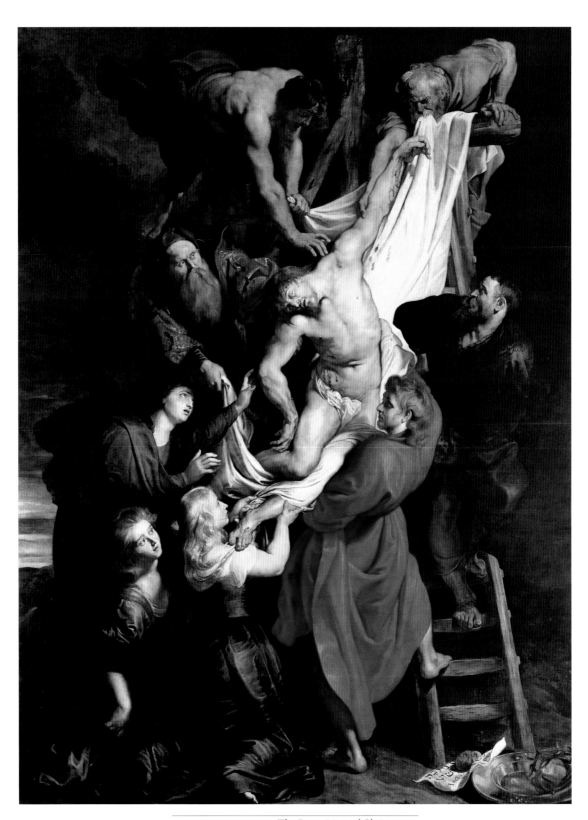

57 PETER PAUL RUBENS *The Deposition of Christ*, 1612

range, the contract was also a way of composing neighbourly differences, like who should pay for a common wall.

The arquebusiers' patron saint was Christopher, a legendary giant who sought to serve the most powerful ruler in the world. His first master, an emperor, was frightened by the devil, so Christopher switched allegiance from the emperor to Satan. But the devil in turn was frightened of a crucifix, and Christopher was converted by a wise old hermit to the service of Christ. Since he did not know how to say his prayers, the hermit set him the task of serving Christ by helping his fellow men, carrying them on his broad shoulders across a river. One dark and stormy night, Christopher heard a little child crying to him from the shore to help him across. As he carried him, the child grew so heavy that the giant nearly toppled into the raging flood. When he asked the reason why, the little boy – who was, of course, the Christ Child – answered that Christopher had been bearing the world's Master, and with him the weight of the whole world, on his back. He had found the most powerful ruler in the world.

The guild naturally wanted their altar to honour their patron saint. But the Council of Trent, in their broad reform of Christian art (see p. 118), had stipulated that altarpieces must not stray too far into the dangerous territory of saints and legends: only Christ could be represented in the central scene.

The learned, ingenious and devout Rubens made a virtue of necessity. Recalling that the name Christopher means 'bearer of Christ', he designed the entire triptych to reflect the theme of 'bearing Christ'. The outside shutters, which close over the central panel, show, on the left, the bemused giant fording the river, his cloak blowing in the wind, with a tiny Christ Child riding on his shoulder. On the right, the saintly hermit holds up a lantern to light their way. He too can be said to be bearing Christ, the Light of the World. During services, of course, the triptych would be opened, and three scenes of bearing Christ would become visible. On the left is the Visitation, when Mary pregnant with Jesus – bearing Christ – comes to visit her cousin Elizabeth, pregnant with John the Baptist:

> *And it came to pass, that, when Elizabeth heard the salutation of Mary, the babe leaped in her womb; and Elizabeth was filled with the Holy Ghost:*
>
> *And she spake out with a loud voice, and said, Blessed art thou among women, and blessed is the fruit of thy womb.*
>
> *And whence is this to me, that the mother of my Lord should come to me?*

For, lo, as soon as the voice of thy salutation sounded in mine ears,
the babe leaped in my womb for joy.
 And blessed is she that believed: for there shall be a performance of
those things which were told her from the Lord.
 LUKE 1:41–5

On the right is the Presentation in the Temple,

And, behold, there was a man in Jerusalem, whose name was Simeon;
and the same man was just and devout, waiting for the consolation of
Israel: and the Holy Ghost was upon him.
 And it was revealed unto him by the Holy Ghost, that he should not
see death, before he had seen the Lord's Christ.
 And he came by the Spirit into the temple: and when the parents
brought in the child Jesus, to do for him after the custom of the law,
 Then took him up in his arms, and blessed God, and said,
 Lord, now lettest thou thy servant depart in peace, according to
thy word:
 For mine eyes have seen thy Salvation.
 LUKE 2:25–9

Mary bears Christ in her womb, and his divinity is recognized by the unborn
Baptist; Simeon holds him in his arms, and sees his salvation.

But the panel Rubens designed and painted first, the central panel that fits
directly over the altar and gives a deeper meaning to these joyful epiphanies of
Christ's infancy on either side, is the great *Deposition* [PLATE 57]:

Then took they the body of Jesus, and wound it in linen clothes with
the spices as the manner of the Jews is to bury.
 Now in the place where he was crucified there was a garden; and in
the garden a new sepulchre, wherein was never man yet laid.
 There laid they Jesus therefore because of the Jews' preparation day;
for the sepulchre was nigh at hand.
 JOHN 19:40–42

In Rubens's altarpiece, Christ's dead body is not yet being wound in the linen
cloth. The gleaming white shroud is being used to bear Christ, to lower him
lovingly and reverently down from the Cross into the sepulchre.

It is not a sepulchre that stands below, but the altar – and for the Church the altar *is* Christ's sepulchre. Here the body sacrificed for others will be distributed as the eucharistic host – just as the basin of blood Rubens painted beneath the Cross will reappear as the eucharistic wine.

The story of the altarpiece will be completed again and again for those who receive communion will, in turn, bear Christ's body, and become members of one living body, the Church of which Christ is head: 'So we, being many, are one body in Christ, and every one members one of another' (Epistle to the Romans 12:5).

The arquebusiers, commissioning their altarpiece, acquired a work of art not just for, but about themselves. The great mystery of the Christian Church is that the earthly story of Christ does not end with his Entombment, that his body is raised on Easter Sunday.

In the oldest depiction of Christ's Passion, the tiny fifth-century Roman ivory carvings [PLATE 39], Easter is shown in a way that may now seem very strange. By the tomb of Christ the soldiers are sleeping and two women sit mourning in conventional attitudes of grief. From none of these would we guess that anything unusual had occurred. But the spectator sees what they have not yet seen, that the doors are open and the tomb is empty. We glimpse what the holy women and the Apostles were in a minute to glimpse – from the tomb scrupulously sealed and watched, the body of Christ has been removed. It is the same scene that we see in the mosaic cycle of the Passion at Sant'Apollinare Nuovo in Ravenna, discussed in Chapter Seven.

Its true significance is as hard for us to grasp as it was for Christ's followers. The empty tomb is an absence to be lamented, apparently evidence only of a stolen body, not yet a miracle to be celebrated. Its implication – the resurrection in the flesh of Christ – will be understood, by the viewer as by the holy women, only later, through his miraculous appearances – to the disciples on the way to Emmaus, and to the Apostles gathered together when the doors are shut.

Although critical as a clue to what has happened, the image is nonetheless pictorially underwhelming – and we can understand why it never became a favourite scene with artists: absence is hard to make compelling; inference is dull to paint. And so artists seeking to elicit an immediate, deeply felt response had to find another way of representing the Resurrection – a dramatic transformation witnessed at first hand.

None is more dramatic than the *Resurrection* painted by Grünewald for the Isenheim altar [PLATE 58; see also PLATES 41 and 56, and pp. 129–37].

When the altar was closed, you will remember, it showed the atrocious sufferings of the crucified Christ, and the grief and pain of those who loved him.

As the outer shutters were opened, scenes of joyful miracles attested to his divine nature – the Annunciation to the Virgin Mary, angels serenading the Nativity – concluding with the most joyful and most miraculous scene of all: the breathtaking moment when Christ rises from the tomb.

Its heavy stone lid is cast aside, and the sleeping guards are scattered as if by an explosion in the night. Christ's trailing white linen shroud now changes colour as it floats upwards with him, first turning royal red and finally gold. But for the five wounds in his hands, feet and side, and which Grünewald here shows emitting rays of golden light, his body is intact and glorious. His face, so distorted by anguish in the panels of the *Crucifixion*, has been restored to its True Likeness, transmuted into golden light, so that we see him as the three disciples once saw him on a high mountain, when he was 'transfigured before them: and his face did shine as the sun' (Matthew 17:2). Behind him the sun itself rises; as in the first centuries of the Church, Christ is the Sun of Justice (see p. 73).

Grünewald shows us what, according to the Gospels, nobody saw. And he not only shows us the miracle of the Resurrection, he compels us to see its significance. Unlike the holy women and the Apostles, we need neither mourn nor doubt beside the empty tomb. We are made witness to the explosive triumph of light over darkness – and realize that neither death nor life will ever be the same again. The dead body we saw mutilated on the Cross, which still lies beside the tomb on the predella below, is raised and made glorious.

But to those who had not seen this vision – who had seen only the empty tomb – what did the risen body mean? The early Church was in no doubt what our response should be – which is why artists usually followed the scene of the Empty Tomb with that of the Incredulity of Thomas, the miraculous appearance of Christ which teaches that to be saved we must believe.

Yet the appearance to the Apostles was not the first miraculous appearance of Christ after the Passion. By returning to the Gospel account of what happened after the tomb was found empty, artists were able to express the fundamental transformation that the Resurrection had brought about in the relationship between mortals and God.

Titian's *Noli me tangere*, now in the National Gallery, London, is about the size of a poster that you might put up in your room [PLATE 59]. And it was in fact probably painted, in Venice around 1510, to be used in a private room, for individual contemplation and devotion. The event it addresses is the great turning-point in the Gospel of St John. Coming on Easter morning, Mary Magdalene has found the tomb empty, and summoned Peter and John. Startled by what they have seen, the men return bewildered to their colleagues:

58 MATHIS GRÜNEWALD *The Resurrection*, from the Isenheim Altarpiece, 1510–16

*But Mary stood without at the sepulchre weeping: and as she wept,
she stooped down, and looked into the sepulchre.*

*And seeth two angels in white sitting, the one at the head, and the
other at the feet, where the body of Jesus had lain.*

*And they say unto her, Woman, why weepest thou? She saith unto
them, Because they have taken away my Lord, and I know not where
they have laid him.*

*And when she had thus said, she turned herself back, and saw Jesus
standing, and knew not that it was Jesus.*

*Jesus saith unto her, Woman, why weepest thou? whom seekest
thou? She, supposing him to be the gardener, saith unto him, Sir, if thou
have borne him hence, tell me where thou has laid him, and I will take
him away.*

*Jesus saith unto her, Mary. She turned herself, and saith unto him,
Rabboni, which is to say, Master.*

*Jesus saith unto her, Touch me not: for I am not yet ascended to
my Father: but go to my brethren, and say unto them, I ascend unto my
Father, and your Father; and to my God, and your God.*

JOHN 20:11–17

Mary Magdalene, her auburn hair catching the early morning light, kneels on the
ground. Her left hand rests on the jar of ointment, her right is lifted in wonder at
the gardener who has turned out to be the risen Christ.

Christ, his feet pierced with the nails of the Cross, gathers his shroud round
him as he bends away from her hand. But he also leans towards her, comforting
and sheltering. To our surprise he holds a hoe; it is as though he has tactfully
picked it up in order to reassure her that it was quite natural she should mistake
him for the gardener – an elegance of manners that matches the graceful swaying
of his body, as it does the courtliness of the Latin imperative, *Noli me tangere*:
'Desire not to touch me.'

Mary is the first person to see the risen Christ, as she has just been the first
to see the empty tomb. The prime witness to the two proofs of the Resurrection,
she stands, or rather kneels, for all subsequent believers.

The subject of *Noli me tangere* was not a very common one in Venice at the
time; but the Magdalen was, then as now, a saint with whom many found it easy
to identify – the woman who had enjoyed the pleasures of the world and of the
flesh, who had sinned and loved much and yet had been found acceptable by
Christ. She might have seemed especially sympathetic to Titian, who, like her, was

both idiosyncratically devout and sexually irregular: he was ultimately to marry the mother of his son only because he thought (mistakenly, as it turned out) that she was on her deathbed. But for whatever reason or motive – and we have no idea for whom the picture was made – Titian's treatment of the subject is a close and subtle meditation on the Gospel text.

As Christ stands, calling Mary by her name, telling her that he is ascending to his father and to hers, we note the flock of sheep behind him. This may, of course, be merely a conventional landscape element: after all, sheep are often found in fields – but it is hard not to see him as Christ the Good Shepherd of St John's Gospel (John 10:1–18), who has just laid down his life for his sheep.

But there is more. Titian is among the greatest love poets of the Western tradition, and this picture is above all a study of different kinds of love. It shows the moment at which earthly, corporeal love recognizes its limits and is transformed and sublimated into divine love. It is to tend Christ's body that Mary has come to the garden. She weeps at the empty tomb because they have taken away her Lord, and she accosts the gardener only in order to be able to remove the corpse. Even after death, it is through physical contact, by honouring his body, that she seeks to express her love of Christ. And when he appears, she reaches out to touch it, in a gesture eloquent of physical desire.

Yet the time of bodily love, of the love she understands, is past. Christ draws back from one kind of contact and leans forward to offer another, for which the time has not yet quite come: he is not yet ascended. With a Mozartian subtlety of movement, the two figures express a perfect equivalence of yearning. Mary's gesture concedes that what she loves is now unattainable in the terms familiar to her, that the fulfilment of her love will be not physical, but spiritual. And her anguish of a few minutes before is resolved; because a lord who cannot be touched is a lord who can never be taken away.

The meaning is carried as much by the landscape as by the figures. While the ground on which Mary kneels is brown and barren, Christ stands amidst new green growth. In a literal, spatial sense, he has passed from death to life. Behind Mary, fortified buildings of farm and town suggest wealth and security, the comfort of human society. It is also the side on which the unseen tomb must lie. Behind Christ we see the flock of sheep and the lapis lazuli blue of Heaven, a community to which she and the Apostles are summoned in due course, to be with 'my God and your God'. The two sides of the landscape are held in balance by the brilliant ultramarine of the sky and the red of Mary's dress, and yet linked by the central tree, which continues the line of Mary's back in a strong diagonal rising from right to left, carrying her movement upwards.

59 TITIAN *Noli me tangere, c.* 1510–15

I think we can be certain that some at least of this was consciously intended by Titian. Like most Venetians, he worked out his composition on the canvas, and traces of his earlier thinking can be seen either with the naked eye or thanks to X-rays. Originally, he may have painted Christ walking out to the left, rejecting the Magdalen's love, but not offering his own. The two backgrounds appear to have been switched at quite an advanced stage of the composition, the buildings being moved from Christ's side to Mary's. And the central tree was originally plumb in the middle, dividing the canvas unequivocally, a small lollipop-shaped affair, which Titian later hid under a grey cloud. The link between the present, slanting tree and the Magdalen, which now unites the two halves of the picture, was therefore no accident.

The picture has long been acknowledged as one of Titian's greatest creations, but it also has a distinguished place in the history of the National Gallery. When war broke out in 1939, the gallery's entire collection was evacuated to a slate mine in North Wales. Eventually, in January 1942, it was decided that every month one picture should be brought back to sustain the public, brave the bombs in Trafalgar Square and to hang alone in the gallery. Kenneth Clark, then the Director, solicited the public's views on which picture should return, and was astonished to find that the first two requests were for Titian's *Noli me tangere* and El Greco's *Agony in the Garden*.

In the bleak circumstances of the time, both choices have a striking resonance. But Clark, knowing that the *Agony in the Garden* was only a studio work, and mindful of his role as guardian of the nation's aesthetic standards, refused to let it come to London. And so the *Noli me tangere* became the first Picture of the Month, drawing such crowds that the scheme was continued for the rest of the war. Every month tens of thousands came to contemplate one picture, and returned next month to see another. In a way rarely before experienced in modern times, great paintings became part of everyday life.

High-handed though it may now seem, Clark's judgment was, I believe, entirely sound in deciding that the first Old Master painting to return to London should be the Titian. For it is a meditation not so much on an episode of Christ's life as on a constant in ours, and one that was quite inescapable in 1942. Titian has painted the moment in everyone's life when it becomes clear that love is transformed, but not diminished, by the destruction of the body. Sublime, enduring love will, with faith, bring about the impossible reunion.

Speaking to Mary Magdalene, Christ foretells his ascension to his Father in Heaven. It is effectively the opening episode of the Acts of the Apostles. Christ has chosen the followers,

*To whom also he shewed himself alive after his passion by many
infallible proofs, being seen of them forty days, and speaking of the
things pertaining to the kingdom of God …*

*And when he had spoken these things, while they beheld, he was
taken up; and a cloud received him out of their sight.*
ACTS OF THE APOSTLES 1:3, 9

Unlike his other miraculous appearances after his death, Christ's last appearance
on earth posed an almost insoluble problem for the artist. For the important thing
about this appearance was the fact of disappearance, and as we saw in the empty
tomb, absence is hard to paint interestingly. Christ's Ascension is the final proof
that he is now 'at the right hand of God'; that we are waiting for him to come back,
and that the purpose of the Church is to prepare everyone for his Second Coming.

The art of the early Church found all this impossible to represent – and since
movement is as difficult to paint as absence, most artists continued to show the
Ascension as a static scene: Christ standing on the Mount of Olives, where the
Ascension was thought to have taken place, or seated among the clouds, with the
Apostles below. The significance of such scenes could never have been very clear
to many viewers.

As the faithful in the later Middle Ages began more actively to engage with
Christ's life, death and miracles, a new kind of image evolved – of which a little
woodcut by the great German artist Albrecht Dürer is one of the last and most
famous examples [PLATE 60].

The artist's intentions are obvious: to make us feel we are witnessing the
Ascension as the Apostles witnessed it. Christ disappears beyond the upper frame
of the print as he disappeared before their gaze, his feet and the hem of his gown
seen in perspective from below. The cloud is a mere accessory, for, as theologians
insisted, Christ is not hidden by it but disappears of his own volition. He leaves
behind him his footprints – the miraculous footprints that pilgrims to the Holy
Land flocked to see on the Mount of Olives.

The print's meaning may be profound, but the image to modern eyes cannot
help seeming absurd, as Christ vanishes from sight like a self-propelled missile.
In this instance, Dürer's art is an irrecoverable victim of the space programme.

If Christ's Ascension, his physical departure from earth, is almost impossible
to represent, his reappearance at the end of time offers magnificent pictorial
opportunities. The theology of the Second Coming has always been hard to grasp,
and, from the Gospels onwards, for this reason it has perhaps been most
powerfully expressed through images.

60 ALBRECHT DÜRER *The Ascension of Christ*, from the *Little Passion*, 1509–11

CHAPTER ELEVEN

TILL KINGDOM COME

*And then shall appear the sign of the Son of man in heaven: and then
shall all the tribes of the earth mourn, and they shall see the Son of man
coming in the clouds of heaven with power and great glory.*

*And he shall send his angels with a great sound of a trumpet, and
they shall gather together his elect from the four winds, from one end
of heaven to the other.*

*Now learn a parable of the fig tree: When his branch is yet tender,
and putteth forth leaves, ye know that summer is nigh:*

*So likewise ye, when ye shall see all these things, know that it is near,
even at the doors.*

*Verily I say unto you, This generation shall not pass, till all these
things be fulfilled.*

MATTHEW 24:30–34

To few generations since Christ's death could his words have sounded more
urgent than to those living in Rome around 530, when the great mosaic of his
Second Coming was fashioned in the apse of the church of Sts Cosmas and
Damian [PLATE 61].

Since 410 Rome had been sacked repeatedly by war-like tribes from across
the Alps. In 476 the last legitimate Western emperor was deposed, and the Latin
empire fell definitively into the hands of barbarian sovereigns. The Ostrogoth
King Theodoric tried to rule from Ravenna in peaceful coexistence between Latin
Christians and his Arian subjects, but this utopian project earned him the
enmity of the imperial court at Constantinople (see pp. 28; 80 above). Goths and
Byzantines were at war in various strategic places throughout the Italian penin-
sula. An old civilization had perished; to many, it seemed the end of the world
was imminent.

Theodoric died in 526, but not before his chosen candidate, Felix IV, had
ascended to the papal throne in Rome. Felix obtained the site now dedicated to

Sts Cosmas and Damian from Theodoric's daughter, Queen Amalasunta. Both location and pre-existing buildings were significant. The church Felix erected is in the heart of the Roman Forum – centre of the pagan empire's civic and religious observances – and is built from parts of the imperial Temple of Peace that celebrated Titus's victory over the Jews, and from a circular temple dedicated (it was thought) to the city of Rome. The connotations of both are, in a sense, reflected in the image of the apse mosaic.

The mosaic shows Christ 'coming in the clouds of heaven with power and great glory' – not simply his Second Coming but his final triumph. Christ, Peter the Apostle to the Hebrews on his left, and Paul the Apostle to the Gentiles on his right, are all three dressed in the bordered tunic and pallium – rectangular cloak – of Roman aristocrats and senators. Christ holds the scroll of the law. His right hand points to a nimbed phoenix, the immortal bird of pagan mythology who symbolizes him in the catacombs. In the blue sky above Paul's right arm shines a star: 'I Jesus have sent my angel to testify unto you these things in the churches. I am the root and the offspring of David, and the bright and morning star' (Revelation 22:16). From the top of the apse the hand of God the Father once held out a victor's wreath over Christ, but this part of the mosaic was destroyed in the seventeenth century.

Paul presents St Damian, and Peter presents St Cosmas to Christ. They too carry wreaths – either to offer to Christ or to be crowned by him – and are dressed in tunics that were originally travelling cloaks, but had already become priestly garments among the pagan Greeks and Romans. The two saintly brothers were doctors, martyred in Syria under the Emperor Diocletian; in the name of Christian charity, they had given their services free to the needy. The inscription that runs along the bottom of the mosaic, translated as follows, dedicates the church to them:

> *The palace of God is resplendent with bright gems, but it sparkles*
> *even brighter with the precious light of faith; through the merits of the*
> *physician-martyrs, the sure hope of salvation comes to the people, and*
> *by its dedication this place will grow in honour. Felix has consecrated*
> *it to the Lord as a gift worthy of a pontiff, that he may deserve to live*
> *in theglorious City of Heaven.*

On Christ's extreme right, Pope Felix proffers his church to him. This figure was completely refashioned in the seventeenth century, as was the trunk of the palm tree and the clump of flowers at the pope's feet. The bouquet of tulips, camomile

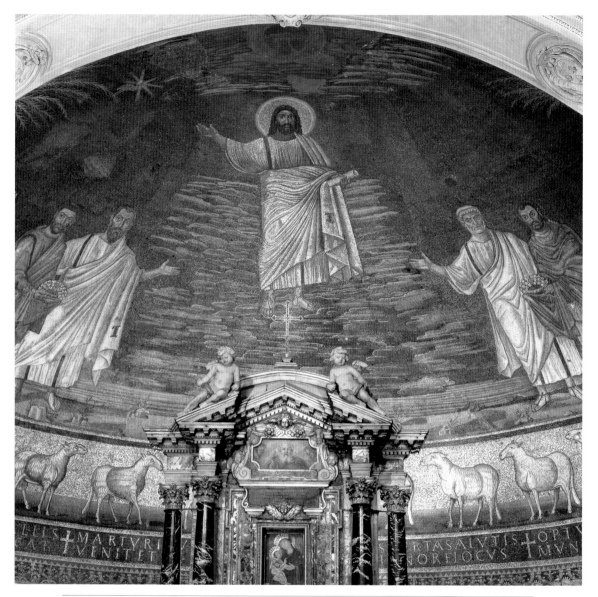

61 *Christ in Glory (The Second Coming),* apse mosaic, Church of Sts Cosmas and Damian, Rome, *c.* 530

and iris includes a homage to the restoration's patron, Cardinal Francesco Barberini, nephew of the pope at that time: enormous bees, the heraldic emblem of the Barberini family, buzz around the flowers.

On Christ's extreme left, St Theodoric, dressed like a high Byzantine official, comes forward with his martyr's crown. He is, of course, the name saint of Queen Amalasunta's father, Felix's patron, King Theodoric of the Ostrogoths.

Below all these figures runs the River Jordan, the waters of baptism, and beneath that the Mystic Lamb stands on the mount from which spring the four rivers of Paradise inscribed with their names, Geon, Fyson, Tigris and Euphrates. Virile rams process from either side towards the Lamb. These are the twelve apostolic sheep, issuing from two cities whose names are clearly marked: Jerusalem on our left (also remodelled in Cardinal Barberini's restoration) and Bethlehem on our right.

The mosaic is of the highest quality of Late Antique art, with smaller and more tightly set fragments of glass than the Byzantine mosaics of Ravenna, giving it a more naturalistic appearance, closer to that of painting. Because of this, and because Cosmas, Damian and Theodoric were all Syrian saints, it is thought that Pope Felix employed craftsmen from Antioch in Syria. The city, famed for its mosaic workshops, was devastated by a catastrophic earthquake in 526, the very year when the work was projected; surviving artists and artisans might well have been glad to emigrate.

But of greater interest is the effect these probable Syrian origins had on the face of Christ as it appears in this mosaic. Unlike the clean-shaven Byzantine Christ-Emperor at San Vitale in Ravenna, this Christ is a fully bearded Syrian monarch, anticipating the bearded, though less robust, True Likenesses imported some centuries later from the Near East. The apse mosaic in Sts Cosmas and Damian came to be viewed as an archetype of the image of the Second Coming, and – though never equalled – was emulated in many later Roman churches.

And indeed, when the original doors to the church – which face due west, directly in front of the apse – were open to the afternoon sun, the mosaic would have been, literally, dazzling. Much of it is made with tesserae of gold leaf fused with glass; some are set with the gold leaf outwards, others with the gold embedded in the plaster, creating a permanent shimmer. The clouds seem aflame with every colour of the sunset, and Christ advances upon them: 'For as the lightning cometh out of the east, and shineth even unto the west; so shall also the coming of the Son of man be' (Matthew 24:27).

The mosaic in Sts Cosmas and Damian is a supreme vision of the glory of the coming of the Lord, a prophetic image of the ultimate triumph of Christ. It is also,

of course, a work of art with a purpose. It represents a very specific moment of
the Creed, between the phrases 'And he shall come again in glory' and 'to judge
both the quick and the dead'.

Knowing that Christ is coming, we must now prepare for judgment. What
that implies is the stuff of centuries of moral theology; and it has also exercised
artists across the whole of Europe. How does the Church, the body of the faith-
ful, make itself ready for the coming of its King?

A Flemish bishop around 1460 could imagine the universal Church as no
other than a tall, light-filled Gothic cathedral, like those of his native land. And
that is how he commissioned Rogier van der Weyden to paint it, in a small altar-
piece now in the Koninklijk museum at Antwerp [PLATE 62]. The shape of the
picture coincides with that of the building it represents, into which we look as
if into a sacred doll's house. In the central panel a two-storeyed nave leads to the
high altar, and the smaller wings show lower side aisles opening into narrow
chapels.

Within this firm, securely enclosed edifice, Rogier pictures the mystic
Church, at once institution and community, which is Christ's body. At its heart is
the sacrifice on the Cross: the scene of the actual Crucifixion in the foreground is
echoed in the background by a priest elevating the Host at the altar.

Around this central sacrament of the Eucharist, all human life unfolds from
birth to death, each stage marked by a separate sacrament of the Church. Every
sacrament is administered by a priest, and endorsed by angels bearing scrolls
inscribed with appropriate texts.

At the font in the left aisle a new-born baby is being baptized. Further along,
a bishop – the very Bishop of Tournai who commissioned this picture – adminis-
ters the rite of Confirmation. The children's foreheads are bound with white
cloths. A greyhound awaits his young master – a living symbol of the boy's faith,
which is being confirmed by anointing.

Next is the sacrament of Penance. A hooded priest hears confession – con-
fessional boxes were not introduced until the sixteenth century – while another
penitent waits her turn. In the right aisle, a bishop ordains a young man into the
priesthood. Nearer to us a young couple are being married – with the bride's pet
griffon dog as an emblem of their fidelity. The cycle of life ends exactly opposite
its starting-point – in the right foreground, where a dying man receives Extreme
Unction.

Patron and painter, priest and penitent – all the people in this picture would
have believed, as many still do, that as we move from birth to death, progressing
within this orderly sacramental framework, we are gradually made more worthy

of salvation. Through our faith and our acts we collaborate with God's purpose, and prepare ourselves to meet him. In this small compass Rogier shows us how Western Christendom in the 1460s saw its Church: a structure shaping man's relationship with God, governing every stage of human life; a structure of authority ruled from Rome by the pope as Christ's vicar. This Church is at once enclosed and enclosing, a structure outside which there could be no salvation.

Less than a century later, the picture of the Church as Rogier painted it has changed dramatically. Two generations later, in 1524, the interior of a small private chapel in northern Italy was entirely decorated with an allegory of the Church as it appeared to the chapel's owner, Battista Suardi, and his friend and painter, the Venetian Lorenzo Lotto. The Suardi Chapel, in a mountain valley near Bergamo, stands besides a road down which mercenary soldiers poured into Italy from beyond the Alps, leaving destruction in their wake. These mercenaries, mostly Germans inspired by Luther's protest, scattered leaflets against the pope, and desecrated sacred images.

In a daringly literal transcription of John 15:5: 'I am the vine, ye are the branches. He that abideth in me, and I in him, the same bringeth forth much fruit: for without me ye can do nothing', Lotto pictures Christ with vine branches growing out of his hands, and trained over an open pergola that seems to form the chapel's walls and ceiling. Prophets and saints ripen among the grapes; but the vine itself is threatened by men with pruning knives who seek to cut it down; inscriptions identify them as heretics.

In a Europe riven by Luther's Reformation, the Church could no longer be imagined as a structure serene and secure. Set in the open, in mountain country like the Suardi Chapel itself, it is a fruitful vine strongly rooted in the body of Christ, but in constant danger of attack.

By the time Lotto was painting, the peoples of Europe could no longer agree on one way of attaining salvation, step by step, each step sanctified through the sacraments of one infallible universal Church. Other things were needed to get ready for judgment.

The Lutheran doctrines which first threatened, then destroyed, the integrity of the Church were formulated under the protection of the Electors of Saxony, German princes resentful of the popes' claim to secular authority. The citizens of Weimar – like those of other German towns, loyal to their ruler and eager to avoid the exactions of Rome – quickly followed where the elector led. But in addition to their worldly interests, both princes and people sincerely believed to have found in Luther's reforms a purer faith, more soundly based on the Gospels and more firmly centred on Christ.

62 ROGIER VAN DER WEYDEN *The Seven Sacraments*, 1460s
(OPPOSITE) Detail showing left panel

In 1524 the Catholic priest of Weimar's town church of Sts Peter and Paul resigned his post to a Lutheran preacher. The church, long a mausoleum of the princely family, was also to become a memorial to the elector's court painter, Lucas Cranach, Martin Luther's friend and Lutheranism's quasi-official artist. The building, with its famous steep roof and steeple, was virtually destroyed during an American air raid in 1945. But as a monument to the Reformation, and to all those who had worshipped there, it was painstakingly restored in the difficult years of the Soviet occupation immediately after the war, and was re-consecrated in 1953.

Services in Sts Peter and Paul are again being held before the altarpiece, painted by Cranach's son Lucas the Younger, commemorating the artist, his patrons and Luther [PLATE 63]. For many in the congregation, the day when it was replaced on the high altar, in a church risen from its ashes, was a day of faith renewed.

The altarpiece is, as Luther would have wished, the word made paint: and while every picture may tell a story, only a particular kind of picture can preach a sermon. The sermon here is on the Lutheran doctrine of salvation.

The wings show the Elector Johann Friedrich the Magnanimous, his wife Sibylla, and their sons, all kneeling in prayer. In the central panel, every device of pictorial realism is used to make us believe that we are present at Golgotha, standing at the foot of the Cross. Yet the simultaneous appearance of Moses and the risen Christ, contemporary portraits and John the Baptist, makes it clear that we are not eyewitnesses to an event but participants in a debate. This is art as argument. And the clue to this pictorial puzzle lies in the proper understanding of Scripture, now – one of the triumphs of the Reformation – translated into German and equally available to everybody in the congregation.

Moses holds the Tablets of the Law. A naked Adam, representing mankind under the Law, is driven by death and the devil towards hellfire; but death and the devil are trampled down by the second Adam, Christ, in the foreground. On a hillside the Israelites, sighing for the fleshpots of Egypt, are plagued by snakes; the brazen serpent heals them. The angels appear to the shepherds announcing the birth of Christ. These scenes – already pictured many times by Lucas Cranach in paint and in edifying prints – illustrate the words of St Paul, the main biblical authority for Luther's beliefs: 'For sin shall not have dominion over you: for ye are not under the law, but under grace' (Epistle to the Romans 6:14); and 'For the law made nothing perfect, but the bringing in of a better hope did; by the which we draw nigh unto God' (Epistle to the Romans 7:19). To the right of the Cross Cranach and Luther stand together beside John the Baptist, who with his right

hand directs Cranach's attention upwards to the crucified Christ, and with his left points down to the Lamb of God.

The white-bearded old artist – two years dead when his son painted the altar-piece – stands in prayer, eyes fixed on the viewer. We see him being washed with the blood from the wound in Christ's side. Luther points to passages in his own German translation of the Bible: 'The blood of Jesus Christ cleanseth us from all sin' (First Epistle of John 1:7); 'Let us therefore come boldly unto the throne of grace, that we may obtain mercy, and find grace to help in time of need' (Epistle to the Hebrews 4:16); and, as Moses lifted up the serpent in the wilderness, 'even so must the Son of man be lifted up' (John 3:14).

This picture is how sixteenth-century Protestants saw salvation. The word of Christ the Saviour, correctly received in faith, is sufficient to redeem us. And in contrast to centuries of Roman Catholic teaching, everything else – ritual, clergy, established church and above all our own actions – becomes secondary. With faith we can be saved not slowly, by regular use of the sacraments, but, in Luther's words, all of a heap.

In this scheme of redemption any good works we may perform are *evidence* of our belief in Christ rather than themselves helping to achieve our salvation: 'And if by grace, then is it no more of works: otherwise grace in no more grace. But if it be of works, then is it no more grace: otherwise work is no more work' (Epistle to the Romans, 11:6). The debate between faith and works was to become a bone of bitter contention between the Protestants and Rome. But Rome was also able to rely on Scripture.

On a quiet street in Seville stands the seventeenth-century chapel of a Spanish brotherhood still active today. Its members are dedicated to Holy Charity, in Catholic doctrine necessary to advance Christ's kingdom on earth and to achieve our salvation in Heaven. And the decoration of this chapel exemplifies that view.

On entering the church, the first thing you see is death striding forward to greet you, sickle, coffin and shroud under his arm – your coffin and shroud. Clumsily, with what was once the flat of his hand, he has just snuffed the brief candle of life and he has done it, as the inscription tells you, *in ictu oculi*, in the twinkling of an eye. In the darkness that follows, everything we see below, the pomp of popes and emperors, learning and art, military might and worldly conquest – all will vanish.

When you turn around, death's eye has well and truly twinkled [PLATE 64]. In the matching picture, the splendour of the Church is still on the left, military prowess still on the right. A rotting bishop is being eaten by worms and beetles, and a knight, wearing the proud cloak of the Order of Calatrava, is not faring

63 LUCAS CRANACH THE YOUNGER *The Crucifixion (Allegory of Redemption)*, 1555

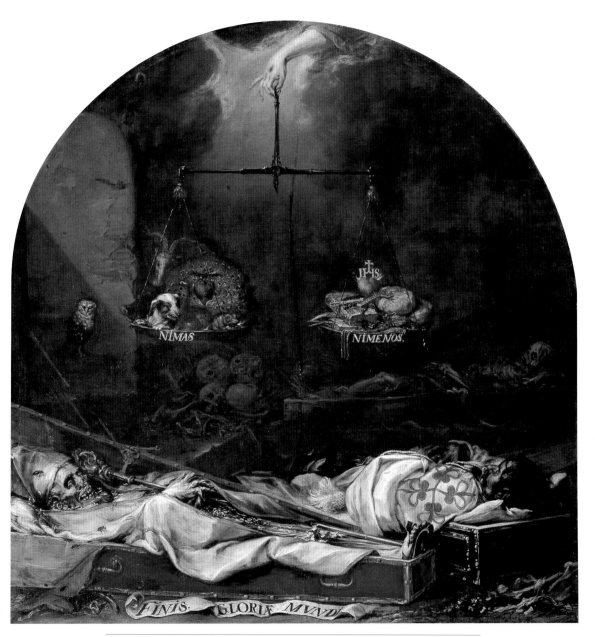

64 JUAN DE VALDÉS LEAL *Finis Gloria Mundi* ('The End of Worldly Glory'), 1671–2

much better. This is *Finis Gloria Mundi*, the end of worldly glory. And the skele-
ton and the skulls behind make clear what is in wait for us all. But there is
something even more terrifying than decomposition to come – judgment – and
above the rotting corpses hang the scales of justice.

In one scale: the seven deadly sins, each represented by an animal – the
peacock for pride, dog for anger, pig for gluttony, goat for avarice, monkey for
lust, sloth for … sloth; in the centre is the human heart, devoured by envy in the
form of a bat. These sins will be enough to damn us. It will take no more, *ni mas*.

The right-hand balance also has a heart in the centre, but this heart is
crowned with the letters IHS, *Iesus Hominum Salvator*, Jesus Saviour of Mankind.
Below it are emblems of the devout life – psalter and prayerbook, loaves of
eucharistic bread, and instruments of penance: a cat o'nine tails, a whip, a chain,
a hairshirt and bristled girdle, a nail-studded cross. We shall need faith of this
intensity to save us; no less will do, *ni menos*.

Alarmingly, the scales are in perfect balance, and they are held by the pierced
hand of the one who will judge us, Christ, crucified and risen in glory.

What will tilt the scales in our favour?

For the Roman Catholic Church, the answer was given by Christ himself in
St Matthew's Gospel:

> *When the Son of man shall come in his glory, and all the holy angels*
> *with him, then shall he sit upon the throne of his glory:*
>
> *And before him shall be gathered all nations: and he shall separate*
> *them one from another, as a shepherd divideth his sheep from the goats:*
>
> *And he shall set the sheep on his right hand, but the goats on*
> *the left.*
>
> *Then shall the King say unto them on his right hand, Come, ye*
> *blessed of my Father, inherit the kingdom prepared for you from the*
> *foundation of the world:*
>
> *For I was an hungred, and ye gave me meat: I was thirsty, and ye*
> *gave me drink: I was a stranger, and ye took me in:*
>
> *Naked, and ye clothed me: I was sick, and ye visited me: I was in*
> *prison, and ye came unto me.*
>
> *Then shall the righteous answer him, saying, Lord, when saw we*
> *thee an hungred, and fed thee? or thirsty, and gave thee drink?*
>
> *When saw we thee a stranger, and took thee in? or naked, and*
> *clothed thee?*
>
> *Or when saw we thee sick, or in prison, and came unto thee?*

And the King shall answer and say unto them, Verily I say unto you, Inasmuch as ye have done it unto one of the least of these my brethren, ye have done it unto me.

Then shall he say also unto them on the left hand, Depart from me, ye cursed, into everlasting fire, prepared for the devil and his angels:

For I was an hungred, and ye gave me no meat: I was thirsty, and ye gave me no drink:

I was a stranger, and ye took me not in: naked, and ye clothed me not: sick, and in prison, and ye visited me not.

Then shall they also answer him, saying, Lord, when saw we thee an hungred, or athirst, or a stranger, or naked, or sick, or in prison, and did not minister unto thee?

Then shall he answer them, saying, Verily I say unto you, Inasmuch as ye did it not to one of the least of these, ye did it not to me.

And these shall go away into everlasting punishment: but the righteous into life eternal.

MATTHEW 25:31–46

At the Last Judgment, when Christ comes to separate the sheep from the goats, it is those who have performed acts of mercy who will be saved.

So it was quite natural that the brotherhood should commission one of their own number, the great painter Murillo, to illustrate the Acts, or Works, of Mercy. To represent them he chose scenes from the Bible. As a painter in the catacombs might have done centuries before, he included both New and Old Testament examples of divine intervention, pictured as contemporary events. Only Christ, angels, Apostles and patriarchs are shown in dignified ancient robes; those succoured are the people of seventeenth-century Spain, indeed of Murillo's Andalucia.

Feeding the hungry is exemplified by Christ's miraculous transformation of the boy's five barley loaves and two small fishes into more than enough to feed five thousand (John 6:5–14). On the opposite wall, giving drink to the thirsty is illustrated by the Old Testament scene of Moses striking water from the rock when the children of Israel were dying of thirst on their way to the promised land (Exodus 17:1–7; Numbers 20:1–13); in the middle of the Sinai desert, a very Spanish little boy on a horse smilingly points to Moses and the miracle. He is the kind of boy who might any day have been given water by the Brothers of Charity in Seville, and in an earthenware jug exactly like the one Murillo shows him holding.

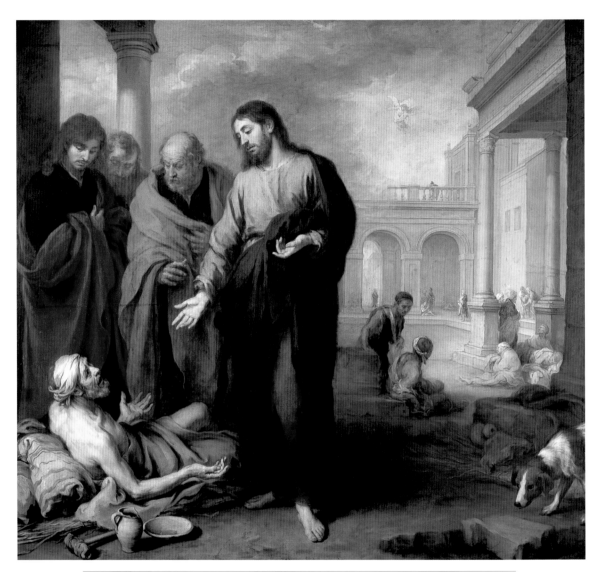

65 BARTOLOMÉ ESTEBAN MURILLO *Christ Healing the Paralytic at the Pool of Bethesda*, 1667–70

In 1812 Napoleon's generals looted the church, and carried off to France the other four Works of Mercy painted by Murillo. They were sold and are now in museums abroad. Giving hospitality to strangers is represented by Abraham entertaining angels unawares (Genesis 18:1–19). Clothing the naked is shown by the return of the Prodigal Son, when the forgiving father 'said to his servants, Bring forth the best robe, and put it on him; and put a ring on his hand, and shoes on his feet' (Luke 15:22).

Visiting those in prison is the angel freeing St Peter from prison (Acts 12:1–11), while ministering to the sick is *Christ Healing the Paralytic at the Pool of Bethesda* [PLATE 65].

> *Now there is at Jerusalem by the sheep market a pool, which is called in the Hebrew tongue Bethesda, having five porches.*
>
> *In these lay a great multitude of impotent folk, of blind, halt, withered, waiting for the moving of the water.*
>
> *For an angel went down at a certain season into the pool, and troubled the water: whosoever then first after the troubling of the water stepped in was made whole of whatsoever disease he had.*
>
> *And a certain man was there, which had an infirmity thirty and eight years.*
>
> *When Jesus saw him lie, and knew that he had been now a long time in that case, he saith unto him, Wilt thou be made whole?*
>
> *The impotent man answered him, Sir, I have no man, when the water is troubled, to put me into the pool: but while I am coming, another steppeth down before me.*
>
> *Jesus saith unto him, Rise, take up thy bed, and walk.*
>
> *And immediately the man was made whole, and took up his bed, and walked.*
>
> JOHN 5:2–9

This Bethesda is not far from Spain: Murillo includes a humble Sevillian earthenware jug and plate, and the poor paralytic could be one of those unfortunates whose care was specifically urged in the instructions given to the brethren of Holy Charity:

> *And whereas the poor and destitute, falling ill, often get so weak that they frequently die in the streets, we order that whenever any of our brothers comes upon such an occurrence, he will attempt to find out*

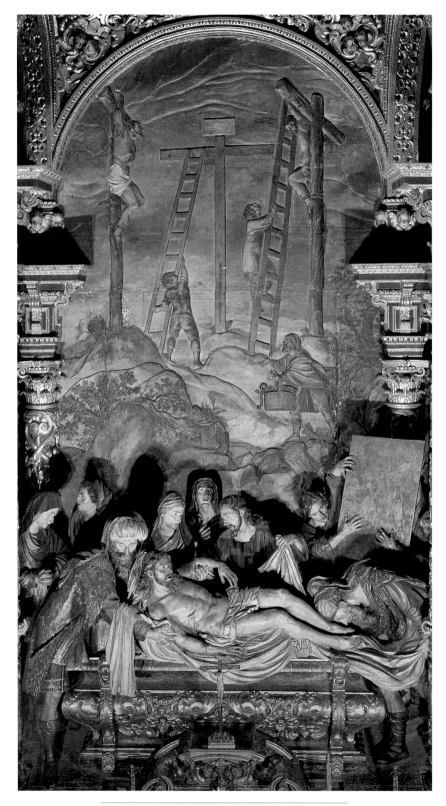

66 PEDRO ROLDÁN *The Entombment of Christ*, 1670–2

what is wrong and, although the poor man may not ask it, to help with the compassion of a father to ease his affliction, and then to seek some way to carry him to our house.

Very early on, a seventh Work of Mercy was added to the six listed in Matthew: burying the dead. Indeed, the Seville Brotherhood of Holy Charity was founded with the principal aim of providing burial for the friendless poor who were left to die in the streets, for drowned sailors and, above all, for executed criminals, whose bodies would otherwise have been left to rot on the gallows to be eaten by dogs.

And so, on the altar wall, beneath the gallows of Golgotha, we see in poly-chromed sculpture the burial of an executed criminal: the criminal is Christ, to whom this last act of mercy was shown by Joseph of Arimathaea, the rich man who for this burial gave up the tomb he had prepared for himself [PLATE 66].

By now it comes as no surprise that the body of Christ has not merely been laid in the tomb; the sculptor has contrived to show it also being lowered onto the altar. And there, at every celebration of the Mass, it will be distributed as the bread of the Eucharist among the congregation, in Christ's supreme act of charity to us all.

Unusually, the man who devised and paid for this extraordinary decoration, Miguel Mañara, did not put up his own coat of arms. Instead, to the left of the altar, we find the emblem of the brotherhood's true founder: the instruments of Christ's Passion, the *Arma Christi* (see p. 160). This is, of course, the key to the whole undertaking; for Christ's love in dying for us inspires and sustains every act of charity that we perform.

Some two hundred years before the Sevillian confraternity of the Caridad built their chapel, one of the richest and most powerful men in Northern Europe, prompted by the misery and famine that succeeded the Hundred Years' War, founded a hospice at Beaune, not far from Dijon in Burgundy, and funded an order of nuns to run it. Anxious for the welfare of their souls as well as worldly reputations, Nicolas Rolin, Chancellor of the Duke of Burgundy, and his third wife Guigone de Salins commissioned a Flemish architect to design the most sumptuous charitable complex in fifteenth-century Europe. They endowed it with an annual income, saltworks, and vineyards which even today produce some of the most prized wines in the world. In this 'Palace for the Poor' the indigent, orphans and the old were fed, clothed and sheltered. Above all, those who were ill were nursed, in what became a model hospital. Only in 1971 were the medical activities of the Hôtel-Dieu transferred to a modern medical centre.

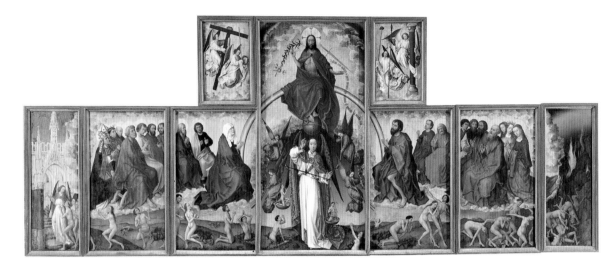

67 ROGIER VAN DER WEYDEN *The Last Judgment*, Hôtel-Dieu, Beaune, 1443–51
(OPPOSITE) Detail showing centre

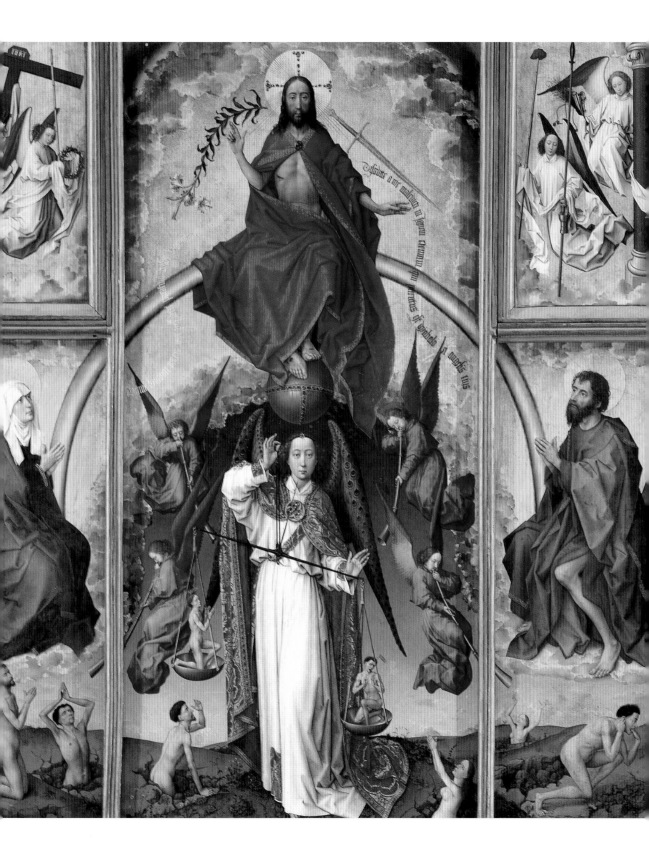

At the heart of Rolin's establishment is the Great Hall of the Poor, opened in 1452, which has been restored more or less to its original appearance. It is much more than a hospital ward. The sick were tended in large curtained four-poster beds set on either side of the hall; behind each bed a chest was provided for the patients' clothes. Tables and benches were placed down the middle of the room for meals, served in pewter dishes instead of the wooden ones usual in hospices.

The huge wooden vault, resembling a ship's hull, is richly decorated. The painted cross-beams, a unique survival from this period, issue from the jaws of polychromed dragons, and grotesque carved human and animal heads look down, as from the ceiling of any baronial hall. Some floor tiles bear the interwoven initials of the founders, N and G, and the motto *Seulle*, meaning that Guigone alone was in her husband's affections.

But these worldly comforts and ornaments are only part – and the lesser part – of the care lavished on the patients. At the end of the hall, clearly visible from every bed, is the chapel where services were said for the spiritual welfare of the sick and dying and those who cared for them. It is here that Guigone chose to be buried.

Above the altar, beneath the stained-glass window, there stood for over three centuries the glory of this place: Rogier van der Weyden's painting of the *Last Judgment* [PLATE 67]. The Hôtel-Dieu is now a museum, and Rogier's dismembered altarpiece has been banished from the charitable community of hospital and chapel and condemned to the aesthetic isolation of a neighbouring showroom. Here, in spot-lit gloom, visitors are invited to admire it as pure art, with few of the irritating distractions of the religious functions for which Rogier specifically devised it.

When its shutters were opened they revealed, unfolding across all nine of its separate panels, the gold and crimson, awesome splendour of the General Resurrection and Last Judgment. In the centre, Christ sits enthroned above the earth on a rainbow, with angels on either side. The prophecy that inspired the Brotherhood of Holy Charity in Seville has here been made terrifyingly visible: 'When the Son of man shall come in his glory, and all the holy angels with him, then shall he sit on the throne of glory' (Matthew 25:31). The white-clad angels flourish the Instruments of the Passion: Cross, crown of thorns, sponge, lance and column, holding them reverently through long sleeves or in white linen cloths. Naked under his crimson robe, Christ shows his wounds. This Judge has suffered and died for us. In his right hand he points to the white lily of mercy. An inscription cites St Matthew's Gospel, where Christ welcomes those who have shown

themselves charitable: 'Come, ye blessed of my Father, inherit the kingdom pre-pared for you from the foundation of the world' (Matthew 25:34). At Christ's left hand is the sword of justice, and the inscription: 'Depart from me, ye cursed, into everlasting fire, prepared for the devil and his angels' (Matthew 25:41). As angels sound the last trump, the Archangel Michael in priestly vestments, and with peacock-feathered wings, stands on the earth beneath Christ's celestial throne, weighing souls.

On Michael's right the pan of the scales rises, lifting up the devout soul; an inscription reads *virtutes*, virtues. The guilty soul looks terrified as the scales are tipped downwards by *peccata*, sins. On either side of Michael, but still in the golden heaven above the clouds, the Virgin Mary and St John the Baptist head a company of apostles and saints, interceding with Christ for the dead rising from their graves.

Those who struggle up from the earth on Christ's right first turn to him in prayer, then make their way through a flowery meadow to be welcomed by an angel into the Heavenly Jerusalem. Beyond its ornate Gothic portal we see the red glow of fiery seraphim. On Christ's left the resurrected dead stumble towards hell. These are desperate figures. Men pull their ears and bite their fingers with remorse. A couple stagger forwards weeping, the image of Adam and Eve expelled from Paradise. Most terrible of all, the damned, in their last hopeless efforts to escape hellfire, drag each other down into the pit. No devils impel them; no further force of evil is needed; their sins alone have been enough to damn them: *ni mas*.

Nicolas Rolin and Guigone de Salins, identified by their coats of arms, kneel in prayer on the shutters that once concealed this fearful vision. The burden of their prayers is easy to guess.

But the picture was designed to be seen by those lying in the Great Hall of the Poor. What does Rogier's picture mean in the hour of your death? It offers the certainty of resurrection and the hope of salvation. You still have time to perform the duty of the dying and to put your soul in order. Even the poorest are capable of charity, and all are able to repent. Like Rogier's figures of the blessed depicted here, the dying in their beds could turn their faces to Christ and obtain mercy.

On a bracket above the entrance of the Great Hall, once directly opposite Rogier's painted Christ in glory, there sits a statue of the suffering Christ [PLATE 68]. It was installed by Guigone, who after her husband's death devoted her life to nursing the sick here.

In Germany they call this type of image 'Christ on the Cold Stone'. It shows him stripped naked, bleeding after the Flagellation and wearing the crown of

68 *Christ on the Cold Stone (Le Christ au Liens)*, Hôtel-Dieu, Beaune, mid-fifteenth century

thorns, hands and feet bound with rope, sitting on a stone on Calvary waiting to be nailed to the Cross. It is an image of the utmost desolation.

When a patient entered his death agony, the nuns used to light a candle on the holder that still can be seen by the side of this figure, through a little window leading to their dormitory from which they could watch over the ward at night. Christ's presence, it was thought, would console the dying and help them resign themselves to their suffering.

Since Rogier's *Last Judgment* was removed, only this suffering Christ remains watching over this space made for the sick and the poor. Splitting up such a coherent whole has meant a serious loss. But there can be no doubt that the present arrangement precisely mirrors the religious (or rather, secular) assumptions of our time. Few visitors to Beaune now live their lives in dread of the Last Judgment, but most acknowledge our obligations to the sick and the destitute. The high theology of Christ the Judge may have been set aside, relegated to a separate, purely cultural space, but human suffering still speaks to us, in whatever form the artist presents it.

And that is perhaps why it was possible for a twentieth-century Christian artist to design an altarpiece of the General Resurrection with reference to Christ and the Cross, but ostensibly none to the Last Judgment [PLATE 69].

The painter Stanley Spencer, unlike the commissioned officers Owen and Sassoon (see pp. 119; 121), spent the entire First World War as a private soldier: first as a medical orderly at the Beaufort War Hospital near Bristol, then with the 68th Field Ambulancers in Macedonia, and finally on active service in the front line with the 7th Battalion of the Royal Berkshire Regiment. Like these war poets, and so many others, he interpreted his war experiences in religious terms, or – more accurately – his religious vision in terms of his war experiences.

A *Crucifixion* of 1921, now in Aberdeen, is set on a steep and barren mountainside. Of it Spencer wrote: 'The memory I had of some mountain … dividing Macedonia from Bulgaria … as I walked towards the range … every sound was muffled … and only the faint jingle and squeaking of the mules' harnesses.' By 1923 Spencer had evolved a whole architectural scheme for a chapel with 'acres of Salonica and Bristol war compositions', when he was visited by Mr and Mrs J. L. Behrend. Mrs Behrend's brother, Lieutenant Henry Willoughby Sandham, had died in 1919 as a result of an illness contracted during the Macedonian campaign. The Behrends decided to commission Spencer's chapel as a private memorial to him, and it was built near their house in the Hampshire village of Burghclere.

The Oratory of All Souls Sandham Memorial Chapel is decorated by a mural

cycle painted in oils on canvas and completed in 1927. Most of the scenes were conceived during the war; these represent Spencer's own army experiences, and but for their setting would appear to be totally secular. For Spencer these reminiscences represented a symbolic progression, 'a mixture of real and spiritual fact'.

The paintings on the side walls of the chapel consist of large arched-top canvases with below them smaller rectangular 'predellas'. The first such pair shows a *Convoy Arriving with Wounded* and *Scrubbing the Floor*. When lecturing at the Ruskin School of Drawing in 1923, Spencer told his students, 'ordinary experiences or happenings in life are continually developing and bringing to light all sorts of artistic discoveries ... When I scrubbed floors, I would have all sorts of marvellous thoughts, so much that at last, when I was fully equipped for scrubbing – bucket, apron and "prayer mat" in hand – I used to feel much the same as if I was going to church.'

There follow scenes of *Ablutions* and *Sorting and Moving Kit-Bags*; *Kit Inspection* and *Sorting the Laundry*; *Dug-out (or Stand-to)* and *Filling Tea Urns*; *Reveille* and *Frostbite*; *Filling Water-Bottles* and *Tea in the Hospital Ward*; *Map-Reading* and *Bedmaking*; *Firebelt* and *Washing Lockers*. The space above the arched canvases is filled with two panoramic views: *Camp at Karasuli* on the north wall, and *Riverbed at Todorova* on the south wall.

The entire east wall behind the altar is taken up by the *Resurrection of the Soldiers* [PLATE 69]. This picture alone took Spencer nearly a year to complete; it dominates the chapel and all the other scenes are subordinate to it. And the painting itself is dominated by wooden crosses.

Immediately behind the altar is 'a sort of portrait gallery formed by soldiers coming out of the ground and the crosses arranged so as to look like frames'. The resurrected soldiers are emerging from graves behind the altar, shaking hands with their comrades, cleaning buttons and winding puttees.

A collapsed waggon, based on Spencer's recollection of a dead Bulgarian mule team and gun-carriage, occupies the centre of the picture. The dead mules come back to life and turn towards the figure of Christ: 'The ass [knoweth] his master's crib' (Isaiah 1:3). On the waggon boards lies a young soldier intently studying a crucifix. Christ sits inconspicuously in the middle distance, receiving the crosses brought to him by the dead and risen soldiers, as a quartermaster might receive the rifles handed in to him by soldiers at the end of their military service.

The image resembles the war poets' vision of the soldiers carrying their crosses, made Christ-like through their suffering, and a letter from Wilfred Owen,

written to Osbert Sitwell in 1918, seems to support such an approach. He speaks of training new troops in England:

> *For 14 hours yesterday I was at work – teaching Christ to lift his cross by numbers, and how to adjust his crown; and not to imagine he thirst until after the last halt. I attended his Supper to see that there were no complaints; and inspected his feet that they should be worthy of the nails. I see to it that he is dumb, and stands at attention before his accusers. With a piece of silver, I buy him every day, and with maps I make him familiar with the topography of Golgotha.*

Yet Spencer's scenes of life behind the lines are, I believe, conceived in a different spirit. They do not show the mundane tasks of military hospital and encampment as humiliating preludes to the horrors of front-line action, but as acts of charity: feeding the hungry, giving drink to the thirsty, creating shelter, clothing the naked, nursing the sick. The crosses the soldiers hand to Christ behind the altar are – as for Owen – the measure of loyalty to duty and self-sacrifice, service of an ideal and laying down your life for your friends; but it is not their sacrificial aspect that moves the painter. In conjunction with the pictures on the side walls, they become, above all else, the visible emblem of brotherly love, of men's charity to others: 'This is my commandment, That ye love one another' (John 15:12). Christ sits receiving the soldiers' crosses, but we have no sense that he is judging. Rather, he is welcoming these who have died and are risen. Already the blessed of his Father, they have earned the kingdom prepared for them from the foundation of the world through their charity to each other: *ni menos.*

Brotherly love is also the redeeming theme of perhaps the greatest pictorial testament of the First World War. But this painting, by a survivor from the defeated side, is dominated by suffering. It is the *War Triptych* by Otto Dix [PLATE 70]. The great twentieth-century German painter turned to his great pre-Reformation German predecessor, Grünewald, to picture the secular Calvary that was his recollection of the war.

In 1927, the year Spencer completed the Burghclere *Resurrection*, Dix returned from Berlin to Dresden. The son of a foundry worker from the industrial town of Gera-Untermhaus, he had as a boy received a scholarship to the Dresden School of Arts and Crafts. Old Master pictures in the city's famous art gallery, and *avant-garde* works exhibited there, had inspired his own earliest paintings. It was in 1911 in Dresden that he began to read Nietzsche, and it was here, in 1914, that he volunteered for the army, going off to war with Nietzsche and the Bible in his

69 (OPPOSITE) STANLEY SPENCER *The Resurrection of the Soldiers*, 1928–9
(ABOVE) Detail showing centre

pocket: 'I had to go to war ... I had to see it all with my own eyes ... the hunger, the fleas, the mud, the shitting in one's pants with fear ... To be crucified, to experience the deepest abyss of life ...' He was to remain loyal to the philosopher of his youth, continuing into old age to affirm life, a 'monster of force' beyond good and evil, even in its most destructive aspects:

> War is horrible: hunger, lice, mud, terrifying noises. It is all completely different. You see, before the early paintings, I had the feeling that there was a dimension of reality that had never been dealt with in art: the dimension of ugliness. The war was a dreadful thing, but there was something awe-inspiring about it. There was no question of me missing out on that! You have to have seen people out of control in that way to know anything about man.

Between November 1915 and December 1916 Dix saw service in Champagne, in the trenches of Artois, and on the Somme, where he was involved in two major battles. He noted in his diary: 'Lice, rats, barbed wire, fleas, shells, bombs, underground caves, corpses, blood, liquor, mice, cats, gas, artillery, filth, bullets, mortars, fire, steel: that is what war is! It is all the work of the Devil!' In 1927, perhaps the most successful painter of the Weimar Republic, he returned to Dresden as professor at the city's illustrious Art Academy. In 1933, after Hitler came to power, he was sacked without notice and banned from exhibiting his work.

The main reason for his dismissal was this horrific painting, exhibited in Berlin in 1932, and some preliminary etchings and oils:

> The painting began life ten years after the First World War. In the meantime, I had done a lot of preliminary studies, looking at ways of dealing with the war in my paintings. In 1928, after I had been working on the subject for several years, I finally felt ready to tackle it properly. At that point, incidentally, there were a lot of books circulating in the Weimar Republic, promoting a notion of heroism which, in the trenches, had long since been rejected as an absurdity. People were already beginning to forget the terrible suffering the war had caused. That was the situation in which I painted the triptych.

The *War Triptych*'s deliberate echoing of the Isenheim Altar places both artist and painting within the great tradition of German Expressionism – but what else is

Dix saying in adapting to the secular ends of Weimar Republic politics the visual language of Christian theology?

Kollwitz, as we saw in Chapter Ten, equated the downtrodden of society with Jesus the innocent victim. Dix's work is more complex, and harder to interpret with confidence.

In the left wing, 'dawn breaks open like a wound that bleeds afresh'. Soldiers shoulder their heavy rifles going into battle through the mist, like so many anonymous images of Christ carrying his Cross on the road to Calvary. The association is strengthened through the gun-carriage wheel, an earthbound Chi Rho wreathed in cold steel.

A whole village has been reduced to ruin, and many men have suffered and died horrific deaths, in the central noon-time panel. Grünewald's crucified Christ lies upside down on a pile of corpses. His bullet-scarred legs protrude into a sky darkened by gunfire smoke. Pointing to him with a skeletal index finger, a cadaver impaled on a blasted tree plays St John the Baptist. One survivor stands, his face hidden by a gas mask, watching the dead 'Dim, through the misty panes and thick green light, As under a green sea …' Below, another masked man, invisible in reproduction, stares out, 'Cramped in that funnelled hole',

> … *one of the many mouths of Hell*
> *Not seen of seers in visions, only felt*
> *As teeth of traps; when bones and the dead are smelt*
> *Under the mud where long ago they fell*
> *Mixed with the sour sharp odour of the shell.*

Owen had fallen through a shell-hole into a cellar, and was trapped there for three days. Dix, interviewed in 1965, related: 'For years, for a good ten years, I had these dreams, in which I had to crawl through ruined houses with passageways I could hardly squeeze through. I dreamt continuously about rubble and ruins.'

Almost hidden among the impasted painted blood and mud lies a severed head, crowned with barbed wire. In the predella below, soldiers in the pose of Holbein's *Dead Christ* sleep, awaiting not Resurrection but a return to the trenches and the battlefield. The cloth slackly suspended above them holds their rations, to keep them from the rats.

For the right, night-time wing, Dix originally painted a composition of *Trench Warfare*, where a living soldier treads on the head of a dead one. He later replaced this with the present image, reminiscent of a Deposition from the Cross:

70 OTTO DIX *War Triptych*, 1929–32

a soldier with the artist's own features lifts up a wounded comrade. Like Spencer, though in a quite different key, Dix concludes on a note of human charity.

Many viewers see the painting as expressing Nietzschean pessimism. Rejecting the theologians' view of man as the image of God, and the philosophers' view of him as a rational being, it seems to show men trapped in a never-ending cycle of destruction, which the artist must not flinch from depicting. Yet whatever our religious beliefs, our responses to an image like this are still conditioned by the centuries of Christian art we have briefly been surveying.

If Nietzsche's is a world without God, and this a Crucifixion without Christ, the Passion not of one man but of many, this image – like any traditional Crucifixion – still confronts the spectator with the centuries-old questions: how far is this unspeakable suffering my fault? And will I have the courage and generosity to make it less by picking up my fallen comrade?

71 REMBRANDT *Nunc Dimittis (Simeon Holding the Christ Child)*, c. 1669

EPILOGUE

In a world without God, is there still a future for the image of Christ?

No longer dreading Judgment, we do not picture him as Ruler and Judge.

Crucifixes may be ubiquitous, but since the First World War the imagery of suffering has become steadily richer with photographs of real people and real events. Since many of those who suffer most today are not Christians, it is hard now to view the Crucifixion as an emblem of universal suffering. The crosses outside Auschwitz were seen to have been put up to call Jewish suffering into question – or worse – and were decried for that reason. And perhaps the scale of suffering has come to seem too great, and a creed of atonement too remote, for a suffering God to speak to many of redemption, or move us to acts of charity. Americans looked with horror and remorse at the news photograph of a Vietnamese child burned with napalm. As earlier centuries might have reacted to an altarpiece of the Crucifixion, they knew that this suffering was in a general sense their fault and that their actions could help to alleviate the wider injustice and suffering that it represented. And it was this image, and not one of Christ on the Cross, that provided an impetus for bringing the war to an end. Yet you could argue that, in a way, this speaks to the continuing power of the tradition we have been examining: the Franciscan response of pity, followed by contrition and then action was actively present, but the trigger was not a suffering god, but a suffering child. As Francis had argued over seven centuries earlier, it is the love all of us can feel for a child that recalls us most powerfully and most simply to our highest duties of love for all humanity. And nothing will ignite that love more rapidly than an affecting image.

If Mark Wallinger still invokes the *Ecce Homo*, many Western artists today, believers and unbelievers, try to represent the divine and the spiritual in different ways. Some, as Mark Rothko did, return to the aniconic traditions of observant Jews and iconoclasts, depicting the transcendental as radiance or luminous fields of colour. Others seek universality by combining Western and foreign traditions. Stephen Cox, an English sculptor responsible for the altar and reredos of St Paul's,

Haringay, has been inspired by images of divinity in traditional Indian stone carving. The American video artist Bill Viola turns to the writings of Western and Eastern mystics and Jungian psychoanalysis. His installation at Durham Cathedral, *The Messenger*, associates a Christ-like male nude with the Sanskrit concept of *prana*, the breath which animates, the life force – and this itself goes back to pagan Greek and heretic early Christian notions.

But if we no longer heed the messages of the great Christian images of the past, and admire them mainly for their aesthetic qualities, there is one traditional image of Christ that, I believe, remains universally valid. It moves people from any cultural background, whether or not they recognize it as an image of the incarnate God.

It is the Christ Child. Like all babies, the infant Christ is the focus of our aspirations and our apprehensions. We know what he will have to endure, and we want to protect him from it. If there is one emotion that can come close to uniting all humanity, it is surely awe in the face of a new-born child – tender, overwhelming, humbling, strengthening. No artist ever painted it more powerfully than Rembrandt in the picture now in the museum in Stockholm [PLATE 71].

The Child's parents have just handed him to Simeon, the priest in the Temple. And although he appears to be blind, he sees the essential. He intuits divinity and he knows all will now be well. You will remember the text from Chapter Two of St Luke's Gospel (see p. 184). Rembrandt, as so often, concentrates on the heart of the matter; he shows the scene in cinematic close-up. Simeon is transfigured; in his arms he holds Christ. But he and Anna, the aged prophetess (a figure added by a later artist), appear like any grateful grandparents near the end of their days, and Christ is every baby: a newborn child whom all are moved to protect and love, and on whom all hopes are fixed, until the last generation.

Lord, now lettest thou thy servant depart in peace … For mine eyes have seen thy salvation.

NOTES ON SOURCES

CHAPTER TWO
Page 40
'In Cosimo's chapel there were painted...' Gentile Becchi, quoted in C.A. Luchinat, *The Chapel of the Magi: Benozzo Gozzoli's Frescoes in the Palazzo Medici-Riccardi, Florence*, London and New York, 1994

CHAPTER THREE
Page 49
'If you desire us to celebrate...' Tommaso of Celano, quoted in *The Little Flowers, Legends and Lauds. St Francis of Assisi and others*, edited by Otto Karrer, trans. N. Wydenbruck, Sheed & Ward, London, 1947

CHAPTER FOUR
Page 63
'The king goes astray if he thinks...' Address by William of Orange to fellow noblemen in 1564, quoted in Bob Haak, *The Golden Age: Dutch Paintings of the 17th Century*, Thames & Hudson, London, 1984

CHAPTER FIVE
Page 68
'We little fishes...' Tertullian, quoted in *The Early Christian Fathers*, edited and trans. by Henry Bettenson, Oxford University Press, Oxford, 1956
Page 76
' by a lantern...' William Holman Hunt, quoted in *The Pre-Raphaelites*, Tate Gallery/Penguin Books, London, 1984
Page 76
'He who when...' Ibid.
Page 80
'Everyone knows...that the Father is greater...' Arius, quoted in *Documents of the Christian Church*, selected and edited by Henry Bettenson, Oxford University Press, Oxford, 1967

CHAPTER SIX
Page 88
'when he saw Christ...' The legend of the Mandylion, quoted in Ian Wilson, *The Turin Shroud*, Victor Gollancz, London, 1978
Page 97
'our foul, black, shameful deeds', Julian of Norwich,

Revelations of Divine Love, trans. by Elizabeth Spearing, Penguin Books, London, 1998
Page 97
'Nor is it without...' Matthew of Janov, *Rules of the Old and New Testament*, c. 1390, quoted in Hans Belting, *Likeness and Presence: A History of the Image before the Era of Art*, Chicago University Press, Chicago, 1994
Page 101
'The picture makes...' Aristocratic journalist, quoted in Ian Wilson, op. cit.
Page 102
'The face and body...' Ian Wilson, op. cit.
Page 104
'If an image has...' Matthew of Janov, quoted in Hans Belting, op. cit.
Page 110
'As, when upon His drooping head...' Poem by John Keble printed in the Exhibition Catalogue, 1860, quoted in *The Pre-Raphaelites*, op. cit.
Page 115
'The sculpture's enigmatic...' Adrian Searle, *The Guardian*, 22 July 1999

CHAPTER SEVEN
Page 119
'One ever hangs...' Wilfred Owen, 'At a Calvary near the Ancre', Wilfred Owen, *The War Poems*, edited by Jon Stallworthy, Chatto & Windus.
© The Executors of Harold Owen's Estate 1963 and 1983.
Page 121
'Already I have comprehended...' Letter of 2 May 1917, Wilfred Owen, *Collected Letters*, edited by Harold Owen and John Bell, Oxford University Press, Oxford, 1967
Page 121
'The unreturning army that was youth...' Siegfried Sassoon, 'Prelude: The Troops', *Penguin Book of First World War Poetry*, The Viking Press, London, 1979. Reproduced by permission of Mr G.T. Sassoon and The Viking Press.
Page 128
'to be alive, before he had died...' Mateo Vazquez de Leca, quoted in Beatrice Gilman Proske, *Martinez Montañés: Sevillian Sculptor*, New York, 1967

Page 128
'I have a great desire…' Ibid.

CHAPTER EIGHT
Page 144
'It happened that…' Teresa of Avila, *Life of the Holy Mother Teresa of Jesus*, Sheed & Ward, London, 1944 and 1979
Page 145
'The figures are of…' Mme d'Aulnoy, 1679, quoted in Susan Verdi Webster, *Art and Ritual in Golden Age Spain*, Princeton University Press, Princeton, 1998
Page 145
'The face has…' Albert Calvert, quoted in Webster, op. cit.
page 145
'The fictitious came….' Santiago Alcolea, *Spanish Sculpture*, New York, 1969, quoted in Webster, op. cit.
Page 145
'Sculpture has existence…' Francisco Pacheco, quoted in Webster, op. cit.
Page 146
'If there is anything…' Fray Jesús de Maria, quoted in Webster, op cit.
Page 149
'His chief ailment was…' Teresa of Avila, op. cit.

CHAPTER NINE
Page 166
'the most beautiful marble…' Jacopo Galli, quoted in John Pope-Hennessy, *Italian High Renaissance and Baroque Sculpture*, 2nd ed., Phaidon, London, 1970
Page 168
No portrayal of a corpse…' Giorgio Vasari, 'The Life of Michelangelo' in *Lives of the Artists*, first published in Italian in 1550 and substantially enlarged in 1568
Page 168
'Vergine madre…' Dante, *The Divine Comedy*, Paradise, Canto 33

Page 173
'Once Vasari was sent…' Vasari, 'The Life of Michelangelo', op. cit.
Page 174
'It was now necessary…' Ibid.

CHAPTER ELEVEN
Page 209–11
'And whereas the poor…' Rule for the Caridad, quoted in Jonathan Brown, *Images and Ideas in Seventeenth-Century Spanish Painting*, Princeton University Press, Princeton, 1978
Page 217
'The memory I had…' Stanley Spencer, quoted in Duncan Robinson, *Stanley Spencer at Burghclere*, The National Trust, London, 1991
Page 218
'ordinary experiences or happenings…' Ibid.
Page 218
'a sort of portrait gallery…' Ibid.
Page 219
'For 14 hours yesterday…' Wilfred Owen to Osbert Sitwell, 4 July 1918, quoted in *Poems of Wilfred Owen*, ed. C. Day Lewis, Chatto & Windus, London, 1964
Page 222
'I had to go to war…' Otto Dix, quoted in Eva Karcher, *Dix*, Bonfini Press, New York, 1987
Page 222
'War is horrible…' Ibid.
Page 222
'Lice, rats, barbed wire…' Ibid.
Page 222
'The painting began life…' Ibid.
Page 223
'Cramped in that funnelled hole…' *The Poems of Wilfred Owen*, edited by Edmund Blunden, Chatto & Windus, London, 1931. Reproduced by permission of the Estate of Wilfred Owen & Chatto & Windus
Page 223
'For years, …' Otto Dix, quoted in Karcher, op. cit.

FURTHER READING

National Gallery, *The Image of Christ*, edited by G. Finaldi, catalogue to accompany the exhibition *Seeing Salvation*, National Gallery, London, 2000

GENERAL BOOKS

Beckwith, J., *Early Christian and Byzantine Art*, 2nd ed., Harmondsworth, 1979

Belting, H., *Likeness and Presence: A History of the Image before the Era of Art*, Chicago, 1994

Belting, H., *The Image and Its Public in the Middle Ages: Form and Function of Early Paintings of the Passion*, New Rochelle, 1990

Bonaventure, (Pseudo-), *Meditations on the Life of Christ: an illuminated manuscript of the fourteenth century*, translated by Isa Ragusa, edited by I. Ragusa and R. B. Green, Princeton, 1961

Campbell, L., *National Gallery Catalogues: The Fifteenth-Century Netherlandish Schools*, London, 1998

Cormack, R., *Painting the Soul: Icons, Death Masks and Shrouds*, London, 1997

Cross, F. L. and Livingstone, E. A., *The Oxford Dictionary of the Christian Church*, 2nd revised ed., Oxford, 1983

Drury, J., *Painting the Word: Christian Pictures and their Meanings*, London, 1999

Dunkerton, J., Foister, S., Gordon, D. and Penny, N., *Giotto to Dürer: Early Renaissance Painting in the National Gallery*, London, 1991

Dunkerton, J., Foister, S. and Penny, N., *Dürer to Veronese: Sixteenth-Century Painting in the National Gallery*, London, 1999

Ferguson, G., *Signs and Symbols in Christian Art*, Oxford, 1954

Freedburg, D., *The Power of Images*, Chicago, 1989

Hall, J., *Hall's Dictionary of Subjects and Symbols in Art*, London, 1974

Langmuir, E., *The National Gallery Companion Guide*, London, 1994

Lowden, J., *Early Christian and Byzantine Art*, London, 1997

Mâle, E., *Religious Art in France: The Late Middle Ages*, reprinted Princeton, 1986

Mâle, E., *Religious Art in France: The Thirteenth Century*, reprinted Princeton, 1984

Mâle, E., *Religious Art in France: The Twelfth Century*, reprinted Princeton, 1978

Marrow, J. H., *Passion Iconography in Northern European Art of the Late Middle Ages and Early Renaissance*, Brussels, 1979

Pelikan, J., *The Illustrated Jesus through the Centuries*, New Haven and London, 1997

Rijksmuseum, *The art of devotion in the late Middle Ages in Europe, 1300–1500*, edited by H. W. van Os, exhibition catalogue, Rijksmuseum, Amsterdam, 1994

Ringbom, S., *Icon to Narrative: The Rise of the Dramatic Close-up in Fifteenth-Century Devotional Painting*, Abo, 1965

Schiller, G., *The Iconography of Christian Art*, first 2 vols in English, London, 1971 and 1972

Southern, R. W., *The Making of the Middle Ages*, London 1967

Steinberg, L., *The Sexuality of Christ in Renaissance Art and in Modern Oblivion*, Chicago, 2nd revised ed., 1996

Swanson, R. N., *Religion and Devotion in Europe, c.1215–c.1515*, Cambridge, 1995

BOOKS ON INDIVIDUAL ARTISTS AND SUBJECTS

CHAPTER TWO

Luchinat, C. A., *The Chapel of the Magi: Benozzo Gozzoli's Frescoes in the Palazzo Medici-Riccardi Florence*, London and New York, 1994

Simson. O. von, *The Sacred Fortress* (Ravenna), Chicago, 1948

Stevenson, J., *The Catacombs: Rediscovered Monuments of Early Christianity*, London, 1978

Trexler, R. C., *The Journey of the Magi: Meanings in History of a Christian Story*, Princeton, 1997

CHAPTER THREE

Conisbee, P., *Georges de La Tour and his World*, Washington, 1996

National Gallery of Art, *Georges de La Tour* exhibition catalogue, National Gallery of Art, Washington, 1996

CHAPTER FOUR

Gibson, W. S., *Bruegel*, London, 1977

Grossmann, F., *Pieter Bruegel*, London, 1973

CHAPTER FIVE
Amor, A. C., *William Holman Hunt: the true Pre-Raphaelite*, London, 1989
Maas, J., *Holman Hunt and The Light of the World*, London, 1984
Tate Gallery, *The Pre-Raphaelites*, exhibition catalogue, Tate Gallery, London, 1984

CHAPTER SIX
Cameron, A., *The Sceptic and the Shroud*, King's College, London, 1980
Heydenreich, L. H., *Leonardo: The Last Supper*, London, 1974
Kuryluk, E., *Veronica and her Cloth*, Oxford, 1991
Pointon, M., *William Dyce, 1806–1864: a critical biography*, Oxford 1979
Wilson, I., *The Turin Shroud*, London, 1978

CHAPTER SEVEN
Hayum, A., *The Isenheim Altarpiece: God's Medicine and the Painter's Vision*, Princeton, 1993
Metropolitan Museum, *Zurbarán*, edited by J. Baticle, exhibition catalogue, Metropolitan Museum of Art, New York, 1987
Pevsner, N. and Meier, M., *Grünewald*, London, 1958

CHAPTER EIGHT
Hood, W., *Fra Angelico at San Marco*, New Haven and London, 1993
Proske, B. G., *Martinez Montañés: Sevillian Sculptor*, New York, 1967
Webster, S. V., *Art and Ritual in Golden Age Spain*, Princeton, 1998

CHAPTER NINE
National Gallery, *Rembrandt: The Master and his Workshop: Drawings and Etchings*, edited by H. Bevers, P. Schatborn and B. Welzel, exhibition catalogue, National Gallery, London, 1992

Pope-Hennessy, J., *Italian High Renaissance and Baroque Sculpture*, 2nd ed., London, 1970
Weinberger M., *Michelangelo: The Sculptor*, London and New York, 1967
White, C., *Rembrandt as an Etcher*, 2nd revised ed., New Haven and London, 1999

CHAPTER TEN
Bätscmann, O. and Griener, P., *Hans Holbein*, London, 1997
MacGregor, N., 'To the Happier Carpenter': Rembrandt's war-heroine Margaretha de Geer, the London public and the right to pictures*, Groningen, 1995
Martin, J. R., *Rubens: The Antwerp Altarpieces*, London, 1969
Rowlands, J., *Holbein: The Paintings of Hans Holbein the Younger. Complete Edition*, London and Boston, 1985
White, C., *Peter Paul Rubens: Man and Artist*, New Haven and London, 1987

CHAPTER ELEVEN
Bell, K., *Stanley Spencer: A Complete Catalogue of Paintings*, London, 1992
Brown, J., *Images and Ideas in Seventeenth-Century Spanish Painting*, Princeton, 1978
Davies, M., *Rogier van der Weyden*, London, 1972
De Vos, D., *Rogier van der Weyden: The Complete Works*, New York, 1999
Friedländer, M. J. and Rosenberg. J., *Lucas Cranach*, London, 1978
Karcher, E., *Dix*, New York, 1987
Robinson, D., *Stanley Spencer at Burghclere*, National Trust, London, 1991
Royal Academy, *Bartolomé Esteban Murillo: 1617-1682*, exhibition catalogue, Royal Academy, London, 1982
Tate Gallery, *Otto Dix 1891–1969*, exhibition catalogue, Tate Gallery, London, 1992

ILLUSTRATIONS

43 *Christ of Clemency*, 1603
Juan Martínez Montañés, 1568–1649
Polychromed wood
Cathedral, Seville, Spain

44 *Jesús de la Pasión, c.*1619
Juan Martínez Montañés, 1568–1649
Polychromed wood, clothed
San Salvador, Seville, Spain

45 *'El Señor de los Temblores' carried in Procession during the Earthquake of 1650* (detail), seventeenth century
Unknown Cuzcanian artist
Oil on canvas
Cathedral, Cuzco, Peru

46 *St Dominic at the Foot of the Cross, c.*1441–3
Fra Angelico, 1395/1400–1455
Fresco 340 x 155 cm.
Cloister of San Marco, Florence, Italy

47 *The Mocking of Christ, c.*1441–3
Fra Angelico, 1395/1400–1455
Fresco, 195 x 159 cm.
Cell 7, San Marco, Florence, Italy

48 *Elements of the Passion, c.*1330-40, four pages from a devotional book
Top left: Christ with one of his tormentors, the hand that struck him.
Top right:The Crown of Thorns, the wound in Christ's side, the bucket of vinegar and staff with the sponge offered to Christ to drink on the Cross.
Above left:The three nails and hammer with which Christ was fastened to the Cross, the pincers for removing the nails, the cloth with which Christ was blindfolded, the thirty pieces of silver for which he was betrayed by Judas, three bloody footprints from Christ's journey to Golgotha.
Above right: Christ's cloak and the three dice with which soldiers gambled for it, a stick or the reed which Christ was given to hold as a sceptre, a whip, the ladder used to take Christ down from the Cross, the spear that pierced his side, Christ's tomb seen from above.
Unknown German artist from the Lower Rhine or Westphalia
Painted and gilded elephant ivory, 10.5 x 5.9 cm.
Victoria and Albert Museum, London, UK

CHAPTER NINE

49 *Three Crosses*, third state, 1653
Rembrandt, 1606–69
Etching, 38.5 x 45 cm.
British Museum, London, UK

50 *Three Crosses*, fourth state, after 1653
Rembrandt, 1606–69

Etching, 38.5 x 45 cm.
British Museum, London, UK

51 *Pietà*, 1497–1500
Michelangelo Buonarroti, 1475–1564
Marble, height 174 cm., width 195 cm.
St Peter's, Vatican, Rome, Italy

52 *Pietà*, begun *c.*1545, abandoned 1555
Michelangelo Buonarroti, 1475–1564
Marble, height 226 cm., width of base 123 cm., depth of base 94 cm.
Museo dell' Opera del Duomo, Florence, Italy

53 *Rondanini Pietà*, unfinished at artist's death, 1564
Michelangelo Buonarroti, 1475–1564
Marble, height 195 cm.
Castello Sforzesco, Milan, Italy

CHAPTER TEN

54 *Dead Christ*, 1521
Hans Holbein, 1497/8–1543
Tempera on limewood, 30.5 x 200 cm.
Kunstmuseum, Öffentliche Kunstsammlung, Basle, Switzerland

55 *The Downtrodden*, 1900
Käthe Kollwitz, 1867–1945
Etching, third state, 22.8 x 19.5 cm.
Collection of Dr Richard A. Simms, Los Angeles, California, USA

56 *The Entombment*, from the Isenheim Altarpiece, 1510–16
Mathis Grünewald, 1475/80–1528
Oil on limewood, 269 x 307 cm.
Musée d'Unterlinden, Colmar, France

57 *The Deposition of Christ*, 1612
Peter Paul Rubens, 1577–1640
Oil on panel, 420 x 310 cm., central panel of a triptych
Cathedral, Antwerp, Belgium

58 *The Resurrection*, from the Isenheim Altarpiece, 1510–16
Mathis Grünewald, 1475/80–1528
Oil on limewood, 269 x 143 cm.
Musée des Beaux Arts, Colmar, France

59 *Noli me tangere, c.* 1510-15
Titian, active *c.* 1506; died 1576
Oil on canvas, 108.6 x 90.8 cm.
National Gallery, London, UK

60 *The Ascension of Christ*, from the *Little Passion*, 1509–11
Albrecht Dürer, 1471–1528
Woodcut, 12.6 x 9.7 cm.
British Museum, London, UK

PICTURE CREDITS

BBC Worldwide would like to thank the following for providing photographs and permission to reproduce copyright material. If not mentioned below, photographs were supplied by the museums, galleries and individuals credited in the list above. While every effort has been made to trace and acknowledge copyright holders, we would like to apologize should there have been any errors or omissions.

AKG London: 38, 58; Alinari: 84, 105; Artothek: 204, 224; Bridgeman: 78; © Teo Chambri: 151; e.t.archive 100, 135, 178 (*bottom*); © Pedro Feria: 120; L'Ufficio Turistico, Greccio: 50; Giraudon: 200, 212–13; Institut Amatller d'Art Hispànic: 147, 148, 205, 210; National Trust Picture Library: 220–1; © Nicolò Orsi Battaglini: 155; © John Parker: 112, 216; Réunion des Musées Nationaux, Paris: 47, 109; SCALA: 26, 27, 30, 31, 34, 35, 39, 43, 69, 71, 74, 75, 82, 95, 124, 143, 167, 170–1, 182, 187, 196, 201.

INDEX